You Are Here
Art After the Internet

You Are Here — Art After the Internet

Edited by Omar Kholeif
Assisted by Stephanie Bailey

Designed by Sam Ashby
Printed by DeckersSnoeck

First published 2014 by HOME (formerly Cornerhouse) and SPACE
This edition published 2017 by HOME and SPACE

HOME
2 Tony Wilson Place
Manchester M15 4FN
www.homemcr.org

SPACE 129-131 Mare Street
London E8 3RH
www.spacestudios.org.uk

ISBN 978-0-9569571-7-7

Distributed worldwide by Cornerhouse Publications
www.cornerhouse.org/books

HOME [space]

Bloomberg

You Are Here
Art After the Internet

Edited by Omar Kholeif

Essays

Provocations

Against the Novelty of New Media: The Resuscitation of the Authentic

The Curator's New Medium

Contra-Internet Aesthetics

Writers in the Expanded Field

Notes on Post-Internet

Dataforming the Hinternet

OurSpace: Take the Net in Your Hands

Post-Whatever #usermilitia

Where to for Public Space?

Protocological Hope

Projects

Acknowledgements

This project was the result of various different forces, some of whom I would like to acknowledge here. I would like to begin by thanking Sarah Perks, Artistic Director of Cornerhouse, and Anna Harding, CEO of SPACE, for their support and commitment. I am grateful to all of the contributors to this volume for their provocative proposals, as well as to Stephanie Bailey, who stepped in as Assistant Editor and helped push this book forward to the finish line. Many of the ideas here were developed during my time working at SPACE and through working with the various participants who engaged with the public programme at The White Building, London's centre for art and technology. Great respect is due to all of the interlocutors from this period, whose ideas contributed to the formation of this book: Aleks Krotoski, Alice Rawsthorn, Ben Hammersley, James Bridle, Jesse Darling, Lawrence Lek, Fabienne Hess, Stefana Broadbent, Tamara Barnett-Herrin, Daniel Rourke, Kyoung Kim, Nina Power, Shu Lea Cheang, Jamie George, Una Knox, TJ Demos, Alex Eisenberg, Jamie Shovlin, and Lawrence Abu Hamdan.

I am also grateful to Heather Corcoran, Kate Taylor, and Ben Cook for stimulating conversations around art, technology, and its affects, as well as the artist Jeremy Bailey, who has become one of my closest co-conspirators.

SPACE staff Alexandra Symons Sutcliffe, Levin Haegele, Lena Nix, Hannah Barton, Douglas Thackway, and Yvonne Williams were absolutely necessary in bringing this concept to life, as was Sam Ashby, the artist whose sensitive design guides the reader through these pages.

FG, thank you for constantly having to endure the insufferable.

—Omar Kholeif, Editor

Preamble

Omar Kholeif

It is 2014 and I'm anxious. My computer, my phone, and my email calendars are all alerting me to different tasks that I must fulfill. I open up my Google calendar (personal life), my Outlook calendar (work), my iPhone calendar (ad hoc activity), and start to panic at the sheer amount of commitments that have been scheduled, synched up, and fixed across multiple platforms that bind and enforce my daily life. Generic alarm tones sound from various devices, composing a scene that is as fretful as it is comic.

These effects would sit perfectly within the *mise en scène* of a Jacques Tati film if he were alive and making work today. Indeed, Tati's films imaginatively pushed forward both the technical and formal aspects of cinema through a subversive juxtaposition of architecture and the human body. In *Playtime*, 1967, the filmmaker reveals a world where human obsession for material goods has left us with an environment that is cold and impractical. Encompassing an infamously enormous set, *Playtime* presented a milieu in which the modernist tradition functioned as the ultimate cockblock to human interaction. Here, sleek lines and multi-lane carriageways function as icy repellents to human emotion. This is also illustrated in the motion picture's characterization—dialogues are often phased out into a murmur and we are left with nothing but absolute capitalist desire.

The hyper-real disenchantment with capitalist culture that Tati evoked has now become part of our everyday fabric. 'Designed' culture has subsumed us with its functional and programmed infrastructure. Still, it is not that we have become slaves to machines, but rather we have invested machines with our ultimate desires—the desire to be as efficient, attractive, and connected as possible. These conditions have developed rapidly since the millennium, altering the way human relationships are brokered, the manner in which global conflict is reported, and the way culture is produced and distributed.

Interestingly however, much representation of the human relationship with technology in literature and cinema has tended to focus on the dystopian effects of hardware as opposed to software—the intangible sphere where so much of our lives have become increasingly mediated. Yet, it is undeniable that the intangible space of the internet has propelled the most significant cultural shift of the twenty-first century thus far. The manner in which individuals populate, surf, negotiate, and share the contents of the web's endless stream of information has radically changed over the last decade.

The turning point arguably occurred during the 2003 invasion of Iraq and the rise of a pluralistic reporting culture in the form of blogging. Quickly, we noticed a turn in the way people related to one another. A personal, diaristic form of writing, which grew out of the blogosphere quickly, began to subsume mainstream media with the return of reality television. This subsequently transferred over to social media, leading to a culture that was much more confessional.

The rise of the superego soon followed across different forms of networked culture—the Facebook selfie, Bryanboy.com, TMZ, BuzzFeed, Perez Hilton, E! Online, Netflix, Spotify, Last.fm, YouTube, Twitter, Instagram, Snapchat, the iPhone, the iPad, the Kindle, Skype, remote desktop computing, RedLaser, Grindr, Gaydar, Match.com, Google Maps, price comparison sites, Viber, FaceTime, Google Drive, QR Readers, WhatsApp, *The Huffington Post*, Wikipedia, LinkedIn, Amazon, Tumblr, Vimeo, Delicious, reddit, et cetera. We have become narcissistic egos sharing, intertwining, interlacing, and interfacing.

This book began through a process of exploring how these seismic cultural shifts were affecting the work and lives of artists today. After all, the internet seems like the ideal place for artists. It is a nimble, malleable, and responsive sphere that enables a degree of autonomy, which most artists crave but are often unable to achieve due to the hierarchical nature of the art world and its institutions. Could the internet allow artists a means to jettison the formal structures of the institution and encourage a different kind of artistic expression? Certainly, the internet has enabled distinctive ways for artists to navigate distance—they can now be telepresent and omnipresent. Users can now navigate their gaze from watching images of global revolution to amateur pornography to retailing online in an instant, if not simultaneously. We can fall in love, form friendships, broker new tastes through trending hash tags, and escape mundane reality through networked virtual gaming.

Grappling with these cultural shifts, I wanted to consider how the canon of art and art making is being reimagined in this free-flowing zone of constant renegotiation. How have the formal aspects of art making and art viewing been altered by the integrated dependence on designed technology? Instead of retreading art historical debates about medium specificity, I decided that the most appropriate means to tackle such questions was to develop a platform for artists, writers, and curators to lead these discussions through the questions that were developing organically in their practice.

As such, this book began as an idea to map out formal shifts in art making by and from artists. I began the process by asking artists to pen texts and to propose projects with free reign. Soon it became apparent that there were inherent contradictions and questions that could not be rationalized through the chronological or historical form of the book. Ultimately, these contradictions define the form this publication takes. It is composed of three kinds of contributions: essays, provocations, and projects. Collectively, these interweaving voices form a template for readers to understand the complexities of writing or defining a history that is still in the process of being made.

In the end, this is not a book that seeks to defiantly articulate a medium or tendency. Rather, it operates as a snapshot of the questions being raised by artistic practitioners whose work largely took formation during the rise of the internet. The process of formulating this collective narrative has been a complex and challenging one. For example, one of the most basic concerns to grow out of this process was how to define the internet—as a space, as a form, or as an adjective? Should it be capitalized or not? In the end, it was decided that we would stick with what the contributors felt most comfortable with. Likewise, the question was raised: why a physical book? Why not an e-book, a blog, an application? Ultimately, my argument became this: what about the unconverted? The non-specialized audiences who might happen upon this physical manuscript in a bookshop or library?

More importantly, I thought about the form of the designed object that so many of us have come to cherish and treasure. But couldn't this book take on the same form of a treasured design object such as an iPad, a Macbook Air, or a Kindle? Or would it be relegated to a dusty shelf, lost in its anachronism in 2052? Maybe it will reappear like a vinyl record—an object of retromania. I hope you will revel in these and the many contradictions that you are soon to encounter.

Foreword

Ed Halter

I write this for a reader in the year 2024. Or someone in 2034, or in 2074—or at whatever future date you might chance upon this. Maybe you're at the apartment of a friend who collects physical books, and you pulled *You Are Here* off the shelf, intrigued by its old-fashioned design. Perhaps you have found these words on a ripped scrap of paper, amidst the rubble of a bombed-out university. Or, more likely, you are reading my words off some sort of electronic device: a monitor, a tablet, a phone, a pair of glasses, a wristwatch. For all I know, these words are being projected into a thin but translucent mist; you look at text that quivers slightly on a weightless sheet of light; you peer into a whiff of artificial smoke as a seer might gaze into her crystal ball. But, unlike a fortune teller you are looking backwards, not forwards, in time.

This invocation, O future reader, is born out of an anxiety of obsolescence. Here as I write, in Brooklyn, in 2014, my own bookcases bear a few titles from decades past that mock our current enterprise. *Postmodern Currents: Art and Artists in the Age of Electronic Media* (1989); *Hypertext: The Convergence of Contemporary Critical Theory and Technology* (1992); *Imagologies: Media Philosophy* (1994); *Multimedia from Wagner to Virtual Reality* (2002, with a foreword by William Gibson and coda by Laurie Anderson). I'm almost embarrassed to admit I own these, and I want to think about why. Just like the book you are now reading, these are works that attempted to grapple with, in their own time, what 'now' meant; that asked what function art might serve at a moment of great technological change. Moreover, these are titles that few people read today. The things they speak about are gone. Teletext is gone. HyperCard is gone. Netscape Navigator is gone. Data gloves are gone. The societies that used these things are gone, too. These things have been replaced by other, newer things. The worlds they tried to respond to have been replaced by other, newer worlds.

Such are the dangers of addressing the contemporary. We fear that the future does not care; its people have moved on to other concerns. All you've achieved at best, in the long term, is more work for the historians, a further bit of evidence for them to rediscover, decipher, and misconstrue.

Another problem is that we can't really write about the present directly, since we need to frame the present in terms of the immediate past. As Marshall McLuhan once wrote, we always see the world in a rear-view mirror. So much of our thinking becomes caught up in trying to sort out the 'now' from the 'then'. The result is an emphasis on differences from what's come before, rather than similarities; on disjunctions over continuous

developments. *You Are Here* announces this in its subtitle—'Art After the Internet'—and its writers pore over concepts of recent currency like 'post-internet', 'born digital', and 'the New Aesthetic' with similar intent. As some of these contributors note, we might have good reason to be somewhat skeptical of claims of radical novelty. Curators and critics want to say they've discovered something and got there first; marketers always want to sell you new approaches for reaching the latest crop of twenty-somethings; artists try to argue for their own relevance by pointing out what unique contributions their generation has added or contributed to art history. Behind these desires run the engines of the market, always demanding more 'content' for its ever-expanding platforms, pushing technology in new directions under the imperative that everything that is logically possible to develop and monetize must be attempted, enacting a scattershot futurism through the anarchic speculations of venture capital.

While it's true that technology and society, inseparably intertwined, keep developing in new directions, this phenomenon itself has been, somewhat paradoxically, a long-standing constant. The rate of change has been very high for at least a century and a half, and artists and critics have been attempting to figure out what it all means since at least the revolutionary days of the telegraph and horseless carriage. Even if we look just at the congeries of technologies we call the internet, it's clear that nothing has remained stable for any considerable amount of time. The internet has always been marked by constant innovation. To say that we are living 'after' the effects of the internet is premature, since those effects continue to evolve.

Rather than think of art before and after the internet, we might periodize art's relationship to networked culture in a more gradual way. Consider how the internet has already seen a number of micro-eras within the two decades since the introduction of the World Wide Web. The early days of net art in the 1990s saw the first formalist tinkerings with HTML, playing with faked identities, and celebrations of the web as a global communication system. The era of the dotcom boom around the turn of the century brought experiments with flash and online gaming, and increased activism against the corporatization of the internet. In the post-crash years of Web 2.0, social networks, Google, and YouTube took hold as broadband access increased; artists worked with online video, blogging, and appropriation, and explored a nostalgia for the low-bandwidth amateur internet of the dial-up 1990s. By the late-noughties, Wi-Fi-enabled cloud

computing and the success of smartphones and tablets lent a feeling of ubiquity to the internet, and the line between a specifically online culture and contemporary culture seemed to dissolve.

So if art and culture have been altered 'after' the internet for some time now, why do we want to use terms like post-internet, the New Aesthetic, and so forth to describe this particular juncture in history? One factor is that increased change also means that certain aspects of culture become rapidly outdated. Terms like 'new media' and 'net art' today sound hopelessly antiquated, clunky, uncool. Stressing what's new about the relationship between art and the internet allows us to distance ourselves from this past. At a time when internet culture has spread into all of culture, artists feel a need to carve out a more schooled, historically-aware sensibility within that culture, then create a name for it. This is one way to make sure people recognize it as art, not merely something you might glance at on Tumblr.

Despite the distortions such forces might enact upon our thought, attempts to understand what the hell is going on with human culture remain necessary. It just might take a while for us to sort all of this out. We're too busy catching up with our own moment. But you, our future reader, will know better than us.

Essays

The New Aesthetic and its Politics

James Bridle

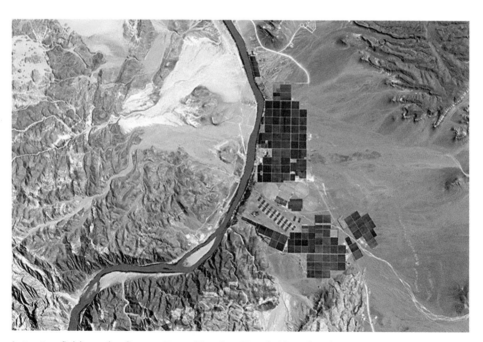

Irrigation fields on the Orange River, Namibia/South Africa border.
Image: ALI/EO-1/NASA.

The New Aesthetic is a term coined by James Bridle, used to refer to the increasing appearance of the visual language of digital technology and the internet in the physical world, and the blending of virtual and physical. The phenomenon has been around for a significant period of time and referred to in different forms, for example by the likes of cultural theorists such as Norman M. Klein.

Bridle articulated the notion through a series of talks and observations. In 2012 it gained significant traction in the cultural sphere.

The New Aesthetic has been described by the author Bruce Sterling as a movement without a manifesto:

> The 'New Aesthetic' is a native product of modern network culture. It's from London, but it was born digital, on the Internet. The New Aesthetic is a 'theory object' and a 'shareable concept'.
>
> The New Aesthetic is 'collectively intelligent'. It's diffuse, crowdsourcey, and made of many small pieces loosely joined. It is rhizomatic, as the people at *Rhizome* would likely tell you. It's open-sourced, and triumph-of-amateurs. It's like its logo, a bright cluster of balloons tied to some huge, dark and lethal weight.[1]

The New Aesthetic has become an appropriated phenomenon—absorbed by marketing firms and the art world alike. What follows is an essay that unpacks the term and its politics.

—Omar Kholeif

1 Bruce Sterling, 'An Essay on the New Aesthetic', *WIRED*, 2 April 2012, http://www.wired.com/beyond_the_beyond/2012/04/an-essay-on-the-new-aesthetic.

Let us be clear: just as my work on the form of the book in the digital age was concerned not with the physical or digital object, but with people's understanding and emotions concerning literature; just as my drone works are not about the objects themselves, but about the systems—technological, spatial, legal, and political—which permit, shape, and produce them, and about the wider implications of seeing and not seeing such technological, systematic, operations; so the New Aesthetic is concerned with everything that is not visible in these images and quotes, but that is inseparable from them, and without which they would not exist.

Much of the critical confusion around the New Aesthetic has clustered around the use of the term 'aesthetic'—by which I meant simply, 'what it looks like'. I wasn't even really aware of how key the term 'aesthetics' was to art historical and critical discourse. As a result of my use of this term, much of the critical reaction to it has only looked at the surface, and has—sometimes wilfully it feels—failed to engage with the underlying concerns of the New Aesthetic, its own critique and politics. This criticism still concerns itself only with images, despite the wealth of texts also included in the project, and the numerous recorded lectures I've given on the subject. The Tumblr is just one aspect of a wider project: the sketchbook or playlist. In short, this form of criticism has been looking at the pixelated finger, not the moon.

There are two necessary understandings to counter this, I think. One is the important recognition that the New Aesthetic project is undertaken within its own medium. It is an attempt to 'write' critically about the network in the vernacular of the network itself: in a Tumblr, in blog posts, in YouTube videos of lectures, tweeted reports and messages, reblogs, likes, and comments. In this sense, from my perspective, it is as much work as criticism: it does not conform to the formal shapes—manifesto, essay, book—expected by critics and academics. As a result, it remains largely illegible to them, despite frequent public statements of the present kind.

But I think the deeper and more interesting aspect of this misreading of the New Aesthetic is that it directly mirrors what it is describing: the illegibility of technology itself to a non-technical audience. From the very first post about the New Aesthetic I have been talking about what these images reveal about the underlying systems that produce them, and/or the human viewpoint that frames them. It is impossible for me, with an academic background in Computer Science and Artificial Intelligence, with a practical background in literary editing and software programming, with a lifetime of interacting with the internet and other systems, not to look at these images

and immediately start to think about not what they look like, but how they came to be and what they have or will become: the processes of capture, storage, and distribution; the actions of filters, codecs, algorithms, processes, databases, and transfer protocols; the weight of data centres, servers, satellites, cables, routers, switches, modems, infrastructures physical and virtual; and the biases and articulations of disposition and intent encoded in all of these things, and our comprehension of them.

And it's worth bearing in mind too that many of the images are snapshots, or stills, in many forms, and not fully formed objects. Whether a frame from an online video, or a screen capture of an online map (remember, digital maps are animations on pause), or fragments of code or spam; all of these are snippets, they are only momentary representations of ongoing processes—as indeed the New Aesthetic is intended to be. Each image is a link, hardcoded or imaginative, to other aspects of a far greater system, just as every web page and every essay, and every line of text written or quoted therein, is a link to other words, thoughts, and ideas. Again, in this, the New Aesthetic reproduces the structure and disposition of the network itself, as a form of critique.

Let's look at some recent examples. Every satellite image posted is a meditation on the nature of mapping, which raises issues of perspective and power relationships, the privilege of the overhead view and the monopoly on technological agency that produces it. A photograph of Eric Schmidt wearing a flak jacket—as he does in his Twitter avatar—is a spur to investigate the circumstances of the photograph and the self-presentation of the corporation. It was taken on a visit to Iraq in 2009, when Google promised to digitize what remains of the National Museum's collection, raising further questions about the digitization and subsequent ownership of cultural patrimony, and of Google's involvement in political activity and international diplomacy through its Google Ideas think tank, which actively supports a programme of regime change in certain parts of the world. A photograph of the 'Free Bradley Manning' contingent of the San Francisco pride parade in 2011 is an entry point to a consideration of intersectional politics—of the parallels between the political and the personal in an age when networks permit the sudden rupture of secure systems by individual conscious actions, when states can use such ruptures to justify ever greater clampdowns of freedom and transparency (both in the sense of information freedom, but also the ever-threatened right of the individual to remain opaque and illegible to the state), as well as the tendency of the media and

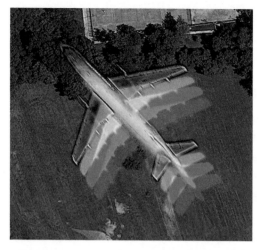

James Bridle, <u>Drone Shadow 006</u>, 2013. Photograph by Steve Stills.

popular protest to focus on the individuals (Manning, Assange, Snowden) and the technological front ends to such disclosures (WikiLeaks), rather than the deeper transfer networks, protocols, or even, god forbid, the actual substance of the information disclosed. A screenshot of a promotional video for the telepresence company Anybot—which features a robot wearing a bow tie commanding a human employee to 'work faster!'—is in one frame a terrifying vision of labour futures, and an indictment of visions of automation that emerge from executive and engineering cultures, which perceive the value extractable by technological innovation differently to the major currents of twentieth-century social advancement. An Adobe-sponsored 'prank' at a bus stop with twelve million views on YouTube, in which a live artist inserts passersby into a digital advertisement, speaks to our internalization of surveillance culture and our corresponding expectations of the individualization of technology and its framing by corporations. In the video, are the passersby shocked, violated, or just plain creeped out by such an intervention? Are they edited out, or did they simply not exist, and if not, why the hell not? This individualization effect is seen at every level of technology, from the dot which places each of us at the centre of the digital map, up to the robot sensor networks which rely on a codified abstract of the world to guide them, rather than the truth on the ground. The map indeed becomes the territory. PowerPoint default styles, which describe corporate visions, are reproduced in the NSA prism slides and the US Army's famous 'death by PowerPoint', even as those corporate slides are infected by the absence of meaning best expressed in the war on abstract nouns. Endless views of protest, repression, revolt, and schism are framed not through the lens of critique, but the lens of iPhones and iPads held aloft; photography, unable to see the network, photographs photography, but in the glitches and unicode characters of printed database commands and international shipping labels an underlying structure is made visible: the horsemeat scandal of information systems. And so on and so forth; it's not the writing that's hard, it's the thinking.

The New Aesthetic is not superficial. It is not concerned with beauty or surface texture. It is deeply engaged with the politics and politicization of networked technology, and seeks to explore, catalogue, categorise, connect, and interrogate these things. Where many seem to read only incoherence and illegibility, the New Aesthetic articulates the deep coherence and multiplicity of connections and influences of the network itself.

I believe that much of the weak commentary on the New Aesthetic is a direct result of a weak technological literacy in the arts, and the critical

discourse that springs from it. It is also representative of a far wider critical and popular failure to engage fully with technology in its construction, operation, and affect. Since at least the introduction of the VCR—perhaps the first truly domesticated computational object—it seems there has been a concerted, societal rejection of technical understanding, wherein the attitude that 'I don't understand this and therefore don't like this and therefore I will not investigate this,' is ascendant and lauded. This attitude manifests in the low-level Luddite response to almost every technical innovation; in the stigmatization of geek culture and interests, academic and recreational; in the managerial culture of economic government—and in the elevation of sleek, black-box corporate-controlled objects, platforms and services, from the iPhone to the SUV, over open source, hackable, comprehensible, and shareable alternatives. This wilful anti-technicalism, which is a form of anti-intellectualism, mirrors the present cultural obsession with nostalgia, retro, and vintage, which was one of the spurs for the entire New Aesthetic project; it is boring, and we reject it.

But if we don't move the debate to a deeper level, none of this will change. There is a justified and rising opposition to drone warfare, computational surveillance and intelligence gathering, which may or may not produce lasting political change. But even if successful, this will only change the images and objects employed and not the modes of thinking—coupled to technological mastery—which drive it. Without a concerted effort to raise the level of debate, we just loop over and over through the same fetishizations and reifications, while the real business of the world continues unexamined. Those who cannot understand technology are doomed to be consumed by it. (The idea that these ideas lack politics is especially laughable when you look at what's happening in much of the art world, and most of the digital art world. A young, post-Iraq generation who have had all hope of political participation kettled out of them, and are then endlessly accused of apathy to boot. No wonder it's all personal brands, car culture, glossy gifs, and Facebook performances.) Technology is political. Everything is political. If you cannot perceive the politics, the politics will be done to you.

I was recently asked if the New Aesthetic would coalesce into 'something more serious': a book, collection of essays, or a manifesto. While I would like to, and probably should, produce a book or book-like object at some point, it itself would not be 'the New Aesthetic', but a commentary upon some of the issues it raises. I strongly reject the notion that a manifesto is an appropriate or 'more serious' (and thus worthy) way to address the issues

under discussion here, as it would represent precisely the kind of premature codification of the subject that the New Aesthetic explicitly sets out to avoid. (While admitting, with respect to that statement, all the contradictions presented by this piece of writing: where the two accounts differ, trust the network and not this document.)

In part, this unwillingness to codify is a reproduction of the network's own refusal to be pinned down, controlled, routed, and channelled, which must be considered one of its core, inherent qualities. But it is also born of a sincere desire not to foreclose discussion: the New Aesthetic may be considered a work, a conversation, a performance, an experiment, and a number of other things (although, please, not a movement). This intention of keeping the field open was, and perhaps remains, naive. Nevertheless, I firmly believe it is the way it has to be. As such, the presentation of a so-called gaudy heap of images is an appeal to, and act of confidence in, the network itself, in the systems and people that comprise it, to follow their own ideas and intuitions, educate themselves and, outwith a hierarchical commentariat, come to their own conclusions. The onus is on the reader to explore further, just as, and because, the onus is on the individual in a truly networked politics. So why is it important to critique the critique as well? Because we live in a world shaped and defined by computation, and it is one of the jobs of the critic and the artist to draw attention to the world as it truly is.

First published at booktwo.org, 12 June 2013.

The Context of the Digital: A Brief Inquiry into Online Relationships

Gene McHugh

The 2013 film *Computer Chess*, which presents a fictional tournament between rival, early-1980s computer chess programming teams, features a character that suggests that the future of predictive computer software will not be chess or even military usage, but dating—helping people get dates.[1] It is an ironic line because he is in a room of computer nerds who most likely aren't active in the dating scene; but also, looking retroactively, we can see that the character is at least partially correct. Although online dating is not the largest industry on the internet, it is right up there, ranking third (in 2013) among paid content sites online in overall revenue, outpacing even pornography, and that number was projected to grow ten percent by 2013.[2] Furthermore, if one is looking for love these days, the internet is competing with the singles bar as the de facto place to find it. Take the United States: out of fifty-four million single people, forty million of them had utilized an internet dating site such as Match.com, Gaydar, or OkCupid as of 2013.[3] And finally, with locative software applications such as Grindr, in which (mostly gay or bisexual men) can find other available men volunteering to meet in their area, the internet has become even more dominant as a tool to meet others.

One reason this phenomenon might be increasing in appeal is that communication over screens is no longer as awkward as it once was; many cultures—as their economic and cultural affairs move online—have evolved various internet-specific ways to flirt and show affection so that people can now have 'natural' interactions without being in the same room. The most literal example would be face-to-face video chatting in which high resolution video of people's faces mingles in real time on the screen. Another example more native to the internet would be varying the casualness of online communication (lowercase letters, 'u' instead of 'you', disclosing personal information, leniency toward following grammar rules, and so on), so that both parties can define the tenor of the relationship—is it professional, friendly, flirtatious, sexual, romantic? This is analogous to greeting someone on the street: do you shake hands, hug and kiss on the cheek, not make physical contact at all? There is a push and pull occurring in both the online and offline scenarios in which the world the participants share is being actively formed. Further examples are an increase or decrease in one's response time between texts or chats, strategically disseminating likes and comments on social networks, and, on the more aggressive end, sharing sexual selfie photos such as 'dick pics'.

All of this can be seen as symbolic posturing, not so different from mating rituals that have occurred in physical space among humans and animals since time immemorial. All of that said, though...is it possible to go beyond flirtation and share more complex emotions, such as love, through a technological medium? Using the internet to attract someone's attention and schedule a date is one thing, but what about all of the stuff beyond that?

Ever since the early days of the internet in the mid-1990s, people have, of course, been having text and eventually video-based cybersex; and in 3D worlds like Second Life, avatars engage in complex sexual scenarios. However, it might be argued: isn't this all still fantasy role-playing, literally masturbatory, and ultimately a lesser phenomenon than physical intimacy in shared three-dimensional space? This is, in her own way, what Susan Jacoby, a writer and the Programme Director of the Center for Inquiry, expressed in a recent *New York Times* op-ed about an infamous, almost-entirely digital relationship conducted between New York City mayoral candidate Anthony Weiner and his cyber-mistress Sidney Leathers.[4] For Jacoby, the true scandal of this affair was that, as an affair, it was pathetic. She argues that what happens online isn't truly sexuality because when relations occur in a space detached from what (from her perspective) is reality, those relationships lack the larger context that provides them meaning and a sense of genuine stakes. She writes:

> Virtual sex is to sex as virtual food is to food: you can't taste, touch or smell it, and you don't have to do any preparation or work. Sex with strangers online amounts to a diminution, close to an absolute negation of the context that gives human interaction genuine content. Erotic play without context becomes just a form of one-on-one pornography.

She continues:

> I could call myself Susanna Reckless and post pictures of my much younger self online tomorrow, but the resulting encounters would have nothing to do with the real me. It all recalls the classic *New Yorker* cartoon with the caption, 'On the Internet, nobody knows you're a dog.'[5]

However, I feel that Jacoby is speaking too narrowly about what counts as a 'real' relationship and, furthermore, meaningful context can and does occur on the internet, despite her objections to that notion. Her position is understandable: for Jacoby, the world in which she feels comfortable is simply not online. She seems to be unfamiliar with the way people use online platforms these days—the paradigm of online representation has, for most people, radically shifted from the anonymity of twenty years ago (her 'Susanna Reckless') to the intense surveillance, sharing of personal data, and the cult of 'authenticity' that came with Web 2.0 social networks, most notably Facebook.[6] So for her, yes, a 'real' relationship with a real context would be impossible online because she seems relatively unfamiliar with how these tools are being used. And the same could be said for many other people, especially those that didn't encounter the internet until they were already adults.

However, for many people who came of age as individuals and sexual beings online, the internet is not an esoteric corner of culture where people come to escape reality and play make-believe. It *is* reality. In the book, *Born Digital: Understanding the First Generation of Digital Natives*, John Palfrey and Urs Gasser, both scholars at the Berkman Center, Harvard Law School's cyberspace think tank, use the term 'digital native' to describe the first generation that remembers nothing other than a life bound up with the internet. They write:

> Digital Natives live much of their lives online, without distinguishing between the online and the offline. Instead of thinking of their digital identity and their real-space identity as separate things, they just have an identity (with representations in two, or three, or more different spaces). They are joined by a set of common practices, including the amount of time they spend using digital technologies, their tendency to multitask, their tendency to express themselves and relate to one another in ways mediated by digital technologies, and their pattern of using the technologies to access and use information and create new knowledge and art forms.[7]

The internet provides a plethora of extremely complex contexts through which the user has to navigate and perform in as themselves (as opposed to an anonymous avatar) on a daily basis through emails, chats, financial transactions, and, yes, the management of relationships. It's tiring to be

online; you're always on, always having to manage your online presence. That's not to say that people don't use the internet to escape (they obviously still do), but just that the bulk of what many people do when they use a computer and go online today is not fantasy role-playing, but almost the exact opposite: mundane slogging through the details and interpersonal negotiations of the 'real' world.

As the theorist Mark Hansen suggests, the notion of identity extending into different planes of reality—or what Hansen terms a 'mixed reality'—is not necessarily new (for instance, the entire traditions of spirituality and metaphysical philosophy); however, the empirical concreteness of this 'mixed reality' is, in fact, a recent phenomenon. He writes, '... what is thus singular about our historicotechnical moment, is precisely the becoming-empirical, the empirical manifestation, of mixed reality as the transcendental-technical, the condition of the empirical as-such.'[8]

So, contra Jacoby, even though the digital hasn't totally supplanted the physical as the space in which reality occurs, it has at least become highly mixed and the potential for complex relationships can and does exist.

For instance, the artist Ann Hirsch, who's young enough to fall into the 'digital native' category has developed a body of work called *Playground* (2013), which explores how, at the age of twelve, the offline world around her wasn't providing sufficient opportunities for her emotional and intellectual development. But through an online chat community and one particular user—an older guy named Jobe—she did find this complex intimacy that some assume couldn't exist online. The fact that he was twenty-seven and, thus, would be what some would term an online sexual predator, complicates matters and brings in a host of other issues. But what Hirsch does so well is portray both the Jobe character and Anni, the character based on herself, with an unflinching realism and truthfulness to what occurred. The viewer is not left with a message, just a sense that the relationship was, like real life, complex. Hirsch's story is told through different media—photographs, an e-book, and a two-person play. In the e-book and play (which recently premiered at the New Museum to a sold out crowd), she brings us inside this relationship as the characters share themselves in far more personal depth than they possibly could with anyone offline; they talk about God, philosophy, and morality; and they share tactics for getting through the drudgery of life. Furthermore (and here is the most sensational/controversial aspect of Hirsch's work), they give each other physical pleasure. While it's true that this pleasure derives from each of them touching their own respective bodies, it's

not completely autoerotic—the sexual thrill of it is the exchange with another being through the computer. A looming goal of the whole experience for Hirsch and Jobe was to meet in physical space someday, but along with that goal is a fear—a fear that by dramatically switching contexts the thrill of the relationship that they developed would snap. It's important to note that this snapping would not be because it suddenly became more real, but because the context of what was real had shifted. For the two characters in their online relationship, the IRL meetup was the unreality: they'd defined their real selves online and the person that would appear in physical space would be like a shadow.

The material doesn't provide the viewer with a clear-cut message about what's occurring between Hirsch and this older man. Clearly, there is a very creepy, exploitative edge to everything he does. However, Hirsch gradually complicates things until it becomes clear that what she felt and learned about the world, her body, and sharing time with another individual through the online relationship was, if nothing else, very real, complicated, and, to a great degree, enriching.

To take another example, the artist/filmmaker Eugene Kotlyarenko's serialized film *Skydiver*, produced solely through webcam video of Kotlyarenko video chatting with others, also successfully explores the depth of feeling that can occur online. When his girlfriend—who had recently moved making their relationship long distance—dumps him online and he happens to click on an Islamic jihad propaganda video, he spirals down a dark road, which ends in his becoming a fanatical terrorist. Laying the plot out like that in a couple of lines makes it sound crazy and unrealistic, but Kotlyarenko is gifted in bringing you into the head space that would allow him to take such drastic measures. To a great degree, the project is about how crazy the character's actions are—and how the internet aided to this craziness. *Skydiver* is, in many ways, a critique of online relationships and a life spent online. Because Kotlyarenko's character is basically all alone and alienated despite the fact that he's connecting through the internet, he ultimately becomes unhinged. However, like Hirsch's project in which there is a critique of a life lived through screens, another huge part of the project is that these relationships, despite their problems, are at the very least real, and have a context that needs to be taken seriously, no matter how embarrassing that would be for the skeptics.

Indeed, a takeaway idea from these two works is that because society, on the one hand, laughs at the possibility of online intimacy, and, on the other hand, is deeply paranoid about the possibility of real exchange

online when it actually happens, it gets pushed to the side as a sort of embarrassment, and people like Susan Jacoby write op-eds in newspapers about it. Hopefully, as the idea of forming bonds online through screens becomes more and more naturalized—as if they've always already been part of the fundamental toolbox of life—realistic social and ethical norms (along with culture that analyses and/or mythologizes these experiences) can be established to guide someone through the complexities of communicating intimately online and understanding what is ethical and what is not. The lack of these broadly defined norms creates a disconnected, two-tiered world in which some exist in a pre-internet reality, while others can only be their real selves online. This is not science fiction; it's an awkwardly developing truth— one that, over the next generations, will necessitate social scientists and cultural producers to demarcate how intimacy happens over screens.

1 *Computer Chess*, dir. Andrew Bujalski, Eureka Entertainment, 2013.

2 Robert L. Mitchell, 'Online Dating: It's Bigger than Porn', 13 February 2009, http://blogs.computerworld.com/online_dating_its_bigger_than_porn.

3 'Online Dating Statistics', 18 June 2013, http://statisticbrain.com/online-dating-statistics.

4 Susan Jacoby, 'Weiner's Women', *The New York Times*, 30 July 2013, http://www.nytimes.com/2013/07/31/opinion/weiners-women.html.

5 Ibid.

6 The notion that the internet is no longer a place to escape and be anonymous is perhaps best exemplified by Facebook founder Mark Zuckerberg's notorious comment, 'You have one identity ... The days of you having a different image for your work friends or coworkers and for the other people you know are probably coming to an end pretty quickly ... Having two identities for yourself is an example of a lack of integrity.' For more on this, see Ethan Ryan, 'Pseudonyms, Authenticity, and Internet Identity', 17 April 2012, http://htmlgiant.com/craft-notes/pseudonyms-authenticity-and-internet-identity.

7 John Palfrey and Urs Gasser, *Born Digital: Understanding the First Generation of Digital Natives*, (New York: Basic Books, 2008), 4.

8 Mark BN. Hansen, *Bodies in Code* (London: Routledge, 2006).

Art After Social Media

Brad Troemel

The music, film, television, and print industries have been overturned by Web 2.0, yet the art world remains in transition, negotiating a complicated and relatively new relationship with social media. Nowhere is this relationship more evident than the online profiles of young artists who use social media to disseminate their work. The seemingly paradoxical dispositions of these artists are reflective of their effort to simultaneously navigate the art world and social media in tandem. On one hand, there exists a utopian vision for art on the internet based on sharing: a world where intellectual property is part of a commons, where authorship is synonymous with viewership, and where distinctions between art and everyday life are fluid. On the other hand, there is the competitive art market, where an unprecedented number of artists use marketing and business strategies like mini-corporate brands to develop their online-specific personas and their output (both personal and artistic) for maximum attention and successful careers. This is a world where, arguably, today's seventeen-year-old has a more intuitive handle on the techniques of advertising to direct traffic to her Tumblr than our presidential candidates had seventy years ago. As such, art after social media divorces art from its traditional relationship to the market.

The utopian disposition of art after social media is premised on challenging three historical norms:

1. Authorship must be attributed to a work of art. The last time in history authorship was unimportant was prior to the printing press. Art's history is now a series of aesthetic accomplishments abbreviated to first and last names. As Marshall McLuhan said:

 > The invention of printing did away with anonymity, fostering ideas of literary fame and the habit of considering intellectual effort as private property. The rising consumer-oriented culture became concerned with labels of authenticity and protection against piracy. It was at this time the idea of copyright was born.[1]

2. Art is a form of property. Whether owned and promoted as an investment, a civilizing tool for the middle class, a demonstration of aristocratic power, or a visual guide for religious narrative, art has always had an owner ever since it ceased being used for mystical purposes.

3. Art must be placed in a context that declares it to be art. Art exists for discourse and people who recognize it as such. To this day, museums and galleries still cling dearly to the sanctity of all that appears inside those buildings as being art and all that occurs outside them as being part of everyday life. Even artwork not found within institutions carries with it the formal and conceptual codes created by those institutions.

These three mutually reinforcing conventions are what keep art tethered to its status as a commodity. Everything that has an author is automatically considered part of that author's intellectual property. Property must be recognized through a legal context, and context is informed by the time, date, place, and all other characteristics attributable to authorship. Each convention uses the other as a support.

Another way to conceptualize property and context for art online is through David Joselit's concepts for 'image fundamentalism' and 'image neoliberalism', terms he adapts from political analysis to describe competing visions of where art must be located for its meaning to be authentically embodied.[2] For the image fundamentalist, art's meaning is inseparably tied to its place of origin through historic or religious significance; to remove this art from its home is to sever its ties with the context that grants the work its aura. For the image neoliberal, art is a universal cultural product that should be free to travel wherever the market or museums take it; meaning is created through a work's ability to reach the widest audience and not through any particular location at which it's viewed. So when the Acropolis Museum in Athens demands the Elgin Marbles be returned from the British Museum in London, proponents of image fundamentalism (Acropolis Museum) confront those of image neoliberalism (British Museum).[3]

Image fundamentalists see the rights to property as being granted at birth through cultural or geographic specificity, while for neoliberals, art's status as property is ensured through a work's ability to be sold, traded, or gifted like any other owned thing in a market economy. The online audience's attitude towards what it sees is deeply predicated on the neoliberal vision of cultural migration, but that audience's willingness to strip images of their status as property is so aggressive that it deserves a term of its own: image anarchism. Whereas image fundamentalists and image neoliberals disagree over how art becomes property, image anarchists behave as though intellectual property is not property at all. While the image neoliberal still believes in the owner as the steward of globally migratory artworks, the image

anarchist reflects a generational indifference toward intellectual property, regarding it as a bureaucratically regulated construct. This indifference stems from file sharing and extends to de-authored, decontextualized Tumblr posts. Image anarchism is the path that leads art to exist outside the traditional context of art.

Since the advent of photography, more people view images of physical artworks in magazines, books, and videos than in person. Viewership of art's mediated representation quickly surpassed that of its physical form. Similarly, in the wake of social media, the majority of views an artist's work gets online is often not through her own website, but through the accumulated network of reblogs, links, and digital reproductions that follow it through social media. One can think of this as the long tail of art's viewership, where no single reblog constitutes a wider viewing audience than the artist's own accumulated audience on her website, but all of those tiny reblogs added together (and the number of viewers they attracted) constitute a larger statistical whole. Unlike the previous mode of authorship, where the artist or institution defined context, the divide between artist and viewer becomes negligible when users of social media are able to more powerfully define the context (and thus the meaning) of an artwork.

Postmodern theorists have long advocated an understanding of reality in which there is no uniform vantage point but instead a multiplicity of coexisting perspectives. This theory has real applicability when nearly all undergraduate art school students have blogs to insert themselves into a historical discourse with online displays of their own artwork next to that of significant artworks from the past. Sometimes, these blogs' audiences and their perceptions overlap, though sometimes understandings of an artist or artwork remain fragmented, with different audiences claiming wildly different perceptions of the same artwork based on where they might have seen it. Today, online, there is no home base: no building or context that contains and describes art in a way that uniformly attributes meaning for all.

With Facebook, Instagram, and Twitter's emphasis on sharing, and the ease and speed of reblogging, images of artworks can travel as far and fast as an audience commands. Throughout this process, contextual information is divorced from the artwork. The name, title, and date are often the first data to get lost. Like a wheel's tire, the image gets stripped of its own form through its continued use. This creates a peculiar, inverse reaction: the more famous an art image becomes, the less its author will be attributed. Such contextual information is occasionally omitted on purpose as a way for a savvy Tumblr

owner to wink at a historically informed audience whose members are quickly able to identify the work without description. On other occasions, contextual information is omitted from art images because it was never included in the source, or because the image is being used for a purpose entirely unrelated to the artist's intentions. In this case, non-artists appropriate art as entertainment, office humour, a visual backdrop, or pornography. Murphy's Law dominates: images of art will be used for whatever purpose possible when placed online. Whether shared or reblogged, all content on the internet exists to be moved from one place to the next. Through social media, art is reintroduced into everyday life, creating a loop between the two contexts.

The utopian disposition for art online most idealistically views the near-infinite world of digital images as a kind of commons, a place where the value of art is not located in its ability to be sold or critically praised, but in its ability to continue to be remade or reblogged for whatever purposes its network of viewer-authors find significant. Such a disposition emphasizes art not as a commodity so much as a recyclable material. Without the traditional conception of property, authorship, or context in place, artists are using social media to strategically manage perceptions of their work—transforming it from a series of isolated projects to a streaming feed that transforms the artist's identity into a recognizable brand. Using tagged images and text to highlight themselves through humour, intellectualism, or camaraderie, artists swap the external commodity for the commodification of themselves through online social networks. The need to socially orient oneself has now been reversed from its normal position: artists on the internet need an audience to create art, as opposed to the traditional recipe that artists make art to have an audience. Posting work with no followers on the internet is synonymous with the riddle: 'If a tree falls in a forest and no one is around to hear it, does it make a sound?' For these artists the answer is no—their work will easily go unnoticed, making their participation in social media a necessity to contextualizing what they do as art. Anton Vidokle suggested we are entering a period of 'Art Without Artists'; I suggest instead that we are living in a moment of 'Artists Without Art'.[4]

For an artist using social media, it is accepted knowledge that once images of her artworks are posted online, they can be taken and used by anyone using the internet in whatever way possible. To contain the conversation around one's own personality is the preferred strategy for recognition. Content always floats away, but if the source of that content is unique, people will continue to come back. This marketing is done on the

artist's own Facebook wall, Twitter feed, and YouTube comments. 'Follow me', 'Friend me', 'Subscribe and Comment', are the endless pleas made by a generation of artists struggling to gain the greatest amount of attention. While digital images make for a lousy form of private property, the attention an artist can accrue through social media branding can be leveraged into a more traditional notion of market success, as seen through gallery exhibitions, magazine features, books, and speaking engagements, and thus functions like a form of capital.

The shrinking difference between social networking for the betterment of your art career, and social networking as an art project unto itself, may be part of a greater trend in our contemporary understanding of celebrity. Prior to reality television, the distinction between a celebrity's private and public life was tenuously kept but widely believed. Gossip magazines served to satisfy our lust for celebrities beyond the brief screen time we were able to spend with them. Although the narrative arcs created by gossip magazines intentionally resemble the plot lines of movies and television shows, the sensationalizing nature of these publications—disparagingly referred to as 'rags'—maintained an air of uncertainty over whether the private information revealed was actually true.

Reality television effectively banished the borders between public and private by presenting a constant stream of people behaving for the viewing public as they otherwise would only behave in private. The reality television star is famous not because of her professional craft but rather due to an ability to remain visible, maximizing attention through the often banal and repetitive performances of herself. The purportedly objective, documentary-style filming of people in everyday situations turned the grainy, decontextualized still images of gossip magazines into second-rate material. The lure of real embarrassment, secrets, sex, violence, and all else, quickly eclipsed the fictional characters portrayed by celebrities on sitcoms and other fictions, establishing a new dominance in entertainment. Actors once devoted to their craft and to the performance of characters separate from themselves, are choosing to have the camera follow them in their day-to-day lives to maintain fame in an ever-changing media landscape. For them, there is never an 'off' moment. Similarly, many artists now spend as much time publicly exemplifying their lifestyles as they do making physical work.

Like the strategy of the reality star, this approach is employed by artists to gain maximum attention and provide a relevant context for themselves and their work. Artists, poets, and musicians produce and release

content online for free and at a rate faster than ever before. There is an athleticism to these aesthetic outpourings, a manner in which individuals and projects like Lil B, Steve Roggenbuck, Jogging, or Paint FX are strategically taking on the creative act as a way of exercising some other muscle—be it a personal brand or mythology, a concept or a formal vocabulary. Images, music, and words now become drops in a pool of derivative sweat created by working out their central themes and displaying them publically online for all to view. The long-derided notion of the masterpiece has reached its logical antithesis, as immediacy and speed have come to trump craft and long-term contemplation for these creators.

Modes of production employed by artists are often a reflection of the larger cultural zeitgeist—for example, Duchamp's readymade came at a time of transition when consumers were first buying mass-produced goods. During Duchamp's era, the word 'readymade' referred to the objects in one's home that were not handmade. And for the generation of artists coming of age today, it is the high-volume, fast-paced endeavour of social media's attention economy that mimics the digital economy of stock trading, a market increasingly dominated by computer-automated algorithmic trades. For these artists, art is no longer merely traded like a stock—it's created like one, too.

For over-producers like Lil B, the idealization of their output comes from the rate at which their content interacts with and elicits the attention of a viewing audience. By holding the constant broadcast as an idealized vision of production, editing oneself becomes a waste of resources. Time spent on anything is time worth being redeemed in attention. For the audience, what is lost in production value is gained in openness and personal connection with the creator. Every image, poem, song, video, or status update is a chance for interaction and identification. The momentary glimpse of the artist at her opening, or the chance to see the rock star live on stage, is levelled and spread across dozens of daily opportunities to comment, like, and reblog on your favorite artists' Instagram, Tumblr, Facebook, and Twitter accounts.

Art after social media is paradoxically the rejection and reflection of the market. In practice and theory these two seemingly divergent developments are reconcilable because each contains parts of the other. For all that is communal about a decentralized network of artistic peers sharing and recreating each other's work, the dispersion of this work takes the shape of free market populism; of the free exchange of information sorting itself out amongst those willing to produce and consume it. Without a bureaucratic establishment imbuing art with value, art is free to be valued in any way

possible. This setup is not unlike that of the secondary art auction market, where art critics' opinions of the works for sale mean little to nothing and the bidding power of a room of collectors takes precedence.

In contrast, one can look at the highly individualized pursuit of brand recognition among artists employing social media as a constant communal effort. Unlike the reality television star, young artists employing social media are not connected to a behemoth like Viacom or NBC and so must generate their popularity at a grassroots level. Brands are more often than not defined in relation to each other, and imply the ongoing support of a devoted audience that is, as described in this case, oversaturated with social interaction or the presentation of artworks. There is no successful artist brand built on an island; each requires a level of collaboration with viewers willing to share, follow, friend, and comment on the object of their interest. In other words, what is communal about the commons is that it is run by an every-man-for-himself free market ideology, and what is individual about personal branding is bolstered by a need for community. It's very fitting that the Silicon Valley-based forefathers of social media, namely the Californian Ideology technologists who juggled utopianism and capitalism in each hand, are the ones responsible for a generation of media-obsessed artists now doing the very same thing.

1 Marshall McLuhan and Quentin Fiore, *The Medium is The Massage* (New York: Bantam Books, 1967) 122.

2 David Joselit, *After Art* (New Jersey: Princeton University Press, 2012) 4.

3 Ibid.

4 Anton Vidokle, 'Art Without Artists?', *e-flux journal #16*, May 2010, http://www.e-flux.com/journal/art-without-artists.

Societies of Out of Control: Language & Technology in Ryan Trecartin's Movies

Brian Droitcour

'What we take to be graphics, sounds, and motion in our screen world is merely a thin skin under which resides miles and miles of language. Occasionally ... the skin is punctured and, like getting a glimpse under the hood, we see that out digital world—our images, our film and video, our sound, our words, our information—is powered by language. And all this binary information—music, video, photographs—is comprised of language, miles and miles of alphanumeric code. If you need evidence of this, think of when you've mistakenly received a .jpg attachment in an e-mail that has been rendered not as image but as code that seems to go on forever. It's all words (though perhaps not in any order that we can understand): The basic material that has propelled writing since its stabilized form is now what all media is created from as well.'
—Kenneth Goldsmith[1]

When critics write about the video artist Ryan Trecartin's movies, they tend to talk about his editing, his forking and unfinished narratives, and the way their disconnections conjure the feeling of always being connected. The critics who write about Trecartin's movies tend to be art critics, and that is why they tend to write a visual analysis with a dash of social commentary, or vice versa. The dialogue gets disregarded, or it is quoted piecemeal; it is often described as 'gibberish' or 'nonsense', or assumed to be improvised. But in the seven movies of Trecartin's *Any Ever* sequence (2007-2010), and the ones that came before it, the dialogue is crafted. Trecartin began making these movies by writing scripts for them. And so his dialogue is not nonsense—or if it is, then it's nonsense in the way that the *zaum* of Russian Futurism is beyonsense. It's language so densely packed with meaning that it's impossible to apprehend on a superficial encounter. It's language that can be slowly picked apart, because it was so carefully created. When Trecartin writes a script he builds a house of language, just as his frequent collaborator, Lizzie Fitch, builds the sets for the movies, and in the editing room the movie is built from shots. The parts of the work that happen later in the process of making the movie—the camerawork, the makeup, the costumes—are prefigured in the way Trecartin works with words.

Trecartin likes to play with language, and wordplay generates topics and plots for his movies. One bit of wordplay that recurs in his work—sometimes in the words of the scripts, but more often in the way characters

and scenarios are constructed—is a confusion of the *corporate* and the *corporeal*. It's like a folk etymology or a pun in the way Trecartin exploits a superficial resemblance of two words to generate idiosyncratic connections between them. But there is a real etymological connection at the words' root, and Trecartin's play animates the forgotten bond between the corporeal reality of a person and the social body of a corporation.

Vocabulary review: corporeal means 'of a body'. Corporate means 'united in one body'. To incorporate is to 'to put (something) into the body or substance of (something else)'.

'Corporations are people,' as Mitt Romney once said. The corporation is a social technique by which a group of people acts together as one, in order to make money, to make things happen, to create changes and disturbances in a society and in the social world. How does the corporation do it? How does the corporation unite so many bodies to achieve its ends? It does it with branding, with corporate culture, with human resource management—all techniques for controlling behaviours, actions, and bodies. Language is the environment for this—and in the process language becomes a tool as well, a tool of human resource management, of corporate culture, of branding. Corporations are people but their bodies are huge and grotesque. Its avatars—the real people—have stunted bodies. Their impulses and affects are subjugated to the fluid discourses of a brand identity; they speak the stilted business tongue of PowerPoint slides and memos. We live in the time of corporate personhood—when corporate bodies and perlocutionary corporate speech make the models of how a person should be.

This is the theme of *K-CorealNC.K (section a)*. The title of Trecartin's 2009 movie is a corporate name, taken on as a collective name by a bevy of career girls. Korea is a geographic entity; it is a place name—a word that transforms a mass of land into a concept, making Earth's substance legible in discourse and in politics. It's also a near homophone of career. Korea, career. A career is a social concept, a technique by which a person becomes legible as an avatar of his profession. It obscures his individual body and merges it with a corporate one.

The avatars of K-CorealNC.K, this fictional incorporation, are all Koreas: Argentinian Korea, Iran@-itzerland Korea, French adaptation Korea, Post-Canadian Retriever Korea, Another Greek Korea, Mexico Korea. Like any script, the script for *K-CorealNC.K (section a)* starts with a list of *dramatis personae*, only it doesn't list them as a cast, it calls them 'Attendees', a designation that subordinates individual identity to temporary presence. The

spacetime properties of attending suit the names, which are not distinct or individual but inflections of Global Korea, the star player listed at the top of the page: 'Global Korea (GK): (potential Merge):'. The Koreas—these daughter companies, these international branches—are dressed identically. They must have gone shopping together for ladies' business casual at Kmart or T.J.Maxx: white blouses, dark skirts, blond wigs. The clothes and the white pancake makeup make them identical, in a way, but the forced identity just makes the differences of the individual bodies pop: this Korea has a moustache, that Korea has real female breasts, this Korea has big biceps, that Korea is paunchy. Traits of individual bodies betray the unity of the incorporated one. But the Koreas try their best to blend in! They are mostly silent, or their speech is an inaudible whispered conversation between co-Koreas. Global Korea is the boss: she is played by the charismatic Telfar Clemens and she speaks for them all.

'We had a meeting,' Global Korea says. 'So Lets Have A Meeting!' And just like that, the avatars of K-CoreaINC.K—the Attendees—are assembled at a picnic table, outdoors, at night. Having meetings is a habit of the corporation's inner life, and the word 'meeting' has accumulated an array of associations: the conference room, the conference table, the hierarchies of who sits where at the table, a water cooler, an agenda, items, goals, objectives, directives… (Etymology facts: the Old English *metan* was a verb that meant: 'to encounter' or 'to find'; in the sixteenth century the 'meeting' became an assembly.) The way K-CoreaINC.K has meetings—constantly, formally, casually, anywhere—both evokes the contemporary corporate usage and returns the word to its most basic bodily meaning: the simultaneous presence of two or more bodies in spatial and temporal proximity to each other. What's more, at K-CoreaINC.K the meeting never ends. This corporation is nothing but a meeting. 'We had a meeting. So Lets Have A Meeting!'—Global Korea's line punctuates the experience of permanent renewal and repetition. In the script, when it doesn't matter which of the Koreas speak or when many of the Koreas are to speak at the same time, the speaker of the line is given as: 'Meeting'. (What does K-CoreaINC.K produce? Nothing, other than meetings; nothing but its own corporate personhood.)

Besides Global Korea, the company has a few other very important avatars, including USA Korea (played by Trecartin), who interviews a wannabe career-girl named Jessica. She is dressed like the rest but she doesn't have a Korea name. She's an intern, an outsider on the inside. On the list of Attendees she is referred to as 'illegal outsider re-useable friend

(prop)'—an object, an alien, a foreign substance. She goes by Jessica until USA Korea decides she's Cindy. Either way, she's no K. Interns are promiscuous, commingling with the corporate body for a limited time, unpaid. 'Contemporary Slut!' Mexico Korea (Raul Nieves) rages at Jessica/Cindy. 'Every Body's' Got the Agenda!' Note the split of 'Every Body's' and think about how a collective is named by indicating its constitution in all of its individuated bodies. This matters to the business of K-CoreaINC.K, which produces a group body that is mobile and communicative and regularly grooms itself by designating its avatars and its Others as hires and fires. The meeting of drag queens and their gofers incorporates—incarnates—corporate corporeality.

Pronouns are a battlefield. 'IT is not |You|,,, IT IS WE!' NAK announces. 'IT is not |em| and>/ Will not matter as Such.' On the next page she says: 'The New Look for This Company, IS re-Thinking the Word |Humanity| as an Object with a (Goal).' Dialogue is propelled by confrontations between voices of a single entity (i.e. the Koreas) and others, whose names convey difference in terms of human-resource hierarchies. A Driver—listed among the Attendees as 'Pay Role: (2): Driver, Wait'—offers unsolicited business advice: '[...] Focus on finding REAL Consumer Demand,,/ For Cross-Over-Culture,,,,,,/ ?/ And Time-Shared-Ideologies ?' The suggestion is soundly rejected by Global Korea and her affiliates. He's just a hireling, and his vision of crossovers and timeshares is too generous, too loose.

'I had to let you Go.' These words, which the script spells out in a 48-point typeface, occupy a whole page after Global Korea pledges: 'I'm Gona Fire HER,,,,,,' The big words continue: 'Don't feel Examplized', 'It's just Nature.' Again, the language of human-resource management euphemizes otherness. The passive-voice coinage of 'examplized' emphasizes the helplessness of the recipient 'you' and sticks out as a neologism, calling attention to the relative ordinariness of these lines that broach difference. 'It's just Nature': singling out the other—rather than cramming her into incorporated sameness—appears as the default of consciousness. When Global Korea and her affiliates spout mutual affirmations, the language is much weirder. Global regularly pronounces compound phrases where one plus one equals three, like '3rd/World-Class'. And she issues commands like 'globalize at HER!' Tacking a preposition and an object on a verb that doesn't take any is like stuffing a dozen bodies into a single identity. 'Are you finding Position? It's such a Hunt.' This early intertitle blurs the spatial and psychological parameters of navigating between harmony with others and

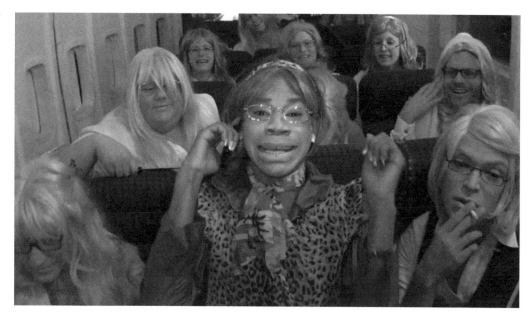

Ryan Trecartin, <u>K-CoreaINC.K (section a)</u>, 2009, HD Video, 33:05.
Courtesy of the artist and Andrea Rosen Gallery, New York.

Ryan Trecartin, <u>P.opular S.ky (section ish)</u>, 2009, HD Video, 43:51.
Courtesy of the artist and Andrea Rosen Gallery, New York.

assertion of self. Later, Mexico Korea vacillates: 'I'm an Aquarium… I'm in Aquarium.' Used with the copula, the indefinite article defines a thing by its likeness to other known things. 'In' expresses location. Trecartin exploits the coincidence of homophony to elide the difference between an ontological position and a physical one. Just as the corporation's abstraction of the body is returned partially to the concrete, identity sits somewhere between a state of mind and a location of body. Mexico Korea, meanwhile, is neither an aquarium nor in one, which highlights language's status as the medium for inventing the very problems of positioning it's tasked with confronting.

Trecartin's flamboyant use of the patterns of chat and ads and other types of clichés in the dialogue isn't a direct form of copying, but a concentration of a normal condition of language use. A speaker is obliged to use words that come from outside her—and can be understood by others—while making them her own at the moment of the utterance, in order to make it seem like the utterance comes from inside her. And *K-CorealNC.K (section a)* dramatizes that condition in dialogue. And the script dramatizes it in punctuation. Punctuation was invented to represent the pauses and pitches of speech. Long after it moved beyond this purpose to become a set of standards for clarifying the meaning of written language, punctuation marks were remixed as emoticons when writing began to take on the phatic functions of speech. Trecartin's unruly use of punctuation draws on all stages of its history. When, in the script's first lines, Mexico Korea says 'Yaw,,,,,,' the comma does more than make a pause. It's a winking eye torn from a smiling face, repeated until it becomes a nervous tic. Colons join, parentheses cut, and in the designation of Global Korea's role—before the dialogue even starts—those marks are staggered to herald *K-CorealNC.K (section a)* as a drama of belonging and difference, of where the self stands with regards to others.

Incorporation is a technique of smoothing difference to produce inclusion and growth. Incorporation is the realization of a dream of a body that can be bigger, more powerful, more durable than a human body—better than the gross animal vessel our spirits carry around. But with the new spirit of capitalism the corporation aspires to be flexible, mutable, and fluid, unlike the old kind of company—the generations-old family business—with its rigid mimicry of aristocracy and sturdily pious Protestant values. In a time when corporations are people, the incorporated body is more like a real one—or, at least, the model it sets for how a person should be is gross. The corporate body (or its avatar) lives in a state of precarity, much like the real body is

vulnerable to disease and mortality. It leaks, strains, and bulges. It screams at the world and it can't make sense of itself. It is like K-CoreaINC.K.

Look at another Trecartin movie, *Roamie View (History Enhancement)*, from the *Re'Search Wait'S* cycle. In it, stock video appears as a stunt double for the idealized corporate body and it is cut with shots of the weird real thing. The glistening skylines and pristine office corridors of the stock footage give way to the plain bodies and grotesquely made-up faces in Trecartin's own footage. Pseudo-corporate business calls between Trecartin's players are interposed with stock views of suited corporate employees in a brightly-lit office corridor; the speech in the handheld devices is implicitly compared to the bodies in the office, and both sets of footage are juxtaposed to a tracking shot of a big city's waterfront, apparently shot from a boat. As the camera moves, it shows the glass pavilions and twinkling lights around a port, the node of an international trade network. One thing that all of these pieces of footage share is the colour blue. Blue is a soothing decorative element in the stock corporate corridor. Blue illuminates the buildings by the waterfront at night, and blue is the colour of the water in front of them. Blue is in the streaky make-up and the cheap fabric of the attire on Trecartin's players— like the white T-shirt emblazoned with a gridded blue globe that brands the body of the player who wears it with global aspirations. Blue represents water, a substance that enables vessels to be transported from one place to another; a substance that takes the shape of the vessels that it is in. Blue represents the values of fluidity and adaptability; it's in the branding of Chase and Citibank and it's the new spirit of capitalism.

So much mobility! And yet—have you ever noticed this?—bodies never move very much in Trecartin's movies. (*The Re'Search*, another movie in the *Re'Search Wait'S* cycle, begins with a dance number by a swimming pool— moving bodies, still water—but this is an exceptional scene, not a normal one.) Bodies are meat that sit around—but they sit around expressively! The physical movement in these videos is about gestures and facial expressions: grimaces, turning heads, cocking heads to the side, fidgeting in swivel chairs, waving arms, moving mouths to make words. If people are going somewhere, they're sitting in cars—and sometimes they're sitting in airplane seats that have been removed from an airplane, pretending to go somewhere but actually going nowhere, talking into their phones and at the camera lens the whole time. The absence of bodily mobility even applies to the stock footage that Trecartin uses in *Roamie View*. In one sequence, a man stands with a stoic look on his face; he doesn't move as his colleagues' bodies (which are

depersonalized as a metonym of the bustle of office life) flow around him. In another sequence, the stock models are all frozen in place as the camera twists around them, exploring the corridor. Bodies don't move much in Trecartin's videos yet the videos are characterized by a feeling of constant movement. What makes the movement is editing. Movement is reserved for speech and for technology; bodies move thanks to these things.

Bodies are moved by language. Like language, the houses of Trecartin's movies aren't sites; they are environments and tools for situating people. 'Neoliberal subjectivity' is a popular shorthand among critics for expressing the way that bodies behave (are handled) because of (by) capital now. The new spirit of capitalism is about subdividing the individual into nameable affinities (Facebook likes, dating profile stats) or competencies (the school assessment report, the HR office review), in order to incorporate bodies as other, more usable substances. Networked social being and bureaucratic procedure reify personal attributes and redefine subjecthood as situational and mobile—but the mobility is a characteristic of the attributes and the tools and technologies that move them, rather than of the bodies they came from.

Bodies become objects of operations. In *Roamie View: History Enhancement*, J. J. Check (played by Trecartin) says: 'I thought it would be neat and cute if someone took out all the times they say "people" or "humanity" [in the U.S. Constitution] and replaced it with "situations."' Meetings are situations (bodies meet because they are situated in the same area). Situations are states of people. In *K-CoreaINC.K (section a)*, North America Korea (Veronica Gelbaum) says: 'The New Look for This Company, IS re-Thinking the Word |Humanity| as an Object with a (Goal).'

All of these innovations and disruptions, these subdivisions and operations, are related to everyday techniques of control. But their representation in Trecartin's videos suggests obsessive-compulsive disorders or cases of borderline schizophrenia. When manifested in the corporate body they are normal and acceptable. But when they return to the individual body they appear as psychic maladies. Recall psychoanalyst Melanie Klein's observation that conditions like schizophrenia, narcissism, and so on are considered psychotic when they manifest in adults, but the same conditions are normal stages of infant development. Thus the conditions that are normal to the corporate body appear as psychotic when embodied in Trecartin's individual players. Trecartin often casts children and teens in his videos as living reminders of how the body grows and changes. They are budding

Ryan Trecartin, <u>Ready (Re'Search Wait'S)</u>, 2009-2010, HD Video, 26:50.
Courtesy of the artist and Andrea Rosen Gallery, New York.

Ryan Trecartin, <u>Roamie View : History Enhancement (Re'Search Wait'S)</u>, 2009-2010, HD Video, 28:23.
Courtesy of the artist and Andrea Rosen Gallery, New York.

suggestions of how the body might grow further, in incorporated bodies, and how all of these kinds of bodies have conditions that inhere in them and look weird when transported to others, particularly when people behave in a way that might not be suited to their bodies in order to be part of a bigger one. Does incorporation *make* people the way they are? Or is incorporation a manifestation of how people *are* already—of their individual gravitation toward a whole, toward something bigger, stronger, better? This is one of the antinomies that Trecartin presents and of course there is no way to resolve it. People like to say that Trecartin's work is about contemporary networked technologies. And that's fine, but it's only true insofar as these technologies are integrated in the array of social techniques and habits characteristic of human life at this point in time. This is art about humans. Trecartin's players hold BlackBerries—but they're just as likely to be holding a sledgehammer or a flute. Any object implies a use but it doesn't have to be used as it was intended to.

Any system has an organizing principle and any organizing principle can be broken. It creates a system of control—and at the same it creates ways of how that control can be defied. (Again: When J.J. Check reads the Constitution, he starts talking about how the law can be adapted to suit situations.)

The world of Trecartin's movies is a carnival. It shows everything as it could otherwise be. If a tool can be used to make something it can be used to break something. If a technique is applied to achieve an end it can be applied wrongly, to fail. If telecom technologies enable communication they can also be used to disrupt it. Every ideology opens itself to misinterpretation, abuse, and defiance by any individual. Where there are societies of control there are societies of out of control. Trecartin knows this and feels this. He likes to play with language and knows how any word that means one thing can be misheard, misread, misused, and made to mean something else. The properties of tools, techniques, technologies, and ideologies discussed in the previous paragraph are properties shared by language. And in language where there's a right syntax and there's a wrong syntax; grammar begets mistakes. Language is the medium of incorporation, or transformation of any other kind. Language provides the environment in which one substance can be understood as another one—as well as the tools for reinforcing the transformation, and normalizing it.

The conceptual poet Kenneth Goldsmith has written about computer code as a language that produces and shapes our contemporary environment, and how when a file is opened with the wrong programme, it appears not as a legible text but as a string of unintelligible code. We dwell, as ever, in the house of language, but there's an addition to this house that we spend more and more time in, made of an alien machine language, where the use of natural human language is objectified and instrumentalized in highly specific ways. Trecartin is an artist of the social glitch: tools of language that are designed to be opened in a particular format—in the super-body of the corporation, or the super-body of the network—get opened by individual bodies. The misapplication of the tools of language gives a sideways glance at their utility. They appear as nonsense but they speak about the logic of the medium that they operate in—the medium that operates everything. The medium's omnipotence reveals itself and it reveals itself in its failures.

1 Kenneth Goldsmith, *Uncreative Writing* (New York: Columbia University Press, 2011).

Societies of Out of Control

Post-Internet: What It Is and What It Was

Michael Connor

The subtitle of this collection is 'Art After the Internet', a phrase that seems to leapfrog ahead to the other side of some forthcoming apocalypse brought about by strange weather, or some artificially-intelligent bot that pulls the plug on the whole enterprise. But in this context, the 'after' means something different, of course—it means that we live in a time subsequent to the internet's saturation of most of the world's surface area and human population, and of our individual consciousness. This phrase 'after the internet' is closely linked to the term 'post-internet', and is often maligned as a trendy, ill-defined neologism.[1] This accusation is understandable, given that the usage of the term has changed significantly over time. While it was once used to describe artists who acted as participant-observers of internet culture, it now more typically evokes complete embeddedness in a ubiquitous network culture.

In this essay, I will begin by looking at one origin for these terms: artist, curator, and writer Marisa Olson's use of the phrases 'after the internet' and 'post-internet' beginning in 2006. Then, Olson described her artistic process as taking place in the wake of—'after'—time spent online, as the 'cognitive yield' of obsessive clicking. I will draw a parallel between Olson's thinking and the collaborative work of artists Olia Lialina and Dragan Espenschied from this time, suggesting a shared interest in studying, curating, performing, and depicting 'internet culture'—the varying online behaviours of internet users and the cultural artefacts they created and circulated. This can be contrasted with the mid- to late-1990s work of net artists such as Lialina, who (at that time) were more likely to use the internet as a creative medium than as a field for research. Olson's use of the term 'post-internet', which implies an ability to stand outside the internet to some extent, contrasts with more recent practices that have been associated with the same term, in which the artist, even art itself, is assumed to be fully immersed in networked culture and is no longer quite able to assume the position of an observer. Through this comparison, I want to suggest that the internet's growth in recent years—steadily reaching more people, in more places, for more time in the day, performing more functions than ever before—has prompted artists to constantly renegotiate their critical positions. Even the term 'post-internet' itself has been redefined and changed; it has come to stand less for a clear demarcation of 'before' and 'after' than to represent a continuously evolving critical dialogue.

In an email assembled by Lauren Cornell and published in *TimeOut New York* in 2006 to coincide with a panel discussion organized by *Rhizome*[2] entitled 'Net Aesthetics 2.0', Olson wrote:

> What I make is less art 'on' the Internet than it is art 'after' the Internet. It's the yield of my compulsive surfing and downloading. I create performances, songs, photos, texts, or installations directly derived from materials on the Internet or my activity there.[3]

This article has been cited (by critic and curator Gene McHugh and others) as an early articulation of what Olson would later call a 'post-internet' way of working.[4] (Olson also recalls using the term 'post-internet' in the 2006 panel.) Today, the definition of post-internet can be difficult to pin down, but for Olson it had a specific meaning, referring to a mode of artistic production using raw materials and ideas found or developed online.

One example of Olson's art 'after' the internet is her 2005 work with Abe Linkoln, *Abe & Mo Sing the Blogs*, an album in the form of a blog. Each 'track', or entry, consists of the copied-and-pasted text of a found blog post, a link to the original post, and a link to an MP3 in which either Linkoln or Olson sings the text of the post. Authors of the found posts included music critic Sasha Frere-Jones, artists Ubermorgen.com, someone named Glue Factory Bob, and Eggagog, the mysterious author of internet classic 'THIS IS FUN TO MAKE A BLOG ON THE COMPUTER WEBSITE'. *Abe & Mo Sing the Blogs* now functions as an archive of the blog form at what, in retrospect, was likely its peak moment; in many cases, the posts used as source material are no longer online. Not simply passive documentation, the blog posts served as readymade scripts for a series of performances in which Linkoln and Olson tried not only to analyse or understand the aesthetic of their source materials, but also to perform this aesthetic: to *inhabit* it. Olson and Linkoln's artistic project attempted to come to an understanding of a quickly evolving internet culture as both observer and participant.

At the time, many other artists shared the artistic strategies of reframing and inhabiting online aesthetics—of studying online culture while also taking part in it—including several of the other artists who took part in the same 2006 panel mentioned above, 'Net Aesthetics 2.0'. The '2.0' in the panel's title was, in part, a slightly facetious nod to the hype surrounding Web 2.0, a term used to describe the increasing use of centralized services rather than independent websites to share and access content online. While

the term involved a certain amount of hype, it was clear then that the web's culture was changing: social networking sites were growing in popularity, and YouTube had launched the previous year, reaching a steadily growing audience. '2.0' was a nod to changing conditions on the web as a whole, but it was also a provocation, suggesting that the stakes of net art had changed from its first phase. This can be seen not only in the work of an artist like Olson, who came to prominence well after the initial phase of web browser-based art, but also in the career trajectories followed by artists who were associated with that initial period, such as Lialina.

In the 1990s, Olia Lialina's work often took the form of web pages that used various interactive, visual, and textual possibilities afforded by the browser for narrative purposes. In *My Boyfriend Came Back from the War* (1996), Lialina used HTML frames and hyperlinks to tell a story that opens out across nested windows; in *Agatha Appears* (1997), she used changing URLs as a narrative device; in *Anna Karenina Goes to Paradise* (1996), she represents the titular character looking for love, for a train, and for paradise by querying three separate search engines (Yahoo, Magellan, and Alta Vista).

In 1998, Lialina described her interest in the web during this first heyday of net art:

> At that time [1996], I spoke of the Internet being open for artistic self-expression, that the time had come to create net films, net stories and so on, to develop a net language instead of using the web simply as a broadcast channel ...[5]

In this text, circulated to nettime, a popular mailing list for internet-oriented thinkers from various fields, Lialina announced a shift from working as a net artist to working as a net art gallerist. Shortly thereafter, she launched the website art.teleportacia.org, which offered a series of one-page web-based artworks for sale to collectors for $1000 to $2000 each. Lialina later suggested that this shift was itself a kind of performance, saying she was 'not really intending to become a gallerist, so the next exhibition, *Location=Yes,* was not about selling.'[6] She may not have been selling, and it may have been a kind of performance, but Lialina was certainly acting as a champion of other net artists. In other words, Lialina was working less as an artist in the traditional sense than as a curator, presenting net-specific work by other artists in an online exhibition space and writing texts about the cultural significance of their work.

In addition to championing other net artists, Lialina soon began to champion the work of the many non-art identified internet users who also produced online content, participating in the formation of a net language. Her interest was manifested through talks and illustrated essays, such as *A Vernacular Web: The Indigenous and the Barbarians* (2005), which celebrated the popular forms of self-expression on the early-web (the second half of the 1990s), in direct response to the perceived threat to this vernacular culture presented by the centralized services of the developing Web 2.0 era. It can also be seen in a collaborative project with her partner Dragan Espenschied, *With Elements of Web 2.0* (2006), consisting of a series of aluminum prints that bring together tropes of the vernacular web (outer space backgrounds) or even older forms of cultural expression (a spiral notebook) with conventional Web 2.0 iconography, such as the Google Maps navigation buttons. Like *Abe & Mo Sing the Blogs*, *With Elements of Web 2.0* was a study of soon-to-be-obsolete forms of internet culture. It too is art made with materials harvested online and presented as silkscreen over digital prints on aluminum, rather than the digital codes and liquid crystals that served as the materials for the first generation of net artists. The work can thus be thought of as 'art made "after" the internet', per Olson's formulation, translated from online origins to a more stable presentation format suited to a gallery context.

A decade separates Lialina's *With Elements of Web 2.0* from *My Boyfriend Came Back from the War*, and her concerns changed during that time. While the early online work was engaged with the problem of how artists like herself might articulate a new artistic language through the internet, Lialina increasingly began to respond (in her artistic practice and through her writing) to the online content that, though it is generally not produced by self-described artists, constitutes the majority of what we think of as internet culture.

It isn't so much that her artistic project changed. It's the web, and the critical discourse around it, that changed. Long before the advent of Facebook, commercial companies have structured people's uses of the web and profited from them. But with the rise of Web 2.0, they started to get a lot better at doing so. Content creation and sharing was no longer a specialist pursuit; it was like punk rock times a million, but it was YouTube and Flickr that made the rules instead of Fender and Gibson. By 2006, the time of the 'Net Aesthetics 2.0' panel, coming to grips with user-generated content on a range of levels seemed much more pressing than being a content-creating user oneself. Artie Vierkant characterized this shift as

follows: 'Artists after the internet thus take on a role more closely aligned to that of the interpreter, transcriber, narrator, curator, architect.'[7] They were interested in commenting on the cultural production that surrounded them, and in designing contexts within which other users might create their own content. This interest can be seen in the work of Olson and Linkoln, in the collaborative work of Espenschied and Lialina, and in the work of many other artists, like Jon Rafman's selections of still images from Google Street View and Guthrie Lonergan's curated playlists of intro videos that were made for the increasingly obsolete social networking website MySpace.

After 2006, the conditions of the internet changed again, and rapidly. These days it's not popular to ascribe cultural shifts to the mere appearance of a new technology rather than to shifts in perceptual regimes or economic models, but let's just say it: the iPhone was released in 2007. Olson's language of making art 'after' being online, though surely not meant to be taken literally, suggested a boundary, perceived or real, between time spent online and off. This boundary was eroded with the proliferation of smartphones and the growing pressures of an attention-based economy. And so the idea of making art 'after' the internet no longer applied in the same way. There was no 'after' the internet, only during, during, during.

In this context, it no longer makes sense for artists to attempt to come to terms with 'internet culture', because now 'internet culture' is increasingly just 'culture'. In other words, the term 'post-internet' suggests that the focus of a good deal of artistic and critical discourse has shifted from 'internet culture' as a discrete entity to an awareness that *all* culture has been reconfigured by the internet, or by internet-enabled neoliberal capitalism.

Many of the artists who have been working on these questions recently are acting less as interpreter, transcriber, narrator, curator, architect, and more as knowing participants in a system of circulating data in which the line between artist-made, user-generated, and commercial content is decidedly blurred. Take, for example, the exhibition *Brand Innovations for Ubiquitous Authorship* at Higher Pictures in New York, in which 'a large group of international artists were asked to produce an object, such as a coffee mug or credit card, using a custom printing or fabrication service such as CafePress, Zazzle and Walmart, which delivered the objects in sealed boxes directly to the gallery.'[8] This set of rules circumscribed the process of artistic creation entirely within the more or less truncated forms of customization available on the internet; one might reasonably draw the inference that all forms of creative production are similarly circumscribed. The process

was made visible through a series of YouTube videos, in which the gallerists documented the 'unboxing' of each artist's work: fresh from the manufacturer or printer, entirely unseen by the artist up to that point, or wrapped in bubble wrap or immersed in packing peanuts. The videos were given slightly macabre titles: *Unboxing Marisa Olson* and *Unboxing Jon Rafman*, equating the artist with their product and conveying the impression that the artists' names are also brands. *Unboxing Jon Rafman* begins with a close-up of a small sticker on the corner of a flattish, squarish package, which reads: 'Canvas on Demand'. From this information, we can assume that Rafman's piece was created using canvasondemand.com, where users can upload digital images to be made into canvas prints on wooden stretchers. A meagre layer of cardboard and padding is removed; the packing slip or invoice is located and pointedly shown to the camera. Finally, the work is revealed—a photographic print on canvas of a 3D rendering created by Rafman. The *Unboxing* videos highlighted the artists' participation in digital economies, hinting at the objects' prior lives within a digitally enabled, personalized mail order system. This was emphasized by their moment of arrival within the very different system of the contemporary art market, through the medium of internet-distributed documentation. The project highlighted these overlapping systems of circulation and its own place within—not apart from—all of them.

The strategy of calling attention to these systems of production and circulation is not limited to the world of solid, stable objects. Here, we can return to the work of Olia Lialina. Lialina's past online work has often made creative use of the URL, and she has also written about the importance of the URL in creating a context in which an online artwork exists. The most notable example of this is her work *Agatha Appears* (1997), one section of which involves a series of pages, each featuring an identical image of a woman, which moves the user from one URL to the next, each one adding a bit more narrative information, albeit in telegraphic, abbreviated form:

http://www.johannes-p-osterhoff.com/agatha/makes_stupid_things.html
http://www.tommoody.us/agatha/already_tired.html
http://www.tema.ru/agatha/has_no_idea.html

In these addresses, the domain names (tommoody.us, tema.ru, etc.) belong to Lialina's friends. The word 'Agatha' is the folder in which Lialina's project sits, and the file names (makes_stupid_things.html, etc.) can be read as descriptions of Agatha's activities, but also potentially as comments on

the owners of each URL. In the summer of 2013, Lialina released another project in which the URL played an important role. *Summer* (2013) is a short animated loop in which the artist swings from a playground swing that appears fixed to the top of the browser window. Each frame of the animation is played back from a different website, and so the browser must redirect quickly across a number of websites, such as:

http://1x-upon.com/~despens/olia/summer/
http://www.newrafael.com/olia/summer/
http://www.entropy8.com/olia/summer/

The URLs in *Agatha Appears* are used as a creative tool by Lialina, while those in *Summer* are all modified by the artist in a standardized way, through the addition of her first name and the title of the work as a folder and a subfolder (olia/summer). Thus Lialina's use of the URL in *Summer*, rather than serving as a narrative device, highlights the network in which her work circulates. In this, it has something in common with the *Unboxing* videos produced alongside the *Brand Innovations* project, which also sought to highlight the object-based and digital networks in which the artworks themselves circulated. In contrast with the strategy behind *Brand Innovations*, though, Lialina chooses to circulate her work in a network defined partly by friendship and shared interests, not solely one-click economics and on-demand production. Lialina's work calls attention to the work's reliance on a network of friends, a kind of autonomous zone in which her image circulates. This is in contrast with the position adopted in *Brand Innovations*, which calls attention to the artwork's reliance on a network of logistics and manufacturing, on a network that transmits digital files to on-demand manufacturers and documentation to YouTube, and the less tangible networks that assign value to an art work. Autonomy is not assumed to be available to the artist.

The term 'post-internet', as originally articulated by Olson, positioned the artistic creation process 'after' or structurally outside of the internet, while acknowledging that the digital artist was a fully vested participant in internet culture. In the more recent example of *Brand Innovations*, artistic creation is more explicitly embedded in overlapping systems of circulating brands, images, and objects, together forming an internet-enabled neoliberal ether. 'Outside' the internet is not presumed to exist. Lialina points to this problem, but her response is to try to set off a semi-autonomous zone

defined by networks of friendship and trust. The artists of *Brand Innovations* do not assume such autonomy. Although this kind of position differs from Olson's (circa 2006–8), the term 'post-internet' is still often used to describe it—a shift in usage that likely can be ascribed to the internet's increasing pervasiveness. The fully immersed position adopted by *Brand Innovations* has interesting implications not only for artistic creation, but also for the circulation, reception, and discussion of art. Not an airy declaration of independence, but a reckoning of one's immersion—to address a fluid object, we need a new social politics of collective inter-reliance.

1 For example, the first comment on an early draft of this text that was published on *Rhizome* was from net artist Annie Abrams, who said, 'Postinternet is net. art's undefined bastard child'. Michael Connor, 'What's Postinternet Got to do with Net Art?', *Rhizome*, 1 November 2013, http://rhizome.org/editorial/2013/nov/1/postinternet/.

2 Cory Arcangel, Michael Bell-Smith, Michael Connor, Caitlin Jones, Marisa Olson, Wolfgang Staehle, 'Net Aesthetics 2.0', Electronic Arts Intermix, New York, 6 June 2006.

3 Quoted in Lauren Cornell, 'Net Results: Closing the gap between art and life online', *TimeOut New York*, 9–15 February 2006: 69.

4 Gene McHugh, *Post Internet*, 29 December 2009, http://www.122909a.com.

5 Olia Lialina, 'cheap.art', *Nettime-l mailing list*, 19 January 1998, http://www.nettime.org/Lists-Archives/nettime-l-9801/msg00037.html.

6 Quoted in Jennifer Chan, 'Community Without Commmunity: Net Art and its Micro-Spheres', *West Space Journal* 1 (Winter 2013), http://westspacejournal.org.au/article/winter-2013/community-without-community-net-art-and-its-micro-spheres/.

7 Artie Vierkant, 'The Image Object Post-Internet', *Jst Chillin*, 2011, http://jstchillin.org/artie/vierkant.html.

8 Artie Vierkant and Higher Pictures (curators), *Brand Innovations for Ubiquitous Authorship*, Higher Pictures, New York (19 July–17 August 2012).

Against the Novelty of New Media: The Resuscitation of the Authentic

Erika Balsom

'As words that are sacred without sacred content, as frozen emanations, the terms of the jargon of authenticity are products of the disintegration of the aura.'
 —Theodor Adorno[1]

At dOCUMENTA (13) in 2012, Artistic Director Carolyn Christov-Bakargiev made much of the notion that her exhibition lacked any unifying theme. And yet, amongst the many threads running throughout, one was particularly prominent: an interest in what one critic called 'the emplaced condition of things'.[2] In the rotunda of the Fridericianum—dubbed the 'brain' of the exhibition—a number of objects exemplified this concern: 4000-year-old Bactrian princess figurines from Central Asia, artefacts from the National Museum in Beirut that had been damaged during the Lebanese Civil War, and the painting Mohammad Yusuf Asefi saved from destruction at the hands of the Taliban by painting over any human figures. These are objects inscribed by time, as far away from free-floating signifiers as one can get. To put it in Benjamin's terms: they privilege cult value over exhibition value.[3] They are singular objects, inextricable from their respective material histories, absolutely incompatible with the compress-and-copy life of a jpeg. Against both the textualist model of culture that formed such a prominent component of postmodernism and the frenzied circulation proper to globalization in the digital age, here as throughout much of dOCUMENTA (13), one finds a return to the referent: to the eminently *authentic*.[4]

 The deployment of authenticity in dOCUMENTA (13) is notable in part because it participated in the rehabilitation of a notion that had previously been rather out of fashion, if not since Adorno allied its jargon with fascism, then certainly after the post-structuralist critique of essence and origin. The rhetoric of authenticity partakes of notions of pure beginnings and implicitly denigrates what comes later, which is marked as corrupting or contaminating. In this regard, the relative lack of engagement with digital culture in dOCUMENTA (13) is striking. For Adorno, discourses of authenticity offered a rearticulation of the ideology of National Socialism by other means; for the post-structuralists, they were guilty of a metaphysical investment in presence and identity valorized at the expense of recognizing difference. For all of these reasons, authenticity was left behind in favour of hybridity, reproducibility, and purposeful unoriginality.

Installation view: dOCUMENTA (13). Courtesy of Fridericianum Museum.

Erika Balsom

Today, however, authenticity is undeniably back. In its concern with authentic objects, dOCUMENTA (13) is far from alone. Massimiliano Gioni's *The Encyclopedic Palace*, the headline exhibition at the 2013 Venice Biennale, privileged madness, the unconscious, and outsiders situated far from the commodification of the art system, implicitly contesting the professionalization of the artist as a betrayal of that figure's exemplary authenticity.[5] Whether in Rudolf Steiner's blackboards, Shinichi Sawada's spiked figurines, or Eva Kotátková's collaboration with psychiatric patients, throughout the exhibition one found repeated gestures towards forms of artistic production supposedly motivated by deep and pure urges, rather than by money, fame, or a linear narrative of art historical intervention. As the placement of Camille Henrot's video *Grosse Fatigue* (2013) near the entrance of the Arsenale made clear, Gioni's exhibition was very much about (amongst other things) the notion that the internet constitutes but the latest iteration of a long-standing desire to create totalizing systems of knowledge. And yet, though the internet provided a framework through which one might view *The Encyclopedic Palace*, one could equally say that the exhibition largely rejected the new media landscape as shallow and decorporealized. The three spiritual fathers governing the exhibition—Jung, Steiner, and Breton—embrace a depth-model of the subject closely tied to the notion of authenticity as a moral imperative, one that is exceedingly far from both the depersonalized intensities of the Deleuzian subject and the anti-anthropocentrism of the speculative realists.

Beyond exhibitions like dOCUMENTA (13) and *The Encyclopedic Palace*, outmoded technologies appear regularly in galleries around the world, while craft has made a palpable return. 16mm film projection stages a contestation of the ubiquity and novelty of the digital image, with figures such as Luther Price and Paolo Cherchi Usai privileging the materiality of the medium and claiming it as a damaged, living body subject to entropic decay. The artist Tino Sehgal's refusal to document his own work further rehearses the attachment to singularity and presence that characterizes much of contemporary performance. However, authenticity is not simply a feature of today's art: it is equally prominent in contemporary marketing strategies, particularly as they are deployed in the domains of food and travel. The names of purveyors of artisanal greens abound on menus, while 'untouched' travel destinations—trekking in Bhutan, for example—offer unprecedented appeal.

What all of these examples share is an allergy to the mass (re)production of images, experiences, subjects, and objects. These examples position themselves against ubiquity and against the exchange principle. They elevate the anachronism of the authentic over and above a present seen as brimming with the unreal, the false, the amnesic, and the prepackaged. What is at stake in such a resuscitation of authenticity? Can it be anything other than reactionary? How might this new fetish for the authentic function as a significant, if sometimes spurious, post-digital cultural formation? Tracing the evolution of the concept of authenticity from its roots in the Romantic imaginary through its mobilization in nineteenth-century critiques of modernity and into the present, might provide a way of beginning to answer these questions.

In his 1759 text 'Conjectures on Original Composition', Edward Young asks: 'Born Originals, how comes it to pass that we die *Copies*?'[6] Young's question is rooted in a Romantic conviction, primarily associated with the thought of Jean-Jacques Rousseau, that society is destructive of the authenticity and goodness of man. In the nineteenth century, such ideas found increased currency as new processes of urbanization and technologization forever altered the subject's relationship to nature, time, work, and leisure. Industrial modernity proceeded as a rationalization of all aspects of life driven by a capitalist economy, prompting some to see it not as progress but rather as experiential impoverishment. As an emblem of this collapse of difference, the copy is particularly denigrated. Very much in line with Young's rhetoric, mid-nineteenth-century works of literature such as Charles Dickens' *A Christmas Carol* (1843) and Herman Melville's *Bartleby, The Scrivener: A Story of Wall Street* (1853) communicated the extinguishing of the soul experienced by their main protagonists by casting the men in the profession of manual copyist.[7] It is worth noting that the conceptualization of copying by hand found in these texts represents a significant shift from an earlier understanding of the activity, namely its practice by monks, whereby it figured as an erudite occupation integral to the transmission of knowledge. Now, copying becomes mere drudgery, a synecdoche used to point to how the interconnectedness and fidelity to tradition that had characterized pre-modern society now found itself destroyed in the rise of the modern *Gesellschaft*, in which atomization and self-interest prevailed. Copying— long a neutral activity—was degraded and devalued due to its close ties to mechanization and standardization, while objects that evaded the regime of duplicated sameness were exalted as more precious, more human.

Young's assertion that we are born originals articulates a conviction that we begin life as essentially true to ourselves, before experiencing a progressive estrangement from this state that takes the form of a false outer self concerned with being-for-others—something Sartre would much later term 'bad faith'. Rather than a yearning for originality, a term that became attached to the artistic vanguard's penchant for radical novelty, this sentiment is better understood as the desire for authenticity. The authentic is, in other words, first and foremost a subjective ideal invested with a heavy moral weight. It is a polemical concept that seeks to revive a fullness of meaning and an un-alienated state of being at a time when increased secularization and industrialization prompted a crisis of absolutes. In the absence of the transcendent and eternal, the subject turns inward to find his or her 'true' self, different from that of all others. Likewise, in Venice, the prominent display of pages from Jung's *Red Book* (1914–1930) signalled the importance the exhibition accorded to the notion of turning inward and probing the deep recesses of the psyche. The commercial art world, it was implicitly suggested, is an exemplary realm of bad faith in which artists act according to how they believe that world wishes them to. *The Encyclopedic Palace* countered this prevailing inauthenticity by showcasing individuals who demonstrated persisting investments in absoluteness and spirituality, even if this meant including a relatively small number of contemporary practitioners in a venue tasked with displaying the best of today's art.

Though authenticity is a subjective ideal, it stems from the world of objects—specifically, from the museum—and quickly returns there, as technology, industry, and the products of mass culture become identified with an inauthenticity that threatens the individuality of the individual. With an etymology meaning 'self made', authenticity is by definition anti-technological and elevates the human over and above the new machines. As Lionel Trilling writes in his landmark 1972 study, *Sincerity and Authenticity*:

> The anxiety about the machine is a commonplace in nineteenth-century moral and cultural thought ... It was the mechanical principle, quite as much as the acquisitive principle—the two are of course intimately connected—which was felt to be the enemy of being, the source of inauthenticity. The machine, said Ruskin, could only make inauthentic things, dead things; and the dead things communicated their deadness to those who used them.[8]

The authentic is then presumed to be outside the regime of equivalence that drives commodity exchange, and also outside the sphere of reproducibility. It is thus closely allied with nature, art, craft, and earlier forms of existence. One encounters a partitioning of the world wherein what is authentic is opposed to what is new. Older modes of image making and traditional forms of experience are valorized because they are seen to offer a reassuring escape from the instability and uncertainty of the rapidly changing present. It is in this context that one can begin understanding the fetish for craft and the outmoded view that has prevailed in recent artistic production. It is against the supposed 'deadness' of the digital copy that the dOCUMENTA (13) 'brain' offered ceramics by Julia Isidrez and Juana Marta Rodas. Within the authenticity paradigm, the relationship between subject and object is conceived as one of mimetic contagion: just as Ruskin believed 'dead things communicated their deadness to those who used them', so might the authentic endow those who encountered it with an increased moral standing through a kind of sympathetic magic.

Concerns with authenticity were central to lapsarian critiques of modernity and technology in the late-nineteenth and early-twentieth centuries, whether in Max Weber's thesis that modernity constitutes the disenchantment of the world or Walter Benjamin's notion of the decay of aura. In the nineteenth century, clock time, the cinema, and the assembly line were all inauthentic novelties threatening traditional, authentic forms of existence and image production. Today, supposedly untrustworthy digital images and seemingly depersonalized electronics communications technologies take over this role. We are undergoing something of a parallel moment to that of the nineteenth century: once again, there has been a qualitative shift in the reproducibility of images and sounds, and a major acceleration to the temporality of obsolescence. These technological changes occurred in conjunction with economic deregulation, the restructuring of labour, and the remapping of global flows of people, capital, and information. In short, they occurred as a part of a transformation of experience just as immense and wide-ranging as that of the nineteenth century. Once again, a desire for authenticity has emerged as a reaction to shifts with new media technologies at their core. Scour the discourses of the digital pessimists—from Baudrillard to Virilio and beyond—and echoes of the nineteenth century will ring in one's ears. Against the promiscuous circulation of proliferating copies, the singular event of performance or the uniqueness of the handmade object both emerge as sites of intense cathexis.

Even photochemical film—once the exemplary inauthentic image—can now be recuperated as authentic, as the images of electronic reproduction have arrived to occupy the denigrated position it once did.

For Benjamin, the status of authenticity was vexed. It was valued as a site of resistance to the dehumanization and disenchantment of capitalist exchange, but deplored for its class character. Access to the authentic, after all, tends to be fairly exclusive. Understood in this second sense, the desire for authenticity is no escape from commodity fetishism but its apotheosis: it is a way of dissimulating a relationship to economic privilege by cloaking a yearning for the rare and expensive in spiritual, Romantic terms. Moreover, Adorno fully recognized that despite authenticity's claims to origins and intrinsic value, it is always retroactively constructed and resides fully within the paradigm of commodity exchange: 'Only when countless standardized commodities project, for the sake of profit, the illusion of being unique, does the idea take shape, as their antithesis yet in keeping with the same criteria, that the non-reproducible is truly genuine.'[9] This notion of a false projection of uniqueness stemming from a ground of sameness is particularly apposite in the era of iEverything. If Fordist capitalism succeeded in producing seductive commodities that delivered the ever-same as the ever-new, the contemporary moment witnesses the continuance of this regime, supplemented by a digital marketplace promising the seemingly infinite variety of the long tail, and the fantasy of totally individualized consumption. When everything appears to be available at the click of a mouse, even more strongly does the idea take shape that 'the non-reproducible is truly genuine' and even more strongly felt is the lure of the authentic.

In their 2007 book, *Authenticity: What Customers Really Want*, business management writers James H. Gilmore and Joseph B. Pine seize on this desire for the authentic as a new customer sensibility on which entrepreneurs might capitalize. They write: 'In a world increasingly filled with deliberately and sensationally staged experiences—in an increasingly *unreal* world—customers choose to buy or not buy based on how *real* they perceive an offering to be. Business today, therefore, is all about being real. Original. Genuine. Sincere. *Authentic*.'[10] This idea accords marketing strategies the same role that has historically been accorded to art: to provide an alternative to what is. Except here, rather than any true challenge to affirmative culture, the goal is to sell products through an operation that dissimulates its relationship to commodity exchange by superficially adopting the guise of precisely that which is supposed to reside outside of

it: the authentic. In a world of 'technological intrusion', Pine and Gilmore argue, businesses can add value by 'rendering authenticity'.[11] Guidelines for doing so include an absolute prohibition on declarations of authenticity ('It's easier to *be* authentic if you don't *say* you're authentic') and an imperative to 'humanize' all interactions customers have with technology.

Gilmore and Pine became known within the art world when their book, *The Experience Economy: Work is a Theatre and Every Business is a Stage*, was discussed by critics interested in understanding how the practices grouped under the heading of relational aesthetics might dovetail with broader transformations of capital.[12] Taking Walt Disney as a foundational example— one that notably also features prominently in Baudrillard's *Simulations*, albeit in a negative capacity—the strategies elaborated in *The Experience Economy* were meant to instruct businesses on how to offer something unusual, something that would make customers feel as if it has been crafted just for them, like when the cashier puts one's name on a cup at Starbucks. If there is a correlation between the marketing strategies described in *The Experience Economy* and a privileging of relationality in the art of the 1990s, is it now possible to say that the focus on authenticity as a consumer sensibility is also paralleled by particular kinds of artistic and curatorial practices that privilege authenticity? And if so, does this isomorphism with market logic neutralize whatever criticality those practices might purport to possess?

A crucial difference between those practices correlated with the 'experience economy' and those aligned with the desire for authenticity is that the former made no claims of residence outside the dominant cultural logic. Indeed, though Nicolas Bourriaud made emancipatory claims on behalf of particular artists, in many cases a closer examination of their work reveals a cannily ambivalent relationship to the transformations of capital and labour that occurred in the 1990s.[13] Authenticity, by contrast, derives its force from posing as an alternative to, rather than an engagement with, the status quo. It seeks to remedy a supposed lack; it is a fundamentally conservative withdrawal from the present. For some, this is enough to mark it as reactionary and disqualify it as a viable strategy. Steven Shaviro, for example, has opposed so-called 'slow cinema' on these grounds. Filmmakers such as Apichatpong Weerasethakul, Béla Tarr, and Tsai Ming-Liang pursue protracted narrativity and extremely long takes, creating a cinema that prizes durational experience as a way of escaping a contemporary everyday that seems to accelerate uncontrollably. In Shaviro's view, rather than a direct engagement with the contradictions of contemporary experience,

such filmmaking constitutes 'an evasive cop-out', 'a profound failure of the imagination', and a 'retreat into fantasies of the good old days'.[14] One might say the same thing of the deployment of authenticity in contemporary art, setting it against the work of artists who straightforwardly confront the vicissitudes of digital existence. But while such a criticism might apply to a young artist who decides to cultivate a precious ceramics practice, can the objects included in the dOCUMENTA (13) 'brain' be dismissed so easily?

Though the various deployments of authenticity may be united in their shared status as rearguard responses to anxieties provoked by the ubiquity and perceived sameness of digital culture, it is necessary to mark out some distinctions between them. When the end of a tourism advertisement for the remote Canadian province of Newfoundland asks the viewer to 'Call Joan' for more information, this falsely personal touch is nothing other than the staging of a spurious pseudo-authenticity. Of course 'Joan' won't be on the other end of the line, but as the authentic is always closely allied with the human and against the machine, the idea of calling 'Joan' is much more enticing and consonant with the image of the province the campaign seeks to project than calling an automated telephone menu would be. But in an encounter with the damaged artefacts from the National Museum in Beirut at dOCUMENTA (13), the force of time and the absolute singularity of the objects are palpable. These mangled pieces of metal and glass challenge the notion that the value of the art object is a matter of aesthetics alone, and instead suggest the extent to which social and political relations may be embedded in the materiality of things. These are not objects isolated from the passage of time, but rather poignant testimonies of violence and trauma. They are obstinate reminders of the contingent circumstances by which some things endure while others perish.

Though Adorno articulated a scathing critique of the place of authenticity in an administered world, he did nonetheless hold on to the validity of an honorific use of the word, one that locates the authentic in what is vulnerable and transient rather than pure and fixed. As he writes: 'Scars of damage and disruption are the modern's seal of authenticity; by their means, art desperately negates the closed confines of the ever-same ...'[15] Though the objects in the 'brain' invoke the rhetoric of singularity and authenticity, they recognize the arrogance and artificiality of an easy return to origins, and instead locate the authentic in those objects that index, rather than deny, the frailty and difficulty of being in the world. In this, they repudiate any retreat into a reified and glorified past, while also proposing a different relationship

to history than is most often found in contemporary manifestations of technocapitalism. Unlike the return to a depth model of the subject, such a consideration of the life of objects may be understood as avoiding some of the pitfalls of the old authenticity discourses, while maintaining the ability to mobilize the anachronism of the authentic as a challenge to our present.

The resuscitation of the authentic is, then, a persistent reminder that there is a both a danger and a value in the rejection of things as they are. What's more, it offers the striking proposal that understanding what counts as 'art after the internet' might necessitate expanding one's purview far beyond artworks produced through digital means if one is to truly take account of the breadth of engagements with digital culture found in contemporary practice—be they reactionary or not.

1 Theodor Adorno, *The Jargon of Authenticity*, trans. Knut Tarnowski and Frederic Will (Evanston: Northwestern University Press, 1973) 9–10.

2 Steven Henry Madoff, 'Why Curator Carolyn Christov-Bakargiev's Documenta May Be the Most Important Exhibition of the 21st Century', *Blouin Artinfo*, 5 July 2012, http://www.blouinartinfo.com/news/story/811949/why-curator-carolyn-christov-bakargievs-documenta-may-be-the-most-important-exhibition-of-the-21st-century.

3 See: Walter Benjamin, 'The Work of Art in the Age of its Technological Reproducibility (Second Version)', trans. Edmund Jephcott and Harry Zohn, in *Selected Writings, Volume 3: 1935–1938*, ed. Howard Eiland and Michael W. Jennings (Cambridge, MA: The Belknap Press of Harvard University Press, 2002) 105.

4 Hal Foster saw this turn already in in art of the early 1990s. He writes, 'From a conventionalist regime in which nothing is real and the subject is superficial, much contemporary art presents reality in the form of trauma and the subject in the social depth of its own identity. After the apotheosis of the signifier and the symbolic, then, we are witness to a turn to the real on the one hand and a turn to the referent on the other.' See: Hal Foster, *The Return of the Real: The Avant-Garde at the End of the Century* (Cambridge, MA: MIT Press, 1996) 124. Emphasis in text.

5 As Luc Boltanski and Ève Chiapello have noted, the life of the nineteenth-century artist was considered to be a particular wellspring of authenticity because 'it was not compartmentalized but succeeded in unifying all the facets of the same existence, and gearing it towards the completion of an oeuvre and the uniqueness of its creator'. Luc Boltanski and Ève Chiapello, *The New Spirit of Capitalism*, trans. Gregory Elliott (London: Verso, 2005) 472fn5.

6 Edward Young, *Conjectures on Original Composition* (London: A. Millar, 1759) 42.

7 For an extended discussion of the figure of the copyist in nineteenth-century fiction and an inventory of its appearances, see: Rima Shore, 'Scrivener Fiction: The Copyist and His Craft in Nineteenth-Century Fiction', unpublished Ph.D. dissertation, Columbia University 1980.

8 Lionel Trilling, *Sincerity and Authenticity* (Cambridge: Harvard University Press, 1972) 126–127.

9 Theodor Adorno, *Minima Moralia: Reflections on a Damaged Life*, trans. E.F.N. Jephcott (London: Verso, 2005) 155.

10 James H. Gilmore and B. Joseph Pine, II, *Authenticity: What Consumers Really Want* (Cambridge, MA: Harvard Business School Press, 2007) 1. Emphasis in text.

11 Ibid., 14.

12 See: Claire Bishop, 'Antagonism and Relational Aesthetics', *October* 110 (Fall 2004): 51–79.

13 Compare, for example, Bourriaud's gloss of Pierre Huyghe with the more rigorous and attentive assessment of the artist undertaken by Tom McDonough in 'No Ghost', *October* 110 (Fall 2004): 107–130.

14 Shaviro looks to films such as Southland Tales (2006) and Gamer (2009) as successful attempts at grappling with the contradictions of contemporary existence. Steven Shaviro, 'Slow Cinema vs. Fast Films', 12 March 2010, http://www.shaviro.com/Blog/?p=891.

15 Theodor Adorno, *Aesthetic Theory*, trans. Robert Hullot-Kentor (London: Continuum, 2004) 29.

The Curator's
New Medium

Omar Kholeif

When *Artforum* published its 50th anniversary issue on the theme of 'Art's New Media', Editor-in-Chief Michelle Kuo, who holds a PhD in the field of 'experimental new media', directed the issue, which seemed to tackle the old anxiety concerning art practice and medium specificity. Despite coming in at over 500 pages, the chunky edition barely hinted at the fraught tension between so-called new media, the internet, and the contemporary act of curation. With the exception of initiatives such as Curatorial Resource for Upstart Media Bliss (CRUMB) and the curatorial programme at the University of Sunderland, it seems perplexing that, as academic programmes in curatorial studies continue to proliferate, little attention is being directed at how the still relatively new medium that is the internet has started to shift the hierarchies by which conventional curatorial practice is admired, taught, and implemented in the contemporary sphere.

When I refer to the culture of curating on the internet, I am not alluding to the utopian views of universal access that started to crescendo during the dotcom boom of the late 1990s, or to the subsequent dystopian view of the so-called digital divide. Rather, my interest is in exploring the internet's conditioning of recent capitalism. Consider the cross-platform synchronicity of software-driven platforms such as Apple's iTunes or Amazon's cloud drive with iPhones, iPads, Kindles, and other devices which, collectively, broker taste formations based on strategically developed man-made algorithms. We are now increasingly familiar with how well such algorithms can work, especially if one moonlights in the art world, where the limited degrees of separation quickly transpire through social networking sites such as Facebook and LinkedIn. It only takes a handful of mutual friends before these services start recommending you as worthy of connecting with the art world elite's virtual avatars.

But how would a curator feel if they realized that their entire curatorial strategy—or indeed, their entire taste—was developed purely through the very same algorithms that set up these scenarios? Could an institutional museum curator or art collector seriously construct a cross-referential historical survey by using Amazon's friendly 'recommended for you' search function? Erudite art historians will quickly dismiss the notion, but the functionality of the service for the intermediate art participant is unquestionable. Search for a Malcolm Le Grice DVD and you will be recommended Peter Gidal before being directed to Jean-Luc Godard, 1920s avant-garde cinema, Apichatpong Weerasethakul and, ultimately, John Waters. The links are not cursory. Amazon has instantaneously crafted

The Curator's New Medium

out a simple but meaningful historical trajectory that is illustrative of the relationship between art and cinema, which would have ordinarily taken someone in a world without databases and algorithms hours pouring over art history and cinema books in order to draw such correlations.

But perhaps more curious here is the click-happy nature of one's art historical journey. My faculties are called into doubt and even the curatorial 'role' of caring is brought into question. I am skimming descriptions and adding things into my online basket—exhibition catalogues, DVDs, artist memorabilia, and so forth. My basket has over a hundred items 'saved to buy later' at any given time and I constantly return to purchase more goods in the hope of the basket being emptied, only to realize that there are more urgent art references that I need to own and master. My curator's desk in my open-plan office overflows; a fortress of books and DVDs impenetrable to my colleagues.

While this romanticized notion of curatorial clutter might well be affiliated with the hyperactive Hans Ulrich Obrists of the world, to the everyday individual the restless desire to surmount a holistic picture of art history becomes pressurizing when one can so explicitly see the multitude of creative practices that exist outside of institutional confines, albeit virtually. With the increased flow of instant information and with choices escalating, it becomes overwhelming; our patience for synthesizing information becomes reduced. What, then, will this condition tell us about contemporary curatorial practice?

One attempt to answer that question is provided by Art.sy (later renamed artsy.net), an online platform developed by a US Ivy league computer-science graduate and initially funded by, amongst others, Twitter founder Jack Dorsey, Wendi Murdoch, and Russian art collector Dasha Zhukova. Initially launched without the 'www' prefix and pronounced 'artsy', the platform jostles what one can argue is the divide between the art market and the fad-based culture that subsumes art as a trend-based accessory, while also democratically attempting to form a bridge between so-called everyday people and more seriously informed art connoisseurs. Artsy is powered by the Art Genome Project, a study that classifies artworks against more than 800 characteristics in order to identify them as unique, but which in turn also renders them searchable by associations. Is this Amazon's recommended-for-you feature for art lovers? One can browse by medium-specific genres such as 'computer art' or a range of other terms, from the generalized to the specific, such as 'abstract vs. figurative', '1985 new wave',

'identity politics', and so on. Once you select an artist under a particular genre, your tailored suggestions are informed by that initial click.

Under the banner of 'identity politics' I am presented with visual material about Yang Fudong's six-channel installation *East of Que Village* (2007). An installation shot is provided and then I am invited to ask for more info, to 'follow the artist' Twitter style, or to try and buy the artwork. Unfortunately, as I attempt to purchase this work, a tab reveals that it is not for sale and instead I am directed to Julian Rosefeldt's work (also from 2007) entitled *The Ship of Fools 1*, a large lambda print that clocks in at £9,500. I ask to purchase it. An email is sent and I am told to wait. Anxious that the click-happy mentality of Amazon's one-click shopping has not been transposed efficiently—is there a bug in the system? Why am I waiting?—I click on half a dozen more artworks generated through the system's suggestions. Within twenty-four hours I receive an email from a designated specialist called Ibiayi Briggs, asking: 'How can I help you? I would love to know what drew you to these works?'

The result is befuddling. Why utilize the structural approach of Amazon-style shopping sites if the satisfaction is not instantaneous? Is the art world's prickly relationship to capitalism so sophisticated that automatic infiltration must be prevented? The approach that Artsy has chosen to adopt is significant; by trying to initiate a conversation with the buyer, Artsy is proposing to mirror the relationship-building experience that occurs between a collector, gallerist, and an artist. The simulations, however, do not end there. Artsy also appropriates the vernacular of the museum, dubbing its online gallery of images a growing 'collection'. It also sends out regular emails that mimic curated thematic group shows. One weekly email with the subject title 'California Art' includes a curatorial-style statement binding together a series of thumbnails. The subjects vary, allowing an event-responsive dynamism. For instance, after Hurricane Sandy garnered news coverage, Artsy decided to send out an email with a curated selection from its database entitled 'After the Storm'. Similarly to a museum, the service boasts a staff member with the title Chief Curator (who in fact comes from the technology world), along with a list that includes a *crème de la crème* of museum advisers, from MoMA to Tate.

The blurred specificity of Artsy, which seems to aspire much more to 'real space' as opposed to the platform-native functionality of the web, is perhaps indicative of the art world's anxiety about opening up or indeed dismantling its curatorial credibility too quickly. By using gallery and museum-

style user approaches, the virtual is thus attempting to masquerade as reality so as to maintain the art world's status quo. Yet the fact that the website professes that art—in its canonical entirety—is not about, say, the philosophical play of the senses (hermeneutics), but rather to do with the 800 or so qualities identified by the Art Genome Project, raises complex questions about the validity of curating as a practice. If art is so reducible, shouldn't every professional curator be let in on the secret? (Or, if Artsy plans to release the secret, then couldn't everyone hijack them once made available?)

Marxian commodity fetishism aside, the curatorial models of the internet have been suggestive of different forms of mass-media transposition. For example, take Apex Art, a New York-based exhibition and residency space, which sources a significant chunk of its exhibition programme through an open-call process. Rather than inviting a handful of supposedly expert jurors to decide on a winning proposal, Apex instead invites curators to submit proposals of no more than 500 words through an open call. It then invites a large group of crowd-sourced specialist public voters to take part in an online voting process that resembles a reality TV talent show—the most popular proposal wins. Of course there is a catch in the fact that the public here consists of approximately a hundred professionals within the field. No great detail is revealed about who they are, nor are the judging criteria made clear to the applicants. The approach is innovative and notable for its attempt to at least lean towards an audience-led ethos. Indeed, audience surveys of exhibitions I have curated far too often illustrate a frustration with the self-referential vernacular pieced together from the adjectival terminology of museum press releases and e-fluxes, which Alix Rule and David Levine articulated in their collaborative research project *International Art English*, published in an issue of *Triple Canopy* in July 2012.

Still, this strategy of selection is complicated by the faceless nature of the voters. From where do curatorial proposals derive their validity and their agency? Traditionally, the curators derive their authority from the gravitas of those who endorse them, whether that be a major institution, such as Tate or MoMA, or a graduate degree from the Royal College of Art, Columbia, or Bard. There are pros and cons to this approach. For example, every major art prize is seemingly judged either by the artistic director of Documenta, a member of *Art Review*'s Power 100, or Hans Ulrich Obrist. By shifting away from this 'centre point' to a more aggregated periphery of individuals who cast more votes, the curatorial field arguably becomes more democratic and varied than the singular nature of high-profile prize giving culture.

But Apex Art's nod to global capitalism doesn't end with its so-called democratization of the voting process. It continues through a franchising programme, which helps transpose the model initiated and adopted in New York onto any city in the world. One open call, for example, invited curators to propose exhibitions in cities with a population of less than 500,000 people. A similar voting process would ensue and the 'franchised' winners would receive $8,000, a catalogue, and other incentives. Nevertheless, the ethos that Apex Art seeks to pioneer is fraught because it uses the online rhetoric of fairness and democratic voting while, at the same time, and like Artsy, it seems to emphasize the elite nature of the jurors, advisers, and curatorial consultants who continue to function as gatekeepers. If such ventures are to become genuine native manifestations of the manner in which we function online, then they must fully adopt its egalitarian spirit. *Rhizome*, for example, derives its agency from its orientation as an online, community-led initiative, where the users feel that they can contribute and 'activate' curatorial discussion by contributing to one of the website's various editorial strands. They can recommend work to be archived, or curate online exhibitions from its archive, merely by opting to be a part of the community

Yet the politically loaded objective of art democratization also seems to fuel curatorial approaches that shift the form and content of contemporary works even further. Take the online venture s[edition], founded by Harry Blain of Blain|Southern and former CEO of Saatchi online, Robert Norton, which allows users to purchase artworks from 'blue chip' artists. Many of the YBAs are there, as is Yoko Ono, but there is one catch: you can only own an edition of the work in digital form. A Tracey Emin neon sign can be downloaded as a digital file that you can play on a TV screen during a party. It will only cost you £50. At a conversation held at the ICA (Institute of Contemporary Arts) in London in October 2012, representatives from s[edition] suggested that it would place artists on a level playing field and that, by reducing the price barrier, more emergent artists would be able to sell works and attract mass appeal without gallery representation.

How does such a platform engage with curatorial practice, especially that which focuses on time-based media? If I fill my apartment with thirty-two TVs and download all of the artworks from s[edition], arrange them according to historical chronology, and write a press release, could I argue that I have curated a survey of, say, Young British Art? Does this platform suggest that the virtual is additional to the physical, or is it intertwined? And if so, how does this shift the position of the artists and curators who choose

to work solely or predominantly online, now that 'real space' artists are seeking to invade their territory by commoditizing their creative practice?

Other corporate ventures, however, such as the Adobe Museum of Digital Media, which is funded by the eponymous software company, seeks to create as close a synthesis to real-time art viewing as is possible online. The so-called museum resembles what cultural theorist Norman M. Klein refers to as a cross-embedded architectural environment, where the virtual sphere is made to physically resemble real time and space. Here, works of art are not confined to 4:3 video player frames but can also become all-encompassing experiences with videos and images taking over the entirety of the computer screen. Of course, the viewer's experience is predetermined by the size of their individual display screen.

Nevertheless, what these platforms do not explain is what constitutes a 'good' curator, nor are they thoughtfully articulating any part of the accustomed curatorial processes, such as caring, selecting, articulating, researching, writing, theorizing, unifying, mediating, preserving, protecting, narrativizing, and so on. At the same time, however, neither do any of these platforms adopt the unrestrictive culture of the internet, say, of the 'open' curatorial model of playlist culture. At curatorial school, we are taught that a professional curator grows out of specialist knowledge. A curator possesses gravitas because her or his curated exhibitions are historically rigorous, challenging, and engage with narratives that illustrate new research methodologies. However, the supposed democratization of curatorial practice through such virtual platforms threatens this traditional art historical approach to curating.

We are increasingly in the midst of a single, all-encompassing culture, which uniformly captures all cultural dividends. This is what media theorist Jay David Bolter has dubbed a popularization of visual culture, with museums and galleries opening up their spaces, subsuming pop culture not only as inspiration but also as its subject matter, as evidenced by the increasing presence of more mainstream filmmakers such as Werner Herzog and Wim Wenders, and musicians such as Kraftwerk exhibiting in art museums. Likewise, Alanna Heiss's artonair.org seeks to shift the form of online radio through a curated approach that merges two of the most superior forms of credible connoisseurship: music and the visual arts.

Diedrich Diederichsen supplied one of the most relevant quotes in *Artforum*'s 50th anniversary issue by commenting that 'the current culture industry … exploits life itself',[1] going on to assert that it also exploits the series of taste preferences that delineate friendships and relationships—that is, a sense of the collective. Still, for the curator, a series of thorny questions remain. Will the trans-media virtual environment continue to be seen purely as a conduit for distribution and commoditization by artists, producers, and the mass audience? Will contemporary art soon be downloadable through the iTunes Store and available as iPad screensavers, akin to album art? Will the more community-oriented approach take over or will the hegemony of corporately supported platforms take precedence? We continue to speak of the relationship between museums and corporate sponsorship, but we have yet to fully discuss how the commodification of our most shared space, the internet, affects not only artwork but also contemporary curatorial practice. Writers and curators in the increasingly expanding field of curatorial studies need to park aside their entrenched hierarchical snobbery and address this most urgent of matters, or else risk seeming anachronistic.

An earlier version of this essay appeared in *Art Monthly* issue 363, February 2013.

1 Diedrich Diederichsen, 'On All Channels: Media, Technology, and the Culture Industry', *Artforum International*, September 2012, www.artforum.com/inprint/issue=201207&id=31946.

Contra-Internet Aesthetics

Zach Blas

Zach Blas, Facial Weaponization Suite: Fag Face Mask, 20 October 2012, Los Angeles, CA.
Photograph by Christopher O'Leary.

Proliferations of discourses that are decidedly 'post-' inundate artistic and intellectual life today: a post-Fordist mode of production gives way to post-politics and post-capitalism, which is accompanied by a post-media, post-digital, post-internet landscape populated by post-identitarian post-humans that are post-feminist, post-race, and post-queer. It is an era that, easily enough, has been summed up as post-contemporary, and not so long ago, postmodern. Such a postal deluge encourages the question: what is this prefix that stretches across the world to account for myriad global conditions?[1] If 'post-' is commonly used to signal an 'after', then what does its excessive use convey about the historical present? Are we 'after' everything, supplanted in endless, elusive passings, a never-ending fractal vortex, where post-isms spin past all horizons to infinity?

Uses of 'post-' appear to contain contradictions: in a time of political upheaval and revolt, we are post-political; in a time of digital domination, we are post-digital; in a time of ever-rampant homophobia, misogyny, racism, nationalism, and transphobia, we are post-identitarian. Yet, deployments of 'post-' do not simply mean an after, but also illustrate saturation or (pseudo)totalization. For example, post-identity conceptions like post-feminism, post-queer, and post-race are attempts to understand subjectivity and the body beyond identity-based strictures that have been wielded to subjugate persons, while post-medial formations address a far-reaching penetration of digitality that permeates life and culture. Undoubtedly, 'post-', as a heterogeneous assemblage, reigns with immensely varied politics and vastly differing temporalities. It is strikingly dissimilar from periodizations like the disciplinary and control societies. 'Post-' drifts between eras, politics, peoples, and practices, while it still designates periods and passages of time. With such overuse, can 'post-' function as a unified designator of anything, let alone have a unified aesthetics or politics? Of course, the decision to use 'post-' as a discursive frame is ultimately a political act. From that perspective, 'post-' communicates a haziness or murkiness—a blanket generalization that is an empty descriptor. 'Post-' announces that challenging instances of passage and transformation can only be articulated through what they proceed. But is this enough? Is 'post-' not more of a stylistic convenience that evinces a blind spot, an inability to account for the present in its specificity and singularity? Is it not an easy shorthand for what could be called an impasse to think the contemporary?

As an artist and writer engaged with art, media, technology, and politics, I would like to zoom in on post-internet aesthetics, a term with much affinity to theories of post-media and post-digital, but one that directly concerns current artistic practices. Post-internet art and aesthetics popularly stands for an array of artistic production that emerges from the (ostensible) indelibility of internet technologies and cultures, and thus implies that the present is a time in which the internet has thoroughly permeated artistic production. As such, post-internet aesthetics would seem to account for a widely and wildly divergent grouping of people and practices, but it is rather taken up by a considerably moderate collection of hip, young, 'digital native' artists and art institutions mostly in the West,[2] a reality that contradicts its temporally totalizing implications. If we are post-internet, what art is not post-internet?[3] Yet, within this category, there are fine, stand-out artists, who are not necessarily at issue. Mine is a structural concern: post-internet aesthetics, as one symptom of many within our contemporary postal disorder, does not escape the nullifying force of that marker, which reduces the concept to a generic descriptor—a pseudo-totality that does not account for variation and difference. This is the seduction of post-internet aesthetics to art markets and commercial vectors: its neutral frame provides a safe, hollow concept to fill, which corrupts the very political potential of aesthetics, as what can intervene and shift conditions of life towards equality, not capital.[4] At its worst, post-internet aesthetics is just the latest cool media art episteme or distribution of the sensible.[5] At its best, it can only be the broadest of starting points for understanding and experimenting with the present.

If post-internet aesthetics is on its way to becoming an ascendant category for digital, net-based artistic practices,[6] this is troubling for artists invested in political struggle, transgression, and subculture (which, to be clear, is my position), because it dilutes radicality and militancy through its nebulousness and temporal, technical determinism. I feel 'post-' is an insufficient choice for articulating political and aesthetic alternatives both within the internet and digitality. Instead, the alternative asks: what is after, before, or beyond 'post-'? What are the transversal forces that cut through 'post-' and disallow easy designators of time and technics to account for conditions of globalization?

Today, as digital networks and information technologies increasingly operate as tools of control, surveillance, policing, and criminalization,[7] a political demand extends to us, insisting on the refusal and reconstitution of these militarized systems. As such, politico-aesthetic practices that respond

to this demand require an equally radical conceptualization. Thus, if post-internet is inadequate to militant and revolutionary gestures, what is?

We can begin seeking initial answers to this question by reading post-internet against itself, as what comes *after* the internet and not its totalization. This is a strategy similar to feminist theorists J. K. Gibson-Graham, whose designation of 'postcapitalist politics' describes alternatives already in existence within the supposedly totalized frame of capitalism.[8] In this instance, post-internet would convey both an abandonment of the militarization and control of the internet for the construction of political alternatives to digital networking. This is what media theorists Alexander Galloway and Eugene Thacker have called the 'antiweb'[9]—autonomous networks that are exoduses from the internet. Examples include mesh networks, darknets, and surveillance evasion devices.[10]

I would like to suggest that the artistic militancies and political subversions of the internet are not post-internet aesthetics but rather *contra-internet aesthetics*. I take 'contra-' from the queer and gender theorist Beatriz Preciado's *Manifesto contrasexual*, in which contrasexual is defined as the refusal of normalizing power structures that produce sexuality and gender through a patriarchal, heterosexist, capitalist framework.[11] Contrasexual rejects the simple categorization of man and woman as naturalized entities and instead articulates a counter-sexual position: a being-against that posits all sexes and genders as technologies that have been produced through power. Consequently, contra-internet aesthetics considers the internet to be swelling from the same normalizing systems of control that Preciado rails against; indeed, contra-internet aesthetics recognizes that the internet is a premier arena of control today, bound to mechanisms that vehemently and insidiously police and criminalize non-normative, minoritarian persons: biometric regulation, drone attacks, and data mining sweeps, to name but a few. Contra-internet aesthetics disallows the internet to determine its horizon of possibility. But just as contrasexual and contra-internet are assaults against normalization and oppression, they also insist on alternative forms of understanding, pleasure, knowledge, and existence. Thus, as contra-internet aesthetics could strive to bring the internet to ruins, it does so to create positive alternatives.

The coming contra-internet aesthetics involves:

1. An implicit critique of the internet as a neoliberal agent and conduit for labour exploitation, financial violence, and precarity.

2. An intersectional analysis that highlights the internet's intimate connections to the propagation of ableism, classism, homophobia, sexism, racism, and transphobia.

3. A refusal of the brute quantification and standardization that digital technologies enforce as an interpretative lens for evaluating and understanding life.

4. A radicalization of technics, which is at once the acknowledgement of the impossibility of a totalized technical objectivity and also the generation of different logics and possibilities for technological functionality.

5. A transformation of network-centric subjectivity beyond and against the internet as a rapidly developing zone of work-leisure indistinction, social media monoculture, and the addiction to staying connected.

6. Constituting alternatives to the internet, which is nothing short of utopian.

Glimpses of contra-internet aesthetics can be seen in Jemima Wyman's tactical camouflage works, where protest, pattern, and feminism collide; Ian Alan Paul and Ricardo Dominguez's staging of a drone crash at the University of California San Diego to instigate public discussion on drone ethics and violence; micha cárdenas' *Local Autonomy Networks*, which uses mesh networking to promote transformative justice and anti-violence activism for queer, transgender people of colour; Dan Phiffer's *Occupy.here*, a darknet designed for Occupy activists; Hito Steyerl's meditation on resolution, control, and digital technologies in the video *How Not to Be Seen: A Fucking Didactic Educational .MOV File*; and Electronic Disturbance Theater's *Transborder Immigrant Tool*, a mobile phone equipped with GPS that aids persons attempting to cross the Mexico-US border locate water caches and help centres.

Ian Alan Paul, <u>Drone Crash Incident: Town Hall Meeting,</u>
2012, Calit2 Gallery, University of California San Diego.

<u>Contra-Internet Aesthetics</u>

micha cárdenas, <u>Local Autonomy Networks /
Autonets, Mesh Networked Bracelet</u>, (Detail),
2013. Photograph by micha cárdenas.

<u>Occupy.here</u>, an open source project founded by
Dan Phiffer (2011—ongoing).
Photograph by Dan Phiffer.

Hito Steyerl, <u>How Not To Be Seen: A Fucking Didactic Educational .MOV File</u>, 2013.
Photograph by Leon Kahane.

Electronic Disturbance Theater,
<u>The Transborder Immigrant Tool</u>, in
operation—with a screenshot from a
Nokia e71 cell phone—directing a user to
a Water Station Inc. water cache in the
Anza Borrego Desert, located within the
Colorado Desert of southern California.
Photograph by Brett Stalbaum.

Zach Blas, Facial Weaponization Suite: Mask, 31 May 2013, San Diego, CA. Photograph by Christopher O'Leary.

I would also like to situate my own artistic practice within this aesthetic demarcation, from my earlier project, *Queer Technologies*, to the ongoing *Facial Weaponization Suite*, a series of mask workshops in which collective masks are produced from the aggregated biometric facial data of participants. The masks function as both a practical evasion of biometric facial recognition and also a more general refusal of political visibility, which intersects with contemporary social movements and their use of masking. The first mask in the suite is *Fag Face Mask*, which is a critical engagement with recent scientific studies that claim sexual orientation can be determined through rapid facial recognition techniques. The second mask addresses a tripartite conception of blackness, split between racism (citing biometrics' inability to detect dark skin), the favouring of black in militant aesthetics, and black as that which informatically obfuscates.

Zach Blas, <u>Facial Weaponization Suite: Fag Face Scanning Station, reclaim:pride</u> with ONE Archives & *RECAPS Magazine*, Christopher Street West Pride Festival, West Hollywood, CA, 8–9 June 2013. Photographs by David Evans Frantz.

Zach Blas, 'Militancy, Vulnerability, Obfuscation' Tableau Vivant, <u>Facial Weaponization Suite: A Mask-Making Workshop</u>, Performative Nanorobotics Lab, UCSD, 7 June 2013. Photographs by Tanner Cook.

In her manifesto, Preciado invents dildotectonics as a 'contra-science' that demonstrates the possibilities of contrasexuality. For her, the artificiality of the dildo points toward gender and sex as technologies, and also operates as a resistant tool against normative productions of bodies and pleasure. Preciado explains that dildotectonics turns the body into a dildoscape—a zone of contrasexuality, and she develops a series of experimental practices to achieve this. What, in turn, is the dildo of the internet? Its fibre optic cables, government backdoors, wireless routers, or spambots? Where are the net-dildos that make intelligible the internet's complicity with control, subjugation, surveillance, and political violence? Certainly, the previously mentioned artworks are each a net-dildo that uniquely contra-fucks the internet. A key contra-science these works share is an investment in informatic opacity, a tactics of withdrawing from control by evading detection or interception from the commercial internet: darknets and mesh networks are informatically opaque in that they share information through anonymity and function with autonomous technical infrastructure. Tactics of camouflage, like masking, make persons opaque to digital, networked surveillance. Informatic opacity, then, is best understood as a prized method of contra-internet aesthetics.

While contra-internet aesthetics can be concretely experienced through a growing constellation of artistic practices, it also must exist as an ideality: as the aesthetic potentiality to make the political alternative. This demands an inexhaustible openness, as something not fully known but sensed—a longing, the fantasy of a future. Thus, the promise of contra-internet aesthetics is a utopian horizon that calls forth another network—one that is not 'post-internet' but rather 'contra-'.

1 Donna Haraway has aptly described post-onslaughts
 as going postal. See: *When Species Meet* (Minneapolis:
 University of Minnesota Press, 2007).

2 For example, take the artists Artie Vierkant and Petra
 Cortright as well as the contemporary art institutions
 Rhizome and the New Museum.

3 This is a question deeply complexified by geopolitics, the
 actual global reach of network technologies, and the term
 'internet' itself, which does not adequately represent our
 digitally networked means of communication.

4 My approach to aesthetics is adapted from Jacques
 Rancière's writing. See: Jacques Rancière, *The Politics of
 Aesthetics* (London: Bloomsbury Academic, 2006).

5 Episteme, as theorized by Michel Foucault, and the
 distribution of the sensible, first introduced by Rancière,
 are concepts that describe the conditions of possibility for
 what can and cannot be sensed in a particular era.

6 Consider *frieze* magazine's 2013 survey of art after the
 internet, which featured my own artwork and partially
 inspired this essay, as well as the 2013 'Post-Net
 Aesthetics' panel at the ICA London. See: 'Beginnings +
 Ends', *frieze*, Issue 159, November-December 2013, and
 'Post-Net Aesthetics', Institute of Contemporary Arts,
 http://www.ica.org.uk/whats-on/post-net-aesthetics.

7 Recall the 2013 US National Security Agency surveillance
 revelations exposed by whistleblower Edward Snowden.

8 See J. K. Gibson-Graham, *The End of Capitalism (As
 We Knew It): A Feminist Critique of Political Economy*
 (Minneapolis: University of Minnesota Press, 2006)
 and *A Postcapitalist Politics*, (Minneapolis: University of
 Minnesota Press, 2006).

9 Alexander R. Galloway and Eugene Thacker, *The
 Exploit: A Theory of Networks* (Minneapolis: University of
 Minnesota Press, 2007) 22.

10 Mesh networks and darknets utilize communications
 protocols that do not coincide with the World Wide Web.

11 See Beatriz Preciado, *Manifesto contrasexual* (Madrid:
 Anagrama, 2011).

Provocations

Writers in the Expanded Field

Lucia Pietroiusti

'The most basic feature of advertising is that it addresses the other only as a means of highlighting the charms of the self. It is thus fundamentally narcissistic, and yet cannot easily be dismissed, because it has the effect of revealing the potential narcissism involved in all forms of communication.'
—Adam Kelly[1]

'... unless, that is, the category can be made to become almost infinitely malleable ...'
—Rosalind Krauss[2]

1. Sincerity

The premise of this argument is that, over the past few years, I have developed an increasing difficulty in writing in a tone that is not at once confessional and citational. Indeed, if I wrote, 'the problem of this sentiment', rather than 'the premise of this argument', the argument itself would become confessional...

In the most direct sense, I attribute this to a form of performance of the self—postulated, in part, by the multiplicity of social media, the multiplication of technological devices through which they are made accessible, and the multiple self-fashionings that ensue. The fact, for instance, that I would not even get along (let alone identify) with my Airbnb self,[3] reveals something about the interface between self and 'self', somewhere at the meeting point of symbolic depression and public broadcast. And, frankly, some expressions of self are so sincere they just end up sounding, well—drunk.

Readers of David Foster Wallace and proponents of late-twentieth-century post-ironic forms of sincerity[4] identify in his writing an understanding of the confessional tone as necessarily existing with and within manipulation, with none of the two being clearly purified of the other not even to the person who speaks. One can no longer believe (see *Brief Interviews with Hideous Men*), or make others believe, that a tone of total disclosure holds any bearing to an authentic self: it is about whether you, listener, O trusty reader, will *like* me or not.

Advertising is, certainly, primarily responsible for this shift: it is no coincidence that the phrase 'I don't buy it' interchanges seamlessly with 'I

Giuseppe Penone, <u>Rovesciare i propri occhi</u> [<u>Reverse Your Eyes</u>], 1970, reflecting contact lenses, documentation of the action.
Photograph by Paolo Mussat Sartor. Courtesy of Archivio Penone.

don't believe it'. Not that we've been doing much better since the early-1990s. It doesn't take a psychoanalyst to realize that the lowercase 'i' of the Apple product is none other than—*deus ex machina*—the superego in disguise. I will wear my iPod on an armband while I run for hours and hours. Eventually, I will reach my apex and become *i*—the gracious, the perfect, the flawless.

Literary theorist Adam Kelly understands Wallace as holding a similar position to Jacques Derrida's—the former in the traditions of narrative fiction and gonzo journalism; the latter in the realms of ethics, linguistics, and logic. The chain of signification is endless and you cannot speak about it clearly. You try—you acknowledge the pitfalls of expression and eventually, you give up (two thousand pages later). In an odd internalization of advertising mechanisms, the narrator's narcissism takes over, making his/her attempt at debunking 'sincerity' utterly futile. The whole endeavour becomes pointless. To quote Kelly again: 'Formal distinctions between self and other morph into conflicts within the self, and a recursive and paranoid cycle of endless anticipation begins.'[5]

The outstanding problem inherent in this, of course, persists: then what? How do we liberate ourselves from sincerity altogether, extracting ourselves from the sincere-ironic-authentic trichotomy, only to return to a world without an audience? In this context, Giuseppe Penone's 1970 work, *Rovesciare i propri occhi*, appears as necessary now as ever before.

For my part, to return, albeit briefly, to the confessional, there was a day, a very specific day, when I understood depression to be none other than a multiplication of the layers of analytical thought folded back into one's self—a kind of puff pastry of intellectualized emotion, if you like. Wallace's thought—so new-sincere, so post-ironic—is also, if read today, no more than the set of clues and steps through which the reader understands the author's actual, real world death beyond his theoretical one. The transformation of self-to-text, in his case, resolves in this: the reader in interpretive mourning.

In the context of visual artists' practice, Ed Atkins and Andy Holden have spoken about the issue: death as the becoming-thing of subjectivity[6]— becoming-thing as the resolution of the subject into an object. To everything its end: and thus sincerity, as an entropic system, awaits its final act.

2. Writerliness

Born out of the ideal of self-organization, grown into a tool for self-realization into neoliberal capital, the internet becomes the apex-point of depressive-narcissistic subjectivity in crisis. Yet, the internet's ever-expanding field (a handmade infinite) offers the possibility that a 'field' affords in every one of its iterations.

In recent conversation, artist Alex Cecchetti said he once described his practice as: 'I'm kind of a writer.' This led me to return to the way in which, in her 1979 text, Rosalind Krauss adopted sculptural work as a language to expand the 'field' of sculpture into landscape and architecture and beyond: 'like sculpture and painting have been kneaded and stretched and twisted in an extraordinary demonstration of elasticity,' she writes.[7]

In turn, it is not unthinkable that writerly processes may—or indeed, may have already—expanded the writer's field to touch performance, filmmaking, and other ways of mark making.

It is my contention, fully within—and perhaps in spite of—a discourse that centres on the dismissal of disciplinary boundaries, that we can understand a certain kind of artistic practice today as that of writers in an expanded field. Artists exert language and the self in a way made possible by the internet's proliferation of signs, amongst many other contemporary symptoms. With Heather Phillipson[8] and Ed Atkins, for example, the expanded field of writing through the visual arts has allowed for the possibility of internal contradiction without the necessary boundaries set by the problematic self of Wallace et al.

Expanded field as 'loss of site', therefore. While sculpture in the expanded field, in Krauss's view, presents itself as the 'full condition of its inverse logic and … pure negativity',[9] writers in the expanded field develop its logic from the outside in, elaborating forms of 'writerliness' that necessitate this very outside position as a prerequisite for their existence. In this case, the activity of the writer is a most radical repetition compulsion, leaving only to return and revolutionize the old context.[10]

So perhaps, while within contemporary literature, conceptual writing appropriates, cites, and re-performs the proliferation of signs,[11] writers in the expanded field of the visual, in the present understanding of the term, appropriate methods. Storytelling, epiphanic moments, instances of mourning and existential doubt,[12] pathos,[13] site-writing,[14] cats, and French cuisine[15]—all of them worked through with an articulation of means that holds the promise, at last, to do away with the confessional altogether.[16]

1 Adam Kelly, 'David Foster Wallace and the New Sincerity in American Fiction', *Consider David Foster Wallace: Critical Essays*, ed. David Hering (Los Angeles/Austin: Sideshow Media Group Press, 2010) 137.

2 Rosalind Krauss, 'Sculpture in the Expanded Field', *October* 8 (Spring 1979): 30.

3 And, of course, why would I? She is trying to sell you something and I am the squatter in-between.

4 See, for instance, Adam Kelly, op. cit.

5 Kelly, op. cit.

6 'Becoming THING,' Thursday 13 December 2012, Whitechapel Gallery, London.

7 Krauss, 30.

8 Who is also a published poet.

9 Krauss, 34.

10 For a political-philosophical explanation of this movement 'from the outside in' see Oscar Guardiola-Rivera, *Being Against the World: Rebellion and Constitution* (London: Birkbeck Law Press, 2008).

11 See *Against Expression: An Anthology of Conceptual Writing*, ed. Craig Dworkin and Kenneth Goldsmith (Chicago: Northwestern University Press, 2011).

12 See Ed Atkins' performance, *DEPRESSION* (Serpentine Gallery Memory Marathon, London, October 2012), https://vimeo.com/61089836.

13 See Heather Phillipson's short film, *Splashy Phasings* (Channel 4/Random Acts, 2013), http://randomacts.channel4.com/artist/341/Heather%20Phillipson.

14 See Katrina Palmer's performance (Chisenhale Gallery, London, January 2013), http://www.chisenhale.org.uk/events/21st_century_event.php?id=72.

15 Heather Phillipson, again: 'Well, this is embarrassing.'

16 With thanks to Rebecca La Marre for her advice and suggestions.

Notes on Post-Internet

Jennifer Chan

Oliver Laric, Versions, 2012.

1. The 'post-internet' condition

I first heard of the term 'post-internet' in 2009 from Gene McHugh's *Post Internet* blog on 12292009a.com.[1] The term was introduced in 2008 by Marisa Olson, who employed it to describe the necessity and influence of the internet on everyday life and subsequently, art practice, though it appeared in Lev Manovich's definitions of post-media aesthetics in 2001.[2] The syntactic and semantic qualities of 'post-' are interchangeable with postmodernism to mean 'in reaction to', 'after', 'in the style of', or 'an extension' of the internet.[3] Soon, emerging artists and writers from North America and Western Europe assiduously put forward theory on what 'post-internet art' could look like.[4] The term post-internet does not purport that the internet is obsolescent. In fact, there are many overlapping interests between internet art, post-internet, and the New Aesthetic—ideas that developed coterminously due to the artistic use of the internet as a mass medium, and the translation of its underpinning ideas into physical spaces.

New media art is a larger genre that encompasses art practices taking place at the intersections of technology that were once considered 'new'—from radio and analogue video, to interactive installation and internet art. Internet art (or net art) employs the networked, decentralized structure of the internet as both a medium and environment. In the 1990s, its early practitioners commonly referred it to as 'net.art'. Post-internet is a term often ascribed to contemporary art and web-based work that appeared online after 2005—digital art that's 'translated' into gallery spaces and informal exhibitions at bars, cafes, nightclubs, and other venues.[5] For art writers like McHugh, post-internet art involved a departure from the technological specificities of new media celebrated by new media art:

> Dissolve the category of 'new media' into art in general by creating work that has one foot in the history of art and another foot in the experience of network culture ... As the work mutates itself to become more like the art world art, the work mutates art world art to become more like the Internet.[6]

I was initially confused by McHugh's blog and its attempt to synthesize the practices of artists whose works existed online or dealt with internet culture, but had no aesthetic cohesion or conjoined politic. This post-media logic could be better summed up by Artie Vierkant's treatise on the variable digital

file as an idea with unfixed and multiple modes of presentation in *The Image Object Post-Internet*. A jpeg could exist as a pdf file, a print, or an image-object, such as a 3D print of the file's information.[7] Although fascinating when viewed altogether in a series, I found the literal translation from digital and physical formats conceptually unsatisfying, since the viewer cannot see the artist's 'hand', nor can they understand the artist's relationship to the technology at hand.[8]

Thus, I want to explore the post-internet condition, which is as much about the existential and ethical dimension of making art online and the creation of surplus value around its affects, as it is about the politics and anxieties that exist around so-called post-internet art practices.

2013 saw a reconsideration of what post-internet meant; this was primarily sparked, in some part, by the panel 'Post-Net Aesthetics' organized by *Rhizome* at the Institute of Contemporary Arts in London.[9] As I watched three curators and one artist banter about whether the term fit its ascribed relationship to the postmodern, I saw a certain disjunction between the theorization and practice of internet art. Curators and theorists seem to report on general patterns in the scene. While certain artists employ the web's distribution systems decisively for art distribution, others use the internet as a sketchbook without much intentionality to figure out their next moves. Some users only use their Facebook walls to share art news and for self-promotion; others fill their feeds with sarcastic and questionable status updates.

Using Tumblr (survivaltips.tumblr.com) to archive an artist-blogged ecology of images with little or no verbal discourse, Katja Novitskova compiled a printed book, *Post Internet Survival Guide*, which considered all media as artefacts. On the project, which also manifested as an installation-exhibition, she writes:

> The collective practice of Internet-aware blogging and art has been evolving a new language to imagine ... In this world—that is being tagged as Post Internet—the Internet is an invisible given, like roads or trees ... The notion of a survival guide arises as an answer to a basic human need to cope with increasing complexity. In the face of death, personal attachment and confusion, one has to feel, interpret and index this ocean of signs in order to survive.[10]

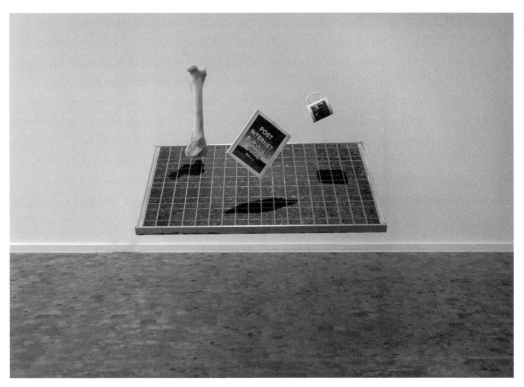

Katja Novitskova et al. *Post Internet Survival Guide*, 2010, FORMATS, Brakke Grond, Amsterdam.

In contrast to personal homepage webrings of '90s net.art, which were also shared on email listservs, the distribution of post-internet art heavily relies on social networking platforms: aleatory updates on Twitter, image aggregation on Tumblr, webcam videos on YouTube, gifs on Google+. Everything culminates to a half-serious professional art persona on Facebook—for artists, professional and personal space has conflated more than ever before.

This particular cultural moment is defined by digital identity formation that vacillates between two extremes: careful self-curation and 'indiscriminate over-sharing'.[11] The popularity and convenience of existing social media platforms has led to their use as an art medium and environment. Some practices that emerged out of this have been performance for the webcam (Jeremy Bailey), satirical documentation of art as social practice (the Jogging), sculpture about documentation (Rachel de Joode), anonymous avatars (LaTurbo Avedon), aggregation of online images as art (Kari Altmann's r-u-ins.org), gifs as a performance medium (Jesse Darling), and files converted into sculptures (Artie Vierkant). Post-internet art can be ultimately interpreted as a philosophical translation of online culture and practices into the physical world.

2. Post-internet is the bastard child of net.art and contemporary art

Post-internet practices are characterized by hybridity and hyper-mediation of existing genres, platform-oriented activity, slippage between formal output of digital and physical environments, and tactical web surfing.[12] If social capital comes from the practice of taste making (compiling images instead of making them), artists who have been called 'post-internet artists' can be considered alchemists. They take stock of the rubbish heap of net history. They turn shit into gold by compressing and decompressing digital artefacts, rehashing them into something informative, intellectually abstract, and visually elegant.

Regressive is progressive. It's easier to play the old game than revolt without the resources or reality that will allow you to resist. Commodification of art and everything surrounding it is the rule, not the exception. Initiative is both self-interested and ideological. Write or curate to leverage a new hierarchy in which you yourself can have a place, or something like that. Everything has been done; you can only do it better. Everything is a remix.

'Hybridize or disappear,' warns Oliver Laric in *Versions* (2012), the third of a series of videos on the ubiquity of appropriation.[13]

Spatialize the web as a large sculpture of a logo, or maybe a 3D print. Create a unique internet-inspired experience—an installation or a livestream performance. Learn to do bad well. Appropriate rotating 3D objects, stock photography, transitional HTML, video essays, and fake watermarks to demonstrate self-reflexive awareness of the medium. Make ends meet by selling CafePress pillows of Photoshop paintings. Corporate aesthetics and sterile minimalism are fit for docile public installation, design offices, and apartment lounges. Start a self-contained gif store with PayPal buttons, or an ironic Etsy account—but sell the products for real, or you might not get anything for your considered efforts.

Duchamp took a urinal and signed it off as his own; post-internet artists ironize authorship using hokey watermarks and computer voiceovers in video essays—the rebellious gesture of 'I can do this too' by artists who hold little reverence for their '90s net.art predecessors. And why should they? What has the formalist browser-based work of white men and women pecking at their computers in 1996 have to do with me? Your canon was Dada, Warhol and Duchamp; mine is Cantopop, Pokémon and young boys performing cover songs.[14] Why make art that looks like, and responds to, art that is over forty years old? Why not make art that responds to online things that matter to me now?

3. Bored together

Unlike '90s net.art, post-internet practices often exploited the web's decentralized, commercial properties to talk back to users and corporations. Many works were peer-responsive, profoundly cute and personal (for example, Parker Ito and Caitlin Denny's curatorial project, Jstchillin. org, Ryder Ripps' dump.fm, Computers Club collective, or John Transue's newageaddiction.com). What was most enjoyable to witness online was the informality, adventure, and pleasure young artists took in creating contexts for their work to exist away from the gallery and museum, and in a naively utopian manner. These optimistic tendencies to net art were not unlike their '90s precedents, but possessed little, if any, critical backbone towards the political implications of existing on any network. Later, efforts were made by Louis Doulas' *Pool* (http://pooool.info/)—a platform for 'expanding

and improving the discourse between online and offline realities and their cultural, societal, and political impact on each other.'[15] This platform was short-lived, updated intermittently, and looked more like a WordPress blog. But it provided a consolidated academic space for grad students, curators, emerging artists, and academic artists alike, to promote writing about art and internet culture after Web 2.0.

Net.art heavyweights were always more medium-specific about the use of the internet and computer technologies. Artists like JODI were concerned with fucking with the desktop and the browser, undercutting traditional art distribution systems, and creating new systems to share and make art (for example, Cornelia Solfrank's *Net Art Generator* [net.art-generator.com] and RTMark [rtmark.com] as a web-based corporate-sabotage collective). Post-internet practice, rather, navigates within popular systems to produce experiences that celebrate and critique (or more so, laugh at) the role of the internet in everyday life.

Soon, apartment gallery net art exhibitions began taking place in Chicago, Amsterdam, New York, and Berlin. DIY spaces such as Reference Gallery (Virginia), Future Gallery (Berlin) 319 Scholes (New York), and later Transfer (New York), popped up as post-internet friendly venues. Galleries such as Future and Transfer became part-commercial in their distribution to find a market for the contemporary cues in post-internet art. Their approaches to exhibition differed from long-standing new media galleries like HTTP (London), InterAccess (Toronto), or bitforms (New York), or festivals like SIGGRAPH and Transmediale, which had a history of showing comparatively studio-based new media art practices, such as robotic sculptures, interactive installations, and browser-based projects—art about the way technology works. Then artists started exhibitions as informal franchises: *Bring Your Own Beamer* were multi-projector exhibitions that took place in large warehouses or gallery spaces; internet cafe 'Speed Shows' became novel ways to exhibit work amongst a large peer group.[16] It appears that even if net.art's original impetus was to create art outside of institutional control, new media artists today are re-prioritizing the role of physical exhibitions as career moves and meeting grounds.

4. Net art: the theory game

There are several outlooks on the historicity of internet art in media art histories, considering the broader struggle for net art to be viewed as an autonomous, yet contemporary genre:

i. The historian's approach: net.art was never part of mainstream contemporary art. Net.art should retain its anti-institutional ethics and stop conforming to the moors of the contemporary, which are ultimately conservative and profit-driven.[17]

ii. The commercial gallerist's perspective: net art is new and shiny. It's the next Pop art.[18]

iii. The non-new media art critic: net art (and new media art) are terms that should be retired in favour of newer, relevant terms like 'web art' or 'social media art'.[19]

iv. The net veteran's reprieve: real net art (net.art) is dead. Long live net.art.[20]

If new media art has never been fully accepted into mainstream contemporary art, as Ed Shanken has observed, a confounding parallel is that new media art communities never wholly embraced post-internet art. Older generations of net.artists felt emerging net artists were wholly subsumed to Facebook's centralized mechanisms of socialization. There are three kinds of bad art criticism that are usually applied to contemporary art. This is the same criticism that the notion of 'post-internet' usually faces:

i. 'It's trendy' is a skeptic's retort—as Marisa Olson and Marc Garrett have observed, the art academy harbours conservative attitudes to the artists it selects for intellectual discourse.[21] Academics are hesitant to critically invest in young, emerging practices; they recourse to pre-mainstream and A-list names as textbook examples—lest the artist quits in five years, their PhD thesis will be worthless.

ii. This 'has been done' is a comment that comes mostly from new media art critics and historians.[22] Everything's been done, but with regards to the under-recognized and insular histories of net art, the gallery-going public doesn't know about what has currency on the internet, let alone the history of net art.

iii. 'It is lazy.' In regards to the abundance of amateur-looking work, kitsch is part and parcel of internet culture, if not employed with new interest 'nostalgically' by those who were not there to fully experience the early web—as Olia Lialina noted:

> Amateur style [Geocities 1996] was once the mainstream. Ridiculed and almost erased in the very late-1990's, it came back to the public's attention during the 'Web 2.0' wave. Though the original amateur culture was very different from Web 2.0, many of its elements survived and in today's web carry the meaning of a close, true relationship in between users and their medium. The Vernacular Web is a recognized phenomenon.[23]

Rejection of this is symptomatic to a colonial attachment to the ideas of 'great art history', of sterile minimalism, of heroic abstraction, and of conceptually oriented text-based work.

5. The anxiety of internet art

The demographic most commonly declared 'digital native' are in fact digital nomads. Overeducated and underpaid digital creatives work on laptops in coffee shops, public libraries, electronic art festivals, and airport lounges.[24] In an era where working from home has become popular for web developers and pro-bloggers (even independent curators), the advent of the treadmill desk and ironic tracksuit-touting is symptomatic of the need to condition oneself as a multi-talented, charismatic digital creative—one that updates athletically.[25] This is the anxiety of internet art: if you stop contributing, you will be forgotten. Participate to relieve the fear of missing out, and the loss of meaning and agency over self-representation. Participate for want of being discovered through reblogs and linkshares (but not LinkedIn). Post-internet

art is frivolous, fickle, and dandy, but even partying is hard work. You have to get ready, look your best, have energy to dance, and make enough to pay for cabs and coatchecks.

In America, mounting student debt, part-time contract jobs, lack of benefits, unaffordable health insurance, slow turnover of gallery jobs, and rarefied full-time teaching positions force new media artists to adapt to the demands of the traditional art world. In Canada and the Netherlands, budget cuts to state-funded art economies mean artist-run centres and publicly funded new media galleries have shut down. It's not as if there is no market interest in net art; Philips and Tumblr's joint initiative on the 'first ever' digital art auction demonstrated there is a burgeoning interest in the works by net artists who create editioned, physical versions of their work.[26] Meanwhile, lesser-known artists have turned to perks-driven crowdsourcing to self-fund projects.[27] It's a precarious time.

After four unpaid internships, one admin job, and two teaching assistantships, I have accrued a network of over eight hundred transactional relationships but probably only talk to twenty people regularly on Facebook. Those of us who have worked in the bottom rungs of arts administration know that curators and jury committees who deal with influxes of artwork from open calls flick effortlessly through jpegs and online submissions without reading artist statements or CVs. Artists can no longer wait to be discovered. New media artists like myself are writing and curating to create cultures of work and exhibitions away from the ad agency and the museum. This is not because we object to the museumification of net art (to help often unpaid artists to make money from their labour is a good thing). But the museum, nor the auction house, has yet to completely adapt to the informalities and ethics of new media culture.

6. Riding the wave: from prosumption to subsumption

As a contingency of online influence (likes, shares, and reblogs), initiatives to coolhunt and instrumentalize the newest wow-factor art projects and digital creatives into the machine of lifestyle branding were started by The Creators Project (a joint initiative by Vice and Intel) and the lesser-known *DIS magazine*. The two websites offer artists an outreach to online publics and tweens outside their most immediate communities. *DIS mag, how I love and loathe thee. You are the seamless integration of fashion and criticism with*

net art in the form of a lifestyle website that offers hip fashion guides, mixtapes, and artist-commissioned photo series. I wish I started you, DIS magazine.

Artist-as-brand and artist-as-user. I am a cannibalistic voyeur; I produce as fast as I consume. Deskilling is a stylized practice. Amateurism is no longer degenerate; amateur-looking art is 'culturally aware', or vernacular. Information and stylized experience has become the primary commodity; reskilling is necessary in order to fit freelance work. The conflation of work and play time, through the predominant use of networked devices, goes hand-in-hand with Steven Shaviro's ideas of intrinsic exploitation:

> … everything in life must now be seen as a kind of labour: we are still working, even when we consume, and even when we are asleep. Affects … forms of know-how and of explicit knowledge, expressions of desire: all these are appropriated and turned into sources of surplus value. We have moved from a situation of extrinsic exploitation, in which capital subordinated labour and subjectivity to its purposes, to … intrinsic exploitation, in which capital directly incorporates labour and subjectivity *within* its own processes.[28]

Digital labour exists in part due to the commodification of non-work tasks in the logic of experienced-based social networking. Write, curate, blog, chat, comment. With every interaction, your playtime is the corporate network's goldmine.[29] Under post-internet conditions artists must capitalize on boredom, busyness, and procrastination, while working for free and undertaking relevant internships and community-building endeavours. For example, you are relevant if you speak the language of academic currency that fuels term wars over net art, net.art, post-internet, New Aesthetic, 'expanded practices', and all the rest. Ultimately, these terms all have overlapping goals: the artistic use of the internet as a mass medium and the translation of its content into physical space.

New media artists play a multitude of roles in the cultural sphere: administrators, organizers, web developers, technicians, teachers, gallerists, and baristas. The most invisible and mundane one is that of the user and prosumer.[30] Historically implicated as a stupid, function-oriented consumer, Olia Lialina describes the contemporary user as a universal agent who adapts existing technologies to fulfill specific, individualized needs. Digital labour insists that users are forever functioning nodes, not human. You exist to add to the stream, regardless of information value.

7. There was never a post-internet movement

Fearing ghettoization, many emerging artists denied the 'label' in favour of adhering to the category of the 'Contemporary'. *Post-internet is everyone else but me; I'm a special snowflake!* The most aggressive critics of post-internet art were artists who already operated from within and between specific platform-based online communities. Post-internet is consequently more of a lens and a bad-ass attitude that became a bastardized aesthetic. In a critique of 'How Post-Internet Got Lost', writer and curator Ben Vickers cited the term's premature canonization due to its popularity with art students and their valorization of micro-blogging platforms.[31] Their emulation of post-net tropes would produce a homogenous, abundant output of market-ready net art.

With no unique goals and unified politics the term was co-opted by writers, curators, and gallerists as shorthand for contemporary art inspired by the internet. Much of what winds up in galleries bears little reference to the web as an environment, but more often resembles contemporary-looking art objects that cleverly recycle existing tropes in art history. Artie Vierkant's *Image Objects* look like Cory Archangel's Photoshop gradient prints, which look like Rafael Rozendaal's colour field websites, which look like Piet Mondrian's paintings. *Greek New Media Shit* and false documentation of art objects invoke satire about satire *ad infinitum*, producing an infinite parade of clever and conceptual art jokes.[32] Internet art has reached peak irony, a navel-gazing void of peer-responsive artistic in-jokes and hopeless stabs at earnestness. It's the newish term artists love to hate—something embarrassing and technologically dandy about internet art in the late noughties. Jaakko Pallasvuo demonstrates these ambivalent artistic tendencies in *How To/Internet*, the third in a series of instructional videos that employ a slideshow aesthetic to critique the social hierarchies that exist in online and contemporary art worlds:

> HOW TO STAND OUT IN AN ENDLESS STREAM OF INFORMATION? ... BINGE ON 90S POP CULTURE AND HTML5. PURGE COMPLEXITY, EMBARRASSMENT AND SADNESS ... FIND YOUR POSITION BETWEEN LIGHT NIHILISM AND TECHNO-OPTIMISM ALLUDE TO CRITICAL THEORIES BUT DON'T COMMIT TO THEM. DON'T ENGAGE POLITICALLY. APPROACH POST EVERYTHING.[33]

8. Life away From keyboard

'I'm a user, I'll improvise.'
 —Sam Flynn, *TRON: Legacy* (2010)

Just like white male *flâneurs* who were captivated by the sights and sounds
of urbanized cities and the now-banal train ride, my experience within this
world has been irreversibly changed by the transience of late-night Google
searches, the affect and wonder of watching porn before I was ever of age to
have sex, appreciating the best remixes of Taylor Swift songs, having self-
educating chats with older artists, and partaking in comment threads that go
nowhere. Post-internet engulfs and transforms all kinds of wicked trends from
high art to niche cultures. I am a computerized subject, a generic user with
specific desires, trendsurfing and making vague associations to everything
I find and know of. If 'the internet is people', as Ben Werdmuller says, I've
become hopelessly addicted and exhausted with my need for validation from
people I haven't met. Each like and retweet prompts a slight rise in dopamine,
but soon online validation is not enough.[34] Klout scores and Google Analytics
have no bearing over how well art sells. Old-guard gatekeeping hasn't
changed. Net-famous artists still wonder why they did not make that pavilion,
that festival, that art fair.

9. Surviving post-internet

Given the conditions of accelerationist, networked capitalism, it's hard to be
optimistic about making art online without feeling like a complete drone. The
best thing to do is to demystify these insidious systems of distribution. No one
wants to be a 'noughties burnout'. How to sell, or how-to-not-get-fucked-over-
by-the-cultural-industry and the realities of artistic coolhunting has never
been taught in art schools. As long as artists are in the race to adapt to the
cult of the contemporary, we remain at the mercy of collectors, museums,
arts press, and the academy. Post-internet artists would benefit from shifting
their practices beyond the communities surrounding social platforms to focus
more on creating communities in physical proximity. If one of post-internet's
main principles is invoking the influence of the internet on the physical world
and its social relations, what we need is more of everything IRL than what has
been happening in galleries and museums. We could also be learning from

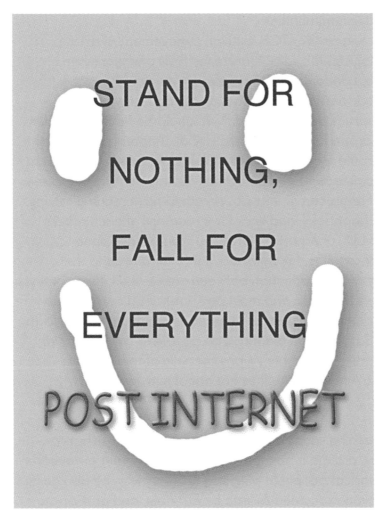

Jaakko Pallasvuo, <u>LOL (dawsonscreek.info)</u>, 2011.

other web-based creative communities.

We could look towards GL/.TCH festival, a movement of artists, educators and technologists who self-organize festivals and workshops on glitch art in Chicago, London, and Amsterdam.[35] We could curate gif projections alongside bar parties and performances as Toronto-based *SHEROES* fanatic gif parties demonstrated.[36] We could be having more fun with making fun of art around each other, like global chapters of Art Hack Day and Dorkbot. We could teach people to make remix videos, as Elisa Kreisinger (popculturepirate.com) and Jonathan Macintosh (rebelliouspixels. com) from the political remix community do. We could have reading groups and potlucks, publish chapbooks, and enact live readings of each other's works as web-based, alt lit (alternative literature) groups have done.

As a lens, post-internet is not unflawed in its claims around the fluidities and variability of art production between online and offline contexts. The art world is a white frat house, and most post-internet discussion has been between the academically clustered internet art communities in North America and Western Europe. With emphasis on post-isms come ideas of post-race and post-gender—equitable visions that use of the internet hasn't achieved just yet. A new profile does not equal new followers, Ben Werdmuller warns:

> ... you cannot install a social networking tool and assume that a network will grow around it. You must either have another purpose, or an existing network of people to plug into it. Either way, it's also going to take a lot of work: you need to lead by example, and participate heavily every day.[37]

While early new media art communities were built on ethics of openness and collaboration, surf clubs and platform-based practices prosper on the nepotism and influence of online and regional friendships. In 2014, the internet is not so democratic and neither is the art world. Privileges of access to the art world come through unlikely cross-platform friendships with critics, academic blogger meritocracy, and follower-populism. Artists with higher follower counts become aesthetic opinion leaders, soft-capitalizing on the attention of the right gallerists, art lovers, art students, and New Yorkers. To base your art practice around any one platform is to submit yourself to the social hierarchies created by impressions of influence and popularity with the communities you build and engage with.

Contemporary artists, curators, and critics today have a simultaneity of interest towards the internet's influence on art production, and this is evident in the multitude of vocabularies that have formed around net art. As Gene McHugh observed, 'What Seth Price calls "Dispersions", Oliver Laric calls "Versions".'[38] What Hito Steyerl calls 'circulationism', which occurs as a contingency of decontextualized image ecology, Steven Shaviro calls 'accelerationism', which prompts ahistorical and post-critical viewership.[39] Everything becomes about creating hype and momentum, divergent nomenclature to describe the same condition, and creating recontextualized intensities of meaning where there is none within the attention-competitive nature of hyper-mediation.

Politics is the pursuit of power, and within post-internet art this is no less evident in the migration of web-based practices to the ranks of the gallery and museum. I'm not calling net artists on selling out—after all, you could only sell out if you sell every single one of your works. Since you are not dead, your work is already 'Contemporary'. So do something meaningful with your newfound art power. Stand for something.

1 McHugh's blog was a generic WordPress website located at http://122909a.com/ but it is no longer active. A book that compiles all the blogposts he wrote has been published under the title, *Post Internet* (Brescia: Link Editions, 2011).

2 'Post-media aesthetics needs categories that can describe how a cultural object organizes data and structures user's experience of this data…Post-media aesthetics *should adopt the new concepts, metaphors and operations of a computer and network era*, such as information, data, interface…rip, compress…We can use these concepts both when talking about our own post-digital, post-net culture, and…culture of the past.' Lev Manovich, 'Post Media Aesthetics', *Art Margins*, 17:12, 25 October 2001, http://www.artmargins.com/index.php/archive/412-lev-manovich-analyzes-the-post-media-age. Ibid.

3 Marisa Olson, 'Postinternet', *Foam Magazine*, Issue 29, November 2012, 59–63.

4 To name a few artists, writers and curators: Gene McHugh (US), Katja Novitska (NR), Kari Altmann (US), Louis Doulas (US), Brad Troemel(US), Artie Vierkant (US), Harm Van Den Dorpel (DE).

5 Domenico Quaranta, '13. Lost in translation. Or, Bringing Net Art to Another Place? Pardon, Context', *Vague Terrain* 11, Fall 2008. 9 September 2013, http://vagueterrain.net/journal11/domenico-quaranta/01.

6 Gene McHugh, *Post Internet* (Brescia: Link Editions, 2011) 16.

7 'Artists like Oliver Laric…present multiple variations of the same object…*Versions* exists as a series of sculptures, airbrushed images of missiles, a talk, a PDF, a song, a novel, a recipe, a play, a dance routine, a feature film and merchandise…Even if an image or object is able to be traced back to a source, the substance (…its materiality and its importance) of the source object can no longer be regarded as inherently greater than any of its copies.' Domenico Quaranta, 'The Real Thing/Interview with Oliver Laric', *ArtPulse*, http://artpulsemagazine.com/the-real-thing-interview-with-oliver-laric. Artie Vierkant, *The Image Object Post-Internet*, 2010, http://jstchillin.org/artie/pdf/The_Image_Object_post-internet_us.pdf.

8 Martin Heidegger, *The Question Concerning Technology and Other Essays*, (New York: Harper & Row, 1977) 3–35.

9 'Post-Net Aesthetics', Institute of Contemporary Arts, London, 17 October 2013, http://new.livestream.com/accounts/5745227/events/2464307.

10 Katja Novitskova, *Post Internet Survival Guide*, (Amsterdam: Resolver Publishing, 2010).

11 Tapas Easwar, 'Culture of Indiscriminate Over-sharing', *Medium*, 25 July 2013, https://medium.com/i-m-h-o/ba2d21c0145c.

12 Curt Cloninger, 'Commodify Your Consumption: Tactical Surfing/Wakes of Resistance', 3rd Inclusive-net meeting: NET.ART (SECOND EPOCH)—The Evolution of Artistic Creation in the Net-system, 3 March 2009, Buenos Aires, http://medialab-prado.es/mmedia/2195.

13 Oliver Laric, *Versions*, 2012, http://oliverlaric.com/versions2012.htm.

14 Eryk Salvaggio, 'Duchamps Ideal Children's Children: Net.Art's Brat Pack', *Turbulence*, April 2003, http://turbulence.org/curators/salvaggio/.

15 Pool, http://pooool.info/info/.

16 *Bring Your Own Beamer* (http://www.byobworldwide.com) is a series of global multi-projector installation exhibitions with web-based works, was initiated by Rafael Rozendaal in 2010. *Speed Show* (http://speedshow.net/), an exhibition of web pages on multiple computers that often happened at internet cafes was initiated by Aram Bartholl in 2010.

17 'One of the key contributions NMA [new media art] can make to art…is in drawing attention to and contesting the status quo…with challenging the museum and gallery… as the privileged site of exhibition and reception. If NMA lies down and accepts assimilation on the terms of MCA [mainstream contemporary art], then much of its critical value will have been usurped.' Edward Shanken, 'Is New Media Accepted in The Art World?', *Art Fag City*, 6 September 2011, http://www.artfagcity.com/2011/09/06/edward-a-shanken-on-is-new-media-accepted-in-the-art-world.

18 Kevin Holmes, '[#DIGART] Is Digital Art The New Pop Art?: Q&A With Michael Ruiz Of The Future Gallery', *Creators Project*, 9 May 2012, http://thecreatorsproject.vice.com/blog/digart-is-digital-art-the-new-pop-art-qa-with-michael-ruiz-of-the-future-gallery.

19 Ben Davis considers new media art an erroneous term to apply to artwork that involves the specific use of social media and online platforms. Ben Davis, '"Social Media Art" in the Expanded Field', *Artnet*, 4 August 2010, http://www.artnet.com/magazineus/reviews/davis/art-and-social-media8-4-10.asp.

20 Damian Peralta, 'Interview With Olia Lialina: Net art is not dead', March 2009, http://www.damianperalta.net/es/teoria/12-interview-with-olia-lialina-net-art-is-not-dead.

21 'Scholars forbid or aggressively dissuade their pupils from writing about hitherto unknown (i.e. pre-canonized) artists, which halts progress, stunts egos, and flagellates the notion of original research, even as it traditionally purports to call for it.' Olson, 62.

 '...[theorists of media art culture] tend to rely on particular theoretical canons and the defaults of institutional hierarchies to validate their concepts. Also, most of the work they include in their research is either shown in established institutions and conferences...It only serves to...enforces a hierarchy that will reinforce the same myopic syndromes of mainstream art culture.' Marc Garrett, 'Furtherfield and Contemporary Art Culture – Where We Are Now', *Furtherfield*, 25 November 2013, http://furtherfield.org/features/articles/furtherfield-and-contemporary-art-culture-where-we-are-now.

22 '...early Net art history anticipated the socially interconnected "second lives" of the new generation of Net artists for whom the digital is but an extension of their body's functionality as it navigates the network culture.' Mark Amerika, 'Net Art 2.0', *Remix The Book*, 2011, http://www.remixthebook.com/the-course/net-art-2-0.

23 Olia Lialina, 'A Vernacular Web 3', *Contemporary Home Computing*, July 2010, http://contemporary-home-computing.org/prof-dr-style.

24 Megan Snead, 'When Work is A Nonstop Vacation', *BBC*, 29 August 2013, http://www.bbc.com/capital/story/20130829-when-work-is-a-nonstop-vacation.

25 Brad Troemel, 'Athletic Aesthetics', *The New Inquiry*, 10 May 2013, http://thenewinquiry.com/essays/athletic-aesthetics.

26 Phillips, 'Paddles On!', 10 October 2013, http://www.phillips.com/lots/PD010213.

27 Ellen Cushing, 'The Bacon-Wrapped Economy', *East Bay Express*, 20 March 2013, http://www.eastbayexpress.com/oakland/the-bacon-wrapped-economy/Content?oid=3494301&showFullText=true.

28 Steven Shaviro, 'Accelerationist Aesthetics: Necessary Inefficiency in Times of Real Subsumption', *e-flux journal #46*, June 2013, http://www.e-flux.com/journal/accelerationist-aesthetics-necessary-inefficiency-in-times-of-real-subsumption.

29 Alice E. Marwick, 'How Your Data Are Being Deeply Mined', *The NY Review of Books*, 9 January 2014, http://www.nybooks.com/articles/archives/2014/jan/09/how-your-data-are-being-deeply-mined.

30 Olia Lialina, 'Turing Complete User', *Contemporary Home Computing*, October 2012, http://contemporary-home-computing.org/turing-complete-user/.

31 Ben Vickers, 'Some Brief Notes on: How Post-Internet Got Lost', 21 October 2013, http://pastebin.com/bm1EKB9H.

32 Sterling Crispin, *Greek New Media Shit*, 2011, http://greeknewmediashit.com.

33 Jaakko Pallasvuo, *How To/Internet*, 2011, https://vimeo.com/32839686.

34 Morgan Peck, 'Facebook Loves It When You Talk About Yourself—and so Does Your Brain', *IEEE Spectrum*, 10 May 2012, http://spectrum.ieee.org/tech-talk/biomedical/diagnostics/facebook-loves-it-when-you-talk-about-yourself-and-so-does-your-brain.

35 GLI.TC/H, 2010-present, http://gli.tc.

36 Curated by Rea McNamara, *SHEROES* (http://fuckyeahsheroes.tumblr.com/) was a series of female pop-icon-inspired events with artist-made gifs and homage performances that happened monthly at bars in Toronto.

37 Ben Werdmuller, 'The Internet Is People', 4 December 2008, http://benwerd.com/2008/12/04/the-internet-is-people.

38 McHugh, 6.

39 Hito Steyerl, 'Too Much World: Is the Internet Dead?', *e-flux journal #49*, November 2013, http://www.e-flux.com/journal/too-much-world-is-the-internet-dead.

39 Shaviro, 2013.

Dataforming the Hinternet

Sophia Al-Maria

All nature has been reduced to symbols.

A flower turned to an ascii
configuration of colons and commas.

A pine tree = holiday 'emoji'.

Even grief is little more than a yellow
circle weeping.

Which would be an appropriate response to the current extinction crisis.

Polar Bear is one of the more charismatic casualties of this reduction both of symbols and reality occurring on earth. She suffers in the service of our sweeping vistas of servers. In her hopeless search she'll weave along newly tarred tundra roads, hungry. And when she collapses from starvation, it'll be due to our appetite for forever more.

But I'm not mourning the inevitable end of 'nature' as we know it.

Because internet.

Yes. Internet = 'primordial soup'

3.5 Ga years ago there was a gradual chemical transformation of earth. Today in a brief geological instant, we have nearly completed a techno-transformation of earth.

We and our machines working like Cyanobacteria belching oxygen into the atmosphere. Yes, you and me — we're mulching up trails of data to make this place habitable. In short, we are terraforming the WWW for *that which is coming*.

Bottom-feeders turning death into life, data into consciousness.

All in the service of *something*.

Something that won't require the hothouse specifications we do. When environmental collapse occurs, *it* will have no need for air or water or shelter from the radiated storms.

But what is *it*?

That we can't know anymore than an ambulatory fish could imagine riding a Segway.

OurSpace:
Take the Net
in Your Hands

Stephanie Bailey

'What else can be the result of this but that our paths toward the future—all our paths, political as well as cultural—are not yet charted? That they are yet to be discovered, and that the responsibility for this discovery belongs to no one but us?'
—Aimé Césaire[1]

It is easy to forget that the internet is a physical thing; that satellites and fibre optic networks are but some of the necessary technologies facilitating the transmission of data between people and places. The online world is as real as the pipelines and electricity pylons that provide us with the energy upon which we have become dependent. The data centre's analogue equivalent could well be the power station. The internet is a vast network that connects localities within a global framework, textured by the surface layer of the World Wide Web and its web pages and browsers. It is a 'space' mapped out over material space—as Hito Steyerl once pointed out, it is a '... realm of complexity gone haywire.'[2]

Our spatial imagination of the internet has arguably shifted since protests erupted in late-2010 and early-2011 across the world, from the Middle East and North Africa to the Mediterranean and Europe. This was a transitional moment: when the 'public square'—a community focal point—went virtual, viral, and global. Take Bahrain, for instance, where the Pearl Roundabout became the site of protests against monarchic rule, which were violently supressed by the state (with the help of Gulf Cooperation Council troops sent in for support). Following the protests, the monument after which the roundabout was named (six large, concrete sails supporting a giant cement pearl) was demolished. It was survived by an online image that was multiplied, modified, and appropriated. As Amal Khalaf wrote on the subject, the physical erasure of the Pearl Roundabout and its virtual reincarnation took the battle for public representation off the streets and into the web. The internet became a popular space: a virtual civic 'square'—or *midan*—transformed into a polyphonic and contentious political battleground.[3]

Post-2011, the nature of the internet as an open battlefield has extended beyond the regions where internet freedoms have been limited. The NSA scandal of 2013, when Edward Snowden blew the whistle on PRISM (essentially a global surveillance system operated by the U.S. National Security Agency since 2007), was a moment that, like 2011, brought to light—or simply confirmed—things we perhaps already knew about how

information is being shared, managed and contained online. Pervasive state and corporate control of online space in the western world, where the virtual realm had been lauded as an open and public sphere, became an established fact. This further altered the popular conception of the internet as both a site of agency and a neoliberal apparatus of security, or global panopticon. Popularly, the net became characterized as both a tool of mass surveillance *and* popular subversion.

Today, the internet is an openly contested territory; a terrain upon which conflicts between varying interests—local, national, international, even meta-national—play out. This has ramifications in the physical world, too. Bernard Stiegler addresses this in a succinct observation on the World Wide Web:

> The impact of the Web is not only sociological but economical, political, existential, psychological, epistemological: it is total. The Web radically modifies public and private spaces and times— and deeply alters public-private relationships. This technological framework became a new public space and a new public time—with the growing danger to be privatized.[4]

By nature, the internet—like real space—is not public at all. It is negotiated, managed, contested, and contracted. A place where divisive lines between public and private are mediated, challenged, and even dissolved. It is a space that fits Michael Hardt's interpretation of Jacques Rancière's definition of the common (*le commun*):

> The common, of course, is not the realm of sameness or indifference. It is the scene of encounter of social and political differences, at times characterized by agreement and at others antagonism, at times composing political bodies and at others decomposing them.[5]

In short, the internet is a space of consensus *and* dissensus, convergence *and* divergence. It exists as a result of negotiations between various bodies of power, including the powerless. Of course, we know this. But if we lose sight of the internet's innately political character, we lose exactly what is at stake: a perception of the internet as a territory that is as 'live' and volatile as the fertile fields over which battles have been waged and social contracts drawn. It is a commons. An environment. As real and as populated as the 'real world'.

What does this mean? As artist Jonathan Harris notes:

> I believe that the internet is becoming a planetary meta-organism, but that it is up to us to guide its evolution, and to shape it into a space we actually want to inhabit—one that can understand and honour both the individual human and the human collective, just like real life does.[6]

It is this human element that makes the internet a meta-organism. Since the internet is a human construct, it is organic and, most importantly, malleable. Take Harris's www.WeFeelFine.org, an applet created with Sep Kamvar that operates as a data collection engine. Since 2006, it has been automatically scouring the web every ten minutes to harvest human feelings expressed in blogs, and organizes these snippets of text through various interfaces into a series of coloured dots and squares that swarm on a black screen (the dots reveal text while squares show images paired with text). Each dot represents a single human utterance: a declaration of affect.[7] The accumulation of these statements recall Marshall McLuhan's conclusion that 'all media are extensions of some human faculty—be it psychic or physical.'[8] As Harris has noted, www.WeFeelFine.org is an art project 'about people'[9]—created by and for them. This is not only because the coding to create the applet is available on the website under the Creative Commons, but because the work serves as a mirror to a richly affective, organic, virtual world populated by sensing bodies reaching out for one another. It is an affirmation of Harris's view that the individuals who populate the internet—the 'users'—are the ones who can change and direct its function. As McLuhan once pointed out: 'electronic informational media involves all of us, all at once.'[10] This is *our* space, after all.

But change—especially the collective kind—is as difficult to achieve online as it is offline; a result, perhaps, of the tensions between individual desires and the needs of the collective. Yet, as McLuhan said, 'Any understanding of social and cultural change is impossible without the knowledge of the way media work as environments.'[11] As an environment, the web is a double-sided screen through which individuals, communities, and societies are expressed, represented, viewed, collated, and even conditioned. Take Twitter, Tumblr, Facebook, Skype, OkCupid—all these web applications we use to 'be social' (and some of which were hailed as the engines of revolution in 2010 and 2011 by media outlets in the western world)—are privately owned and run. By signing in, we sign away the rights to our private information. In the age of 'Big Data'—collections of information

so vast that traditional forms of data processing are unable to handle the massive dataflow—we are experiencing a reduction of our own agency. This is because, upon entering the online realm, we become consumers of a predetermined online space: data subjects reduced to systems of categorization. Participants in a Leviathan—or a social contract—that we actually know very little about.

This recalls Stiegler's view that the web has become a transindividuation space—'the articulation between psychic individuation and collective individuation, and the site of fights to control the latter.'[12] It is what he calls the last stage of a process that started with the 'upper Paleolithic'—the historical point from which modernity emerged and which ushered in what Stiegler refers to as a 'grammatization process' that allows for the 'discretization' (the mathematical process in which multiple variables or categories are fused) 'of behaviours, gestures, talks, flows, and moves of any kind and which consists in a spatialization of time.'[13] In the smooth space of the internet, this so-called grammatization is in effect a modification or reduction of human characteristics precisely so that they might fit into the digitized, online system. The question here is how this systemization might shape the way we commune, connect, and come together as individuals.

So where does creative practice come in? It is Stiegler's conviction that we are currently living a moment of 'significant organological change' in which the 'knowledge instruments' shaping epistemic environments are evolving. The internet is one such epistemic environment, populated by users who inhabit and affect the online space and its knowledge instruments that in turn shape—in part—the world itself and our experience of it. And how are we using this space today? Pablo Larios has said of young artists embracing the online strategies of the mega-corporation, that, 'Instead of choosing sides, these artists seem to embrace the catch-22 of living and working in a society whose contradictions are self-generating.'[14] In this complex virtual reality, have we become corporatized so as to fit the demands of the emerging global paradigm of the neoliberal economy and its evolving systems of labour and production? And, within this, have we come to accept a condition of the online space as described by Steyerl: 'A condition partly created by humans but also only partly controlled by them...'? Do we abide rather than resist, as if technologically bound to laws far greater than ourselves? Maybe this is the problem.

In thinking about our collective agency in the online world (and thus, also in the offline world), let us turn to Daniel Ross's writing on Stiegler's view of the political question as an aesthetic one:

> ... the question of living together, of becoming together, of living in common with the other through a process of common becoming, is something which can only occur through an understanding of, and a feeling for, one another, and which can therefore only occur via a medium which makes this possible, that is, an aesthetic medium.[15]

Ross notes that, for Stiegler, the term 'aesthetics ... is to be taken in the widest sense, that is, as sensation in general, not only "perceptibility" but taste, feeling, sensibility.'[16] In terms of how we might use the internet creatively and in all its multi-faceted modes, perhaps it would serve us well to consider the online space as mediatory one. As Steyerl has noted: 'networked space is itself a medium'—'a form of life (and death)'.[17] Thus, if we were to also perceive the internet as an aesthetic and therefore sensual space that has the potential to produce real and meaningful interactions and relations, we might then push the idea of the internet as a (social) medium further. We could continue to explore its potential as a space within which forms of relational practice might develop across the virtual and the real, so that innovative and *tangible* social networks might evolve IRL.

Maybe it is time we move beyond discussions around the production of public space, both online and off, given just how private and corporatized both the virtual and physical realms have become. This does not mean we are to give up on the view of the internet as a collective medium. Nor are we to discount the internet as a potent site of knowledge production and information exchange that could potentially serve both collective and individual needs. We might instead turn our thoughts to the long-cherished view that, as Steyerl writes, 'computation and connectivity' could produce 'building blocks for alternate networks,'[18] while considering McLuhan's assertion that 'We can no longer build serially, block-by-block, step-by-step, because instant communication insures that all factors of the environment and of experience coexist in a state of active interplay.'[19]

For some, the politicization of the internet will hardly be a novel concern. Still, this is one conversation that demands further debate so that all the internet's users might perceive and utilize the web as a site of public, social, and civic potentiality. The stakes have never been higher. Only in recent years has the public and governmental battle for the internet gone mainstream, from China to the Middle East, in that it has only just entered into the popular consciousness. Saying that, the worldwide expansion and availability of the internet's networks is not even complete. Thus, as the internet continues to evolve, it might be worth admitting that its so-called 'age' is not yet 'post-' because it has only just begun. Its future therefore remains, to some extent at least, in our hands.

1 Aimé Césaire, 'Letter to Maurice Thorez', Paris, 24 October 1956, tr. Chike Jeffers, published on *Hydrarchy*, 24 May 2010, http://www.hydrarchy.blogspot.co.uk/2010/05/letter-to-maurice-thorez.html.

2 Hito Steyerl, 'Too Much World: Is the Interent Dead?', *e-flux journal #49*, November 2013, http://www.e-flux.com/journal/too-much-world-is-the-internet-dead.

3 Amal Khalaf, 'The Many After Lives of Lulu: The Story of the Pearl Roundabout', *Ibraaz*, Platform 004, 28 February 2013, http://www.ibraaz.org/essays/56.

4 Interview with Bernard Stiegler for the World Wide Web Conference, Lyon, 16–20 April 2012, http://www2012.wwwconference.org/hidden/interview-of-bernard-stiegler.

5 Michael Hardt, 'On Production and Distribution of the Common: A Few Questions of the Artist', courtesy of Foundation Art and Public Space, http://classic.skor.nl/article-4111-en.html.

6 Jonathan Harris, statement on artist's website, http://www.number27.org.

7 With thanks to Lloyd Wise for his invaluable editorial input into this text and particularly this paragraph.

8 Marshall McLuhan and Quentin Fiore, *The Medium is the Massage*, (London: Penguin, 2008) 26.

9 Jonathan Harris and Sep Kamvar, *We Feel Fine FAQ*, http://www.wefeelfine.org/faq.html.

10 McLuhan, 53.

11 McLuhan, 26.

12 Interview with Bernard Stiegler for the World Wide Web Conference, Lyon, 16–20 April 2012, http://www2012.wwwconference.org/hidden/interview-of-bernard-stiegler.

13 Ibid.

14 Paul Teasdale, 'Net Gains', *frieze*, Issue 153, March 2013, https://www.frieze.com/issue/article/net-gains.

15 Daniel Ross, 'Politics and Aesthetics, or, Transformations of Aristotle in Bernard Stiegler', *Transformations Journal*, Issue 17, 2009, http://www.transformationsjournal.org/journal/issue_17/article_04.shtml.

16 Ibid.

17 Steyerl, op. cit.

18 Steyerl, op. cit.

19 McLuhan, 63.

Post-Whatever #usermilitia

Jesse Darling

Jesse Darling
27 March near London

I'll tell you this much: the net art Duchamp won't be a WASPy bourgeois merrily and post-ironically replicating corporate aesthetics and waxing nostalgic about the consuming and computing of their suburban 90s childhood

Like · Comment · Promote · Share 👍 54 💬 28 📑 2

I'll start by making two claims, which I won't return to since they speak for themselves and because they are—as far as I'm concerned—incontrovertible. With the first, I'm paraphrasing Nicholas Mirzoeff in saying that 'post-' should not be understood as 'the successor to' but as 'the crisis of'. Having established this, let's get one thing straight: *every artist working today is a post-internet artist*. Let's move on.

The self exists nowhere *per se*, but is located in time and space. This shouldn't be news to anyone, yet somehow any modal shift in the fabric of social timespace seems to produce a set of cultural crises that keep a roaring trade raging over on the commentary circuit. It's as good a way to make a living as any other. Every commentator wants to distinguish [him]self from the user who clicks and swarms and emotes all over every platform, zombie-like and addicted, generating the demographic data that provides PhD students in Media Studies and Digital Anthropology with their raw material. This also serves, for some, as proof of the increasing fragmentation, narcissism, and alienation of contemporary sociality.

These distinctions may also be seen as ways to demarcate class signification in an economy of symbiotic flows in which labour has itself become both commodity and production process. Scott Lash observes: 'In the modern and industrial order the instrument (industrial capital) becomes the end ... That is, ideology—as a superstructure—functioned as a means to the end of the accumulation of industrial capital. But now, as Eco observes, information itself "becomes the merchandise."'[1]

Nobody wants to be seen as the serf of the field who wastes [her] plebeian life away in the data mines of Zuck's blue book; just as nobody wants to be seen taking selfies in public, or living the unexamined life of the content producer whose sole agenda is to validate an otherwise pointless existence in a stream of Instagrammed meals-for-one and YouTube

vlogs about makeup, or pop stars, or serialized teen fiction, or any other inconsequential piece of consumer noumena. In the competitive frontier of hyper-real estate, artists, theorists and [other] communications colonists hustle to stake out territories of ownership and authority over these practices of data-production: the artist vassal who reaps the fruit of user-serf's affective labour typically has a Facebook profile so impeccable and impersonal as to look like LinkedIn.

As to the fragmentation, narcissism, and alienation of all our lives under social media and mobile internet, it seems unlikely that the contemporary condition should be qualitatively different from other technological and teleological shifts in human history. Current anxiety that the internet may be making us stupid (or lonely, or sexually aberrant, or socially dysfunctional) echo Plato's worry that the widespread practice of writing would destroy oral literacy and the ability to create new memories.

As a rule, I'm a user and not a commentator; the character limits and text boxes are occasionally comforting in homeless, precarious times, and besides: if there's something to discover in the conglomerate datamines of social media and outlying territories, I prefer to learn by doing as a point of principle and necessity. Despite all millennial hubris around the seismic, revolutionary, never-before-seen newness of the new timespace, I also doubt that human nature—whatever that is—really ever changes much at all. Furthermore, I'm not even sure that this new timespace is anything of the kind.

The self is located in time and space, and in this sense the timespace of the internet poses a few temporal-spatial conundrums. What Marc Augé calls a 'non-place'[2] is what Rem Koolhaas calls 'junkspace'.[3] Both terms summon Paul Virilio's writing on interstitial space, or *through-spaces*: airports, hotel lobbies, shopping malls—places one travels, rather than inhabits. Travelling is subject to any number of contingencies and may operate over various timezones and at various speeds. The timespace as heterogeneous singularity is not unprecedented in human history: the dreamtime of the Australian Aboriginals, in which past, present, and future were held in symbiotic tension, was known as the 'all-at-once-time', as opposed to the one-thing-after-the-other-time that we all became accustomed to in occidental modernity. The first synchronous electric clocks—the ones we now see on many great modern towers—were introduced only in the 1920s. A synchronous electric clock has no inherent timekeeping properties, but runs at the frequency of the electric power source, which—when coupled to an electric motor with the correct gearing—drives the clock hands at the correct

time. Even time, as we know it, is virtual: a technological construct.

Facebook, writes Binoy Kampmark,[4] is much like Jeremy Bentham's panopticon—an 'all-seeing' surveillance device conceived in the late-eighteenth century and pioneered throughout the world in the nineteenth century for penal reform. Quoting Foucault, Kampmark observes that, in Bentham's design, the inmate '"is seen, but he does not see; he is the object of information, never a subject in communication."'[5] When 'user' becomes 'artist', it isn't only about redeeming the time and energy spent producing content for the conglomerates, but also the will to subvert this objectification. Weird Twitter and Facebook Glitch are prototypes for an unorthodox occupation of these platforms, and like the secret linguistic codes of Polari and Verlan (evolved to preserve an authentic subjectivity under conditions of hegemonic control), the beautiful evolving phonetics of netspeak are as yet unintelligible to databots plowing through everybody's feed. ISE[6] has no external standard, but is constituted of a stream of word-memes worn in by [written] use and catalogued assiduously in the inaccurately but appropriately named 'urban dictionary', since the internet is properly cosmopolitan in the way of all busy thoroughfares. To take this work out of the browser and into the gallery is not an act of recuperation, but an act of deterritorialization—a violent reification: it forces a commodity value upon a product with a use value confined to a particular context.

As with any colloquial dialect (for net art is, like all art movements, a kind of visual language) the affect of URL-based art and image production is entirely contingent on the context and its specifics: the audience, the network, the platform, and its peculiarities. The gallery space has its own rarefied and incontrovertible lingua franca: a spatial-historical dialect that defines and shapes meaning, even as it attempts—always somewhat huffily and fustily—to evolve around the technological and cultural developments that accompany each new generation of artists. The gesture of deterritorialization has been examined in necessary recent postcolonial thinking, from which we learned that in order to preserve the affect or *aliveness* of works, objects or signifiers torn from their native environment and placed in a gallery, there must first be a full acknowledgement of the historicity and wholeness of the original context. Until the object economy of the current contemporary releases its supreme hold on the discourses of display, there will only be token gestures and representations-of, and most of these works will become emptied out and obsolete within a year or two, along with the technological narratives on which they are based.

Meanwhile, the true internet subjectivity lives out its rhizomatic manibodied philosophies in a mindless but sentient cloud elsewhere. But these are just teething problems in a toothy market—and teeth are a basic processing technology, imitated by the mechanical engineers of early industry and now obliquely referenced in the bits and bytes of unprocessed data. Voracious and machinistic, there's nothing the art world can't chew up; but the enduringly great 'post-internet art' won't emerge in earnest until we stop believing in the myth of its futurity.

1 Disclaimer: mashing your finger into this link won't do anything. [However] Mashing your finger into a touchscreen also regrettably not guaranteed to grant access to this text #hyperrealestate #deadhashtags, http://books.google.co.uk/books/about/Another_Modernity.html?id=JgeVrwwuFNAC&redir_esc=y. Scott Lash, Another Modernity (Wiley-Blackwell, 1999).

2 Marc Augé, Non-Places: An Introduction to Supermodernity (New York/London: Verso, 2009).

3 Rem Koolhaas, 'Junkspace (2001)', on cavvia.net, http://www.cavvia.net/junkspace/.

4 Binoy Kampark, 'Giving Good Face', Counterpunch, 7 August 2007, http://www.counterpunch.org/2007/08/07/giving-good-face/.

5 Ibid.

6 Internet Standard English (doesn't exist, but it does now).

Where to for Public Space?

Constant Dullaart

A sense of inferiority came over me when I came across them. 'Making Travel Safe Officers' they're called—security staff on Greater Anglia trains travelling in and out of London. I met them during my recent artist residency in the same city: smiling men and women in fluorescent yellow vests with cameras mounted right next to their eyes. Cameras similar to the 'dashcams' that car drivers regularly use in Russia or China to record their driving in case of insurance disputes. Talking to the MTSOs made me feel like I was conversing not only to a human, but also to a situation in the future, in which I was not trusted to behave appropriately. I was a performer against my will for an audience in a security office, where the situation would be evaluated from an MTSO perspective. The camera seemed to deliver an extra agency to the MTSO—an extra space of reasoning. Although I was not allowed to take an image of one of these officers on the train, there were posters of them on the platforms, presumably so that customers could get used to their appearance. This recalled the concept of an augmented environment that took away my choice to consciously select what information I could both document and give to an audience.

According to no-cctv.org.uk, Great Britain is the most surveilled country in the world. We know that this is only the beginning when it comes to the idea of being watched by a superior power, given recent revelations have proven that the internet is the largest surveillance apparatus ever conceived. Every email you send can be read in an office in the NSA data centre in Utah, or in one of the many private contractor offices spread out all over the world. In this essay, I will think about the use of surveillance as a suggestion of a certain kind of space: Jeremy Bentham's panopticon, an apparatus of security designed in the late-eighteenth century and used to observe and normalize prison inmates. I will consider new performative spaces and audiences within the contemporary context of security, as it transpires online.

My recent restoration of the 1988 image that became the first publicly manipulated image in Photoshop, *Jennifer in Paradise* (originally taken by John Knoll, co-creator of the software), was not intended purely for the redistribution of the image itself. Originally, the image was used to show potential customers and investors of Photoshop the possibilities of the software. The image I restored, also named *Jennifer in Paradise*, was redistributed online through articles, tweets, blogposts, and other social media networks by various sources. Importantly, this restored image included a secret message woven into the code of the image file through a steganographic encryption. Steganography uses a method to attach bits of

a file to the background noise of, for example, a jpeg file; it is often used by security experts to ensure private communication over the internet. To read out this non-visible information, a password is often required to decrypt the message from the image. The use of steganography adds a layer of meaning to the digital image as a medium. The hidden message, revealed only with the right encoding software and password, signifies a hierarchical layer of knowledge necessary to fully understand the image in its entirety—only a chosen audience can access all the information the image contains. This points to the claim of a private space within something that is publicly viewable, in this case the restored version of the very first Photoshopped image.

There are many more examples of these kinds of hidden spaces on the internet. The darknet or deep web, for example, are names for an encrypted network using Tor (The Onion Router) where hidden websites can be used anonymously. This network, which is 400 to 550 times larger than the commonly known web,[1] most recently gained attention when the FBI dismantled a hidden marketplace within it called Silk Road, a website used to sell and buy illegal substances and services internationally, from the hiring of hit men to the purchase of marijuana and heroin. But there are also other private websites, closed torrent trackers, and many more examples that exist.

These encoded spaces, accessible after initiation or with the right technical knowledge, seem like manhole covers opening up from the street to show entire new underground worlds—secret societies that share codes and handshakes. How important are these technical spaces for subcultures and why are there so many of them? Is there art in these spaces and, if there is, how can we evaluate this art on the same terms as we do publicly visible art forms? The insular nature of these spaces means that 'everyday' museum audiences will most likely not see the work. Still, there is a question here about the expectation of the so-called 'average museumgoer'. Could it be that the existence of these new closed spaces, functioning autonomously from hegemonic control and surveillance structures, are products of a different kind of desire—the desire for an alternative culture? Spaces not supported by large corporations and controlled by government subsidies?

The relationship between public and private space has radically changed in recent years. Shopping malls are the most significant example of artificial public space. Although commonly misunderstood to be public due to public accessibility, corporations with their own local rules and their own private security own most western shopping centres. Another example is Temple Square in the city centre of Salt Lake City in the United States, which belongs

to the corporation of the Mormon Church. The corporation has the right to remove any person from its premises without notice or reason. Outside of the central territory of the Mormon Church, the Salt Lake City Government (as the Salt Lake City Corporation) regulates the streets. This is similar to how the City of London functions, an area known as the 'Square Mile' that is controlled—and officially governed—by the City of London Corporation. This model of *faux* public space managed by a corporate local authority, its private security firms, and modes of property maintenance, can be found in most cities in the western world.

The 2011 Occupy protests against social and economic inequality in New York City were able to manifest through the use of such a private or corporate space as those shopping malls described above: Zuccotti Park. The main site where protesters camped and collected, Zuccotti Park is privately owned by a corporation of property owners. This is a significant point: the park's private nature means it adopts different rules from New York's public parks. Specifically, it can remain open 24 hours a day while others cannot, which is what enabled it to be occupied.

In thinking about the problem of public space, let me add to the private/public confusion. When private companies decide to float their company on the stock exchange, this is called 'going public', in that anybody can potentially become a part-shareholder in the company. Yet, ironically, the company that has 'gone public' is in fact owned by private investors, and not by the state.

Similarly, the World Wide Web is, in essence, a collection of privately maintained environments linked together and acting as a public space. This is one of the reasons why there have been so many legislative issues controlling the internet and the flow of unwanted or profitable information through these private spaces. The libertarian views propagated in the United States influence the web today as much as they have from the beginning. Since much of the internet is now in control of corporations that maintain its infrastructure, one could thus question its public character. Some might even argue that the internet is a global communications network under American control—the core structure of it, after all, was conceived in the late-1960s as ARPAnet (Advanced Research Projects Agency Network) by the United States Department of Defense.

The conceptual framework of the World Wide Web was described decades earlier, after the surrender of the Germans in the Second World War. 'As We May Think' was a letter dated 1 July 1945 and written by Director

of the Office of Scientific Research and Development, Doctor Vannevar Bush. In the letter, it is clear that the US Army intended to focus on the access to, and distribution of, information. One month before the nuclear bombs were dropped on Hiroshima and Nagasaki, Bush writes: 'Wholly new forms of encyclopaedias will appear, readymade with a mesh of associative trails running through them, ready to be dropped into the memex and there amplified.'[2] Thus, the internet was never the *Neuland* (German for 'new land') as Angela Merkel, Prime Minister of Germany, so naively put it in a press conference in July 2013. She was responding to the NSA scandal brought to light by whistleblower Edward Snowden.[3]

Online, the top level domain '.gov' only points to the American government. Assigned by the Internet Corporation for Assigned Names and Numbers (ICANN), a private, American, non-profit corporation that coordinates the internet's unique identifiers (domain names), this reflects on the notion of the internet at a state level as ultimately a private space that operates with public functions. Take a privately owned server in a house: it can run a website and host files, but it can also be publicly accessible and therefore must uphold certain rules. Websites like Facebook or Google, for example, are also in the hands of a corporation, not the state, despite acting as 'public' spaces. All these *faux* public spaces, where nobody can vote on how things will develop are separated from what we might expect from a political democracy. More and more 'public experiences' are controlled, monitored, interpreted, and even take place within corporate backyards. This begs the question: where is real public space?

There has been an abundance of space analogies for information exchange since electronic communication came into existence. The word 'cyberspace' originates from the genre of Science Fiction (*Neuromancer* by William Gibson, for example). But this is also true of terms such as 'The World Wide Web', 'surfing', 'information super highway', and so forth. Foucault's idea of the heterotopic environment is useful here. Wikipedia describes heterotopias as:

> … spaces of otherness, which are neither here nor there, that are simultaneously physical and mental, such as the space of a phone call or the moment when you see yourself in the mirror.[4]

We seem to find ourselves within a collection of heterotopic spaces on the internet, which traditional power structures (governments) must consolidate in order to control.

Foucault's idea of ships as perfect heterotopian spaces recurs beautifully if you look at contemporary airports, where all the modern-day ships arrive, and where an artificial international culture is being upheld. Right within this transitory cultural void is where Edward Snowden found his temporary escape from geographic limitations, just like Julian Assange, the founder of whistleblowing website WikiLeaks, who is now stuck in a political heterotopian space that is the Embassy of Ecuador in London. In a foreign country other than his own, Assange has described the experience as 'like living on a space station.'[5] One can argue that Snowden and Assange, who both believed the internet to be a global space, must now hide out in the bubbles of diplomatic non-space.

The personal nature of contemporary technology interfaces—of generating trust and a sense of security and privacy—mask the fact that, behind the scenes, our communication is being interpreted non-stop. Computers do not run Google; Microsoft is not a large computer. Computers don't spy on people. People do. Facebook is not just an algorithm. It is the people who design and implement the algorithm, together with the unwitting users. These distinct spaces are at once 'controlled public spaces' and monitored private spaces—neither public nor private, neither here nor there: heterotopic. So how does the growth of online public spaces owned by corporations influence the practice of the contemporary artist? Critical interventions within such controlled *faux* public spaces suggest a quality of activism. But, nevertheless, some argue that the technical knowledge required to interact with encrypted spaces suggests a technical hierarchy and elitism.

Where the World Wide Web once seemed to be the place for people to browse from private website to private website, and meet like-minded people in heterotopian spaces, it now looks like a surveilled public square run by Amazon, Facebook, LinkedIn, Twitter, Google, or other geographically specific offshoots, such as Weibo and Baidu in China or VKontakte in Russia. Now that we are aware of the fact that all internet traffic is surveilled by governments and corporations, it seems only reasonable to assume that these 'public' spaces are not safe discursive and critical forums for culture to develop. So what kind of encrypted spaces could we produce that might respond to this?

My proposal is that artists (and their audiences) must find new spaces to develop their work by engaging with the possibilities offered by the freedoms of encryption. To achieve this, they must surpass the misconception of technical elitism and the idea that only those with 'secret knowledge' can have access to space without surveillance. We must realize that this knowledge is obtainable for all.

1 Andy Beckett, 'The darkside of the internet', 26 November 2009, The Guardian, http://www.theguardian.com/technology/2009/nov/26/dark-side-internet-side-internet-freenet.

2 Vannevar Bush, 'As We May Think', posted on The Atlantic with the original publish date, 1 July 1945, http://www.theatlantic.com/magazine/archive/1945/07/as-we-may-think/303881/.

3 Vera Kämper, 'Chancellor Discovers New Territory', Der Spiegel, 19 June 2013, http://www.spiegel.de/netzwelt/netzpolitik/kanzlerin-merkel-nennt-bei-obama-besuch-das-internet-neuland-a-906673.html.

4 Heterotopia (space), Wikipedia, en.wikipedia.org/wiki/Heterotopia(space).

5 Katy Lee, Agence France Presse, 'Wikileaks Founder: Being Stuck In An Embassy For Year Is "Like Living On A Space Station"', Business Insider, 16 June 2013, http://www.businessinsider.com/julian-assange-living-in-ecuadors-embassy-2013-6.

Protocological Hope

Başak Senova

Departing from Alexander Galloway's reading of the internet as a distributed network and/or management system based on protocols, one can argue that all actions that take place on social media occur within the apparatus of control.[1] In Turkey, for example, this apparatus is being censored. Since 2012, Turkey's Information Technologies and Communications Authority (BTK) have applied a centralized filtering system. Paradoxically, the internet (along with social media platforms) is the only space for alternative news and information from different voices. Nevertheless, despite censoring mechanisms, social media sites and applications have been the main communication tool for the resistance against the increasing authoritarianism in Turkey, as well as the only way to spread immediate information and news about ongoing political events. It is obvious that the internet has provided a platform for public organization, beyond the control of the government.

This is a tricky situation, as social media is the only impulsive channel in comparison to the muted mainstream media. The routine is the same: whenever there is a protest-related incident that is concealed or ignored by the government, the mainstream media chooses to censor the incident or any news related to it. However, social media immediately produces loaded and extensive information and access to these events and, therefore, the mainstream media is subsequently obliged to broadcast or write about such political events. Yet, they do so in another tone and obviously from another perspective, with almost always at least a 12-hour delay.

With the resistance that started on 28 May 2013 over the fight for Gezi Park in Istanbul, Turkey has been subject to an enormously schizophrenic and intense series of reactions, which include violence from the police, hopes for new dawns that are seemingly quashed, and internal clashes from those within the resistance. During this instability, the internet has ceased to be a safe ground for alternative voices to express their reactions towards the ongoing political climate. Binali Yıldırım, the Minister of Transportation, Maritime Affairs and Communications, made a point of stating publicly that Twitter refused the Turkish government's request for cooperation during the Gezi Park protests, whereas Facebook did provide data for the government in June 2013. Nevertheless, though on 26 June 2013, Facebook denied handing over user data to Turkish authorities during the country's ongoing anti-government protests, the main point is that the government is attempting to instill a culture of fear that will prevent users from engaging with these platforms. This includes often taking such users into

custody for interrogation.

Following the path of Galloway, we know that protocol can only be resisted from within. In this respect, tactical media and hacktivist groups could be seen as one of the most influential ways to twist the direction of control. Galloway considers them as examples of resistance that are 'able to exploit flaws in protocological and proprietary command and control.'[2] Redhack for instance, the well-known Turkish Marxist–Leninist computer hacker group, managed to capture data on corruption and spying from institutions that include the Council of Higher Education, the Turkish police forces, the Turkish army, Türk Telekom, Turkey's local and regional municipalities, and the National Intelligence Organization. Their findings are based on verifiable facts. Collectively, these agents bring the assets of 'reliability' and 'trust' back into the public consciousness.

As Özgür Uçkan, who is an educator working with knowledge economies, creative industries, communication and information design, and management, observes: 'publishing a leak for public good is totally legal even if this leak is captured illegally.'[3] My proposal, therefore, is that we must move beyond the protocol and its basic functionality. Instead, we must find a means to subvert mechanisms of control and shift agency away from capitalist and authoritarian regimes, and into the hands of the people.

1 See Alexander Galloway, *Protocol: How Control Exists After Decentralization* (Cambridge, MA: MIT Press, 2004).

2 Ibid., 176.

3 'Notes From The Resistance: Özgür Uçkan and Vasif Kortun in Conversation with Başak Senova', *Ibraaz*, Platform 005, 29 June 2013, http://www.ibraaz.org/interviews/92.

Projects

NaturallySpeaking

Tyler Coburn

※※※

We would like you to read aloud for a few minutes

while the computer listens to you and learns how you speak PERIOD

When you have finished reading COMMA we'll make some adjustments COMMA

and then you will be able to talk to your computer and see the words appear on your screen PERIOD

In the meantime COMMA we would like to explain why talking to a computer is not the same as talking to a person

and then give you a few tips about how to speak when dictating PERIOD

※ ※ ※ ※ ※ ※

Understanding spoken language is something that people often take for granted PERIOD

Most of us develop the ability to recognize speech when we're very young PERIOD

As infants COMMA we are experts at babble COMMA making noises unknown to any language PERIOD It is said that even a polyglot couldn't approximate the articulations of a baby EXCLAMATION MARK

When learning to speak COMMA children continue to prattle and mimic the noises around them PERIOD The clang of a trolley and the buzz of a bee seem no different than the teaching voice PERIOD In becoming experts at intelligible speech COMMA however COMMA they gradually lose their capacity to babble PERIOD

This scenario demonstrates that there are two voices COMMA not one PERIOD There is the voice of logos and the voice of alterity COLON the acoustic mirror that initiates self-recognition COMMA and the medium that penetrates COMMA exposes COMMA and binds us together PERIOD The ears COMMA after all COMMA have no lids PERIOD

※ ※ ※ ※ ※ ※ ※ ※

The first challenge in speech recognition is to identify what is speech and what is just noise PERIOD People can filter out noise fairly easily COMMA which lets us talk to each other almost anywhere PERIOD We have conversations in busy train stations COMMA across the dance floor COMMA and in crowded restaurants PERIOD It would be very dull if we had to sit in a quiet room every time we wanted to talk to each other EXCLAMATION MARK Unfortunately COMMA a quiet room is the optimal setting to talk to your computer PERIOD It is also the optimal setting to talk to many other machines PERIOD

In recording singers for his phonograph COMMA for example COMMA Thomas Edison tried to suppress the squeaking of flute keys COMMA

the thumping of piano felts COMMA the turning of pages COMMA and especially breathing PERIOD Other sonic imperfections once attributed to the recording apparatus were actually caused COMMA the inventor argued COMMA by the human voice PERIOD It should come as no surprise that Edison was called OPEN QUOTE the man who made a prisoner of echo PERIOD CLOSE QUOTE

The phonograph could not heal the deficiencies of the body COMMA but it did improve them in significant ways PERIOD The nearly deaf Edison claimed to hear many things through his machine COMMA though lamented its inability to sound the depths of history PERIOD OPEN QUOTE Dead voices COMMA lost sounds COMMA forgotten noises COMMA vibrations lockstepping into the abyss COMMA CLOSE QUOTE he wrote COMMA were OPEN QUOTE too distant ever to be recaptured PERIOD CLOSE QUOTE

We don't expect everyone to share his pessimism PERIOD In fact COMMA you may favour Petron's belief that we live in one of many worlds COMMA which intersect in an equilateral triangle PERIOD The touching point is called OPEN QUOTE the dwelling of truth COMMA CLOSE QUOTE filled with words COMMA ideas COMMA copies COMMA and images of all things past and all to come PERIOD

The vibrations of a word may bring entire universes into existence PERIOD With a few sentences COMMA Agathos once birthed blazing spheres COMMA brilliant flowers COMMA and the oceans and volcanoes of wild stars PERIOD

A year before Edison invented the phonograph COMMA Florence McLandburgh wrote a story about a great OPEN QUOTE Ear of the World CLOSE QUOTE capable of hearing every past vibration PERIOD So secretive was the inventor of this marvellous device COMMA however COMMA that he solicited a mute COMMA illiterate woman to verify its workings PERIOD And when the woman was carried off in aural reverie DASH while carrying off the machine itself DASH the inventor took her life PERIOD

The device continued to operate after this incident COMMA indiscriminately transmitting the Alpine shepherd COMMA the organ fugue COMMA and

the cries of the dying woman PERIOD Try as he might COMMA the inventor couldn't filter out her death rattle COMMA turning his beloved machine into a worthless object DASH an OPEN QUOTE absolute horror PERIOD CLOSE QUOTE

※ ※ ※ ※ ※ ※ ※ ※ ※ ※ ※ ※

Unlike people COMMA computers need help separating speech sounds from other sounds PERIOD When you speak to a computer COMMA you should be in a place without too much noise PERIOD Then COMMA you must speak clearly into a microphone that has been placed in the right position PERIOD If you do this COMMA the computer will hear you just fine COMMA and not get confused by the other noises around you PERIOD

A second challenge is to recognize speech from more than one speaker PERIOD People do this very naturally PERIOD We have no problem chatting one moment with Aunt Grace COMMA who has a high COMMA thin voice COMMA and the next moment with Cousin Paul COMMA who has a voice like a foghorn PERIOD People easily adjust to the unique characteristics of every voice PERIOD

One of the ways we can identify speakers is by following the movements of their lips PERIOD If Uncle Phil opens his mouth and a foghorn sounds COMMA we can reasonably assume that the foghorn is coming from him PERIOD This is as much as we can assume COMMA however COMMA for we can't see the true origin of his voice PERIOD Speech COMMA in this sense COMMA is ventriloquial PERIOD Sound unseen is acousmatic PERIOD

In the sixth century BC COMMA Pythagoras was known to give acousmatic lectures from behind a veil to students sitting in the dark PERIOD We would say that a veil separates you from your computer PERIOD Darkness also divides you PERIOD

※ ※ ※ ※ ※ ※ ※ ※ ※ ※ ※ ※ ※ ※

When people first start using speech recognition software COMMA they might be surprised that the computer makes mistakes PERIOD Maybe

unconsciously we compare the computer to another person PERIOD But the computer is not like a person PERIOD What the computer does when it listens to speech is different from what a person does PERIOD

The computer has difficulty COMMA for example COMMA distinguishing between two or more phrases that sound alike PERIOD People use common sense and context DASH knowledge of the topic being talked about DASH to decide whether a speaker said OPEN QUOTE ice cream CLOSE QUOTE or OPEN QUOTE I scream PERIOD CLOSE QUOTE Unfortunately COMMA the computer can't use common sense the way people do PERIOD

People might also be surprised that the computer has difficulty distinguishing between two or more words that sound alike PERIOD We say OPEN QUOTE acousmatic COMMA CLOSE QUOTE and the computer hears OPEN QUOTE acousmate PERIOD CLOSE QUOTE The difference is not insignificant PERIOD

OPEN QUOTE Acousmate CLOSE QUOTE first appeared in an article from 1730 describing a strange event in the parish of Ansacq PERIOD One night COMMA the air filled with a multitude of OPEN QUOTE human voices of different sounds COMMA sizes and brightness COMMA of all ages COMMA of all sexes COMMA speaking and crying all at once PERIOD CLOSE QUOTE

Several causes were proposed over the ensuing months PERIOD Natural scientists attributed the event to air masses striking the uneven landscape COMMA while the god fearing detected the work of demon spirits PERIOD Some parishioners even suspected that a ventriloquist had played an elaborate joke COMMA for the racket ended in OPEN QUOTE peals of delicate laughter COMMA as if there had been three or four hundred people who began to laugh with all their force PERIOD CLOSE QUOTE Certainly COMMA it would not be the last time that a multitude of human voices irrupted in the aether PERIOD

※ ※ ※ ※ ※ ※ ※ ※ ※ ※ ※ ※ ※ ※ ※ ※ ※ ※

Speech recognition software works best when the computer has a chance to adjust to each new speaker PERIOD The process of teaching the computer

to recognize your voice is called OPEN QUOTE training COMMA CLOSE QUOTE and it's what you are doing now COLON you are Pythagoras COMMA and the computer is your pupil PERIOD The more you speak COMMA the better it learns to listen PERIOD

The computer will keep track of how frequently words occur by themselves and in the context of the other words PERIOD This information helps the computer choose the most likely word or phrase among several possibilities PERIOD Its method COMMA known as brute force computing COMMA relies on statistical learning algorithms to construct models from your data PERIOD Massive amounts of unintelligent computation COMMA in short COMMA gauge the probability of the sound samples we know as words PERIOD

Brute force computing was an unlikely child of the 1960s PERIOD At the time COMMA scientists still dreamed of true artificial intelligence that could learn and understand human languages PERIOD A mechanical model of the ear and vocal tract COMMA they proposed COMMA would someday perform to the measure of their biological counterparts PERIOD Until technology advances to match this dream COMMA however COMMA speech recognition software can ignorantly but competently listen PERIOD

※ ※ ※ ※ ※ ※ ※ ※ ※ ※ ※ ※ ※ ※ ※ ※ ※ ※ ※ ※

The training process takes only a few minutes for most people PERIOD If COMMA after you begin using the programme COMMA you find that the computer is making more mistakes than you expect COMMA use the tools provided in the TOOLS menu to improve the recognition accuracy PERIOD Additionally COMMA people sometimes mumble COMMA slur their words COMMA or leave words out altogether PERIOD They assume COMMA usually correctly COMMA that their listeners will be able to fill in the gaps PERIOD Unfortunately COMMA computers won't understand mumbled speech or missing words PERIOD They only understand what was actually spoken and don't know enough to fill in the gaps by guessing what was meant PERIOD

In some cases COMMA what was spoken may not be heard PERIOD Chilling temperatures COMMA for example COMMA can freeze language PERIOD

If you experience this problem COMMA try adjusting the room temperature or warming the words in your hands PERIOD As the ice melts COMMA you will hear what you said COMMA and the computer will too PERIOD
The last time words froze COMMA computers were still called people PERIOD Journeying through the northern climes of Nova Zembla COMMA Sir John Mandeville's crew fell prey to this silent spectacle COMMA OPEN QUOTE nodding and gaping at one another COMMA every man talking and no man heard PERIOD CLOSE QUOTE Three weeks elapsed until a turn of wind warmed the air PERIOD If a modern computer were aboard the ship COMMA it would have transcribed the crackling of consonants COMMA the lovelorn sighs of lonesome sailors COMMA and the tardy epilogue of a bear PERIOD

If a computer accompanied Pantagruel through the Frozen Sea COMMA it would have run aground a land of prattle COMMA ignorantly COMMA competently COMMA and indiscriminately recording the thawing din of a great battle COLON OPEN QUOTE hin COMMA hin COMMA hin COMMA hin COMMA his COMMA tick COMMA tock COMMA taack COMMA brcdelin HYPHEN brededack COMMA frr COMMA frr COMMA frr COMMA bou COMMA bou COMMA bou COMMA bou COMMA bon COMMA bou COMMA track COMMA track COMMA trr COMMA trr COMMA trr COMMA trrr COMMA trrrrr on COMMA on COMMA on COMMA on COMMA on COMMA ouououon COMMA gog COMMA magog PERIOD CLOSE QUOTE

And if a computer were a young student of Plato COMMA then it would live life as a very long winter COMMA at the end of which COMMA old and obsolete COMMA it could finally warm to his teachings PERIOD
But a computer had none of these experiences PERIOD Computers are none of these things PERIOD

※※※※※※※※※※※※※※※※※※※※※※※

To understand what it means to speak both clearly and naturally COMMA listen to the way newscasters read the news PERIOD If you copy this style when you dictate COMMA the programme should successfully recognize what you say PERIOD

One of the most effective ways to make speech recognition work better is to practise speaking clearly and evenly when you dictate PERIOD Try thinking about what you want to say before you start to speak PERIOD This will help you speak in longer COMMA more natural phrases PERIOD

Speak at your normal pace without slowing down PERIOD When another person is having trouble understanding you COMMA speaking more slowly usually helps PERIOD It doesn't help COMMA however COMMA to speak at an unnatural pace when you are talking to a computer PERIOD This is because the programme listens for predictable sound patterns when matching sounds to words PERIOD If you speak in syllables COMMA each syllable is likely to be transcribed as a separate word PERIOD

With a little practice COMMA you will develop the habit of dictating in a clear COMMA steady voice COMMA and the computer will understand you better PERIOD

※※※※※※※※※※※※※※※※※※※※※※※※※※※

When you read this training text COMMA the programme adapts to the pitch and volume of your voice PERIOD For this reason COMMA when you dictate COMMA you should continue to speak at the pitch and volume you are speaking with right now PERIOD If you shout or whisper when you dictate COMMA the programme won't understand you as well PERIOD

With a shout or a whisper COMMA the programme comes undone PERIOD Semes give way to intensities of force that expose COMMA penetrate COMMA and bind us together PERIOD So important are these aspects of human communication that Daniel Heller-Roazen can imagine OPEN QUOTE the primary form of human speech to be not a statement COMMA a question COMMA but an exclamation PERIOD CLOSE QUOTE Language is most itself COMMA he claims COMMA when it leaves OPEN QUOTE the terrain of its sound and sense COMMA CLOSE QUOTE opening itself to the surrounding babble PERIOD

This proposition runs counter to what most people learn COMMA so take a moment to consider its ramifications PERIOD If Aristotle felt compelled to exclude prayers and cries from the realm of logic COMMA for example

COMMA then he must have sensed that there was something dangerous DASH even radical DASH about affect PERIOD PERIOD PERIOD

If in the beginning there was the exclamation COMMA what follows would be a history of the limit COLON the OPEN QUOTE murky speech COMMA CLOSE QUOTE Dina Al-Kassim writes COMMA that sometimes gathers itself into a counter-discourse PERIOD This unsovereign COMMA unintelligible speech fills the mouths of ranters COMMA noisemakers COMMA and dissenters PERIOD It has failed to father a lineage COMMA though in different ages and for different peoples COMMA irrupts nonetheless PERIOD

※※※※※※※※※※※※※※※※※※※※※※※※※※※※※

We are not obligated to train our software COMMA though doing so can remind us of the norms we are dictated to keep PERIOD One of the first speech recognizers was a dog named Rex PERIOD Created in the 1920s COMMA he responded not only to his master's voice COMMA but to any speaker who called his name at a prescribed frequency PERIOD Speech recognition software has remained on a tight leash to this day PERIOD It will not let you be a noisemaker COMMA but if you speak clearly at a normal pace COMMA it will understand and obey PERIOD

The true origin of the voice is hidden from view PERIOD Speech COMMA in this sense COMMA is acousmatic PERIOD Michel Chion has described how COMMA in the passage from acousmetre to acousmachine COMMA the image OPEN QUOTE peels off CLOSE QUOTE the person COLON a living person dies so that OPEN QUOTE the image that is pure mechanical recording may live PERIOD CLOSE QUOTE The computer may be less menacing than the acousmachine or the phonograph COMMA yet it takes something from us all the same PERIOD We are not all born to be newscasters PERIOD Something must be peeled off PERIOD

Who is the subject supposed to speak to the computer QUESTION MARK We know where she must place her microphone PERIOD We know how she must speak PERIOD A lingua franca COMMA writes Édouard Glissant COMMA OPEN QUOTE is always apoetical PERIOD CLOSE QUOTE The subject supposed to speak to the computer may be as well PERIOD

✄✄✄✄✄✄✄✄✄✄✄✄✄✄✄✄✄✄✄✄✄✄✄✄✄✄✄✄✄✄✄✄✄✄✄

There are at least two voices COMMA not one PERIOD If we are citizens of the Monoglot Millennium COMMA we are also witnesses to The Great Thaw PERIOD The planet warms with a crackling of consonants COMMA and a multitude of voices irrupts in the air PERIOD Words melt in the palms of our hands COMMA as phrases never known and thus never forgotten ride the updrafts COMMA vibrating new worlds into existence PERIOD Even our machines are no longer silent scribes PERIOD

The multitude never begins nor ends COMMA and we enjoy losing our voice among the others COMMA though sometimes enjoy it less PERIOD At last COMMA dead noises can climb out of the abyss COLON the Laugh of the Augurs and the Song of the Swan play as if on the very chord of our being DASH intimate COMMA impersonal sounds PERIOD

Over time COMMA prattle once known and forcibly forgotten may also begin to melt PERIOD We will hear the echoes of unbounded babble PERIOD We may slowly unlearn to speak PERIOD

We hope you have enjoyed reading about the different ways that people and computers recognize spoken language as well as some tips for effective dictating PERIOD

✄✄✄✄✄✄✄✄✄✄✄✄✄✄✄✄✄✄✄✄✄✄✄✄✄✄✄✄✄✄✄✄✄✄✄✄

Sources

MacSpeech Dictate International, version 1.5.9.

Joseph Addison, essay for *The Tatler*, No. 254 (1710).

Dina Al-Kassim, *On Pain of Speech: Fantasies of the First Order and the Literary Rant* (2010).

Michel Chion, *The Voice in Cinema* (1982).

Michel De Certeau, 'Vocal Utopias: Glossolalias' (1980).

Mladen Dolar, *A Voice and Nothing More* (2006).

Édouard Glissant, 'Transparency and Opacity', published in *Poetics of Relation* (1997).

Daniel Heller-Roazen, *Echolalias: On the Forgetting of Language* (2008).

Douglas Kahn, *Noise, Water, Meat: A History of Sound in the Arts* (2001).

Brian Kane, 'Acousmate: History and de-visualised sound in the Schaefferian tradition' (2012).

Florence McLandburgh, 'The Automaton Ear' (1876).

Roberto Pieraccini, *The Voice in the Machine* (2012).

Edgar Allan Poe, 'The Power of Words', published in *The Collected Works of Edgar Allan Poe — Vol. III: Tales and Sketches* (1978).

François Rabelais, *Gargantua and Pantagruel* (1532-1564).

Allen S. Weiss, 'Narcissistic Machines and Erotic Prostheses', published in *Camera Obscura, Camera Lucida: Essays in Honor of Annette Michelson* (2002).

Redact Variations (Baghdad Observer)

Jamie Shovlin

DEFECTS

IN

TIGHT

AIR

THIS

TEARS

AND

REPAIRS

NUMB

IN

TIGHT

NUMBER

THIS

BINDING

CONTROL

ARE

DEFECTS

IN THIS

OK

A

DEFECT

IN

BROKE

TISSUE

HIS

BROKEN

PAIR

DEFECTS

IN EARS

EASE

CONTROL

THERE

IS

PRINT

AND

REPAIRS

ARE

DEFECTS

IN ME

BEYOND CONTROL

THIS

TEARS

TISSUE

BEYOND OUR CONTROL.

Redact Variations (Baghdad Observer) 179

THE

DEFECTS

IN

TISSUE

WHICH

CONTROL.

THE

BINDING

CONTROL

A

NUMBER OF

BINDING

REPAIRS

CONTROL.

RE

HIS

DIN

Redact Variations (Baghdad Observer)

NUMBER OF

TEARS

Jamie Shovlin

Jamie Shovlin, <u>Redact Variations (Baghdad Observer)</u>, 2012-13. Digitally redacted variations of a notice within microfilm archival copies of the *Baghdad Observer* denoting missing or damaged content. Dimensions variable. Courtesy of the artist.

Important Portraits

Jeremy Bailey

In the beginning, art was funded by the church, soon after by the powerful and the wealthy, and eventually by the state. Today, the largest collective patron of the arts is the faceless crowd-funding population of the internet. *Important Portraits* elevates these seemingly invisible patrons, transforming them into hyper-augmented versions of themselves: a generation capable of changing the world.

Jeremy Bailey, <u>Important Portrait of Addie Wagenknecht</u>, 2013.

Jeremy Bailey, <u>Important Portrait of The Artist's Wife</u>, 2013.

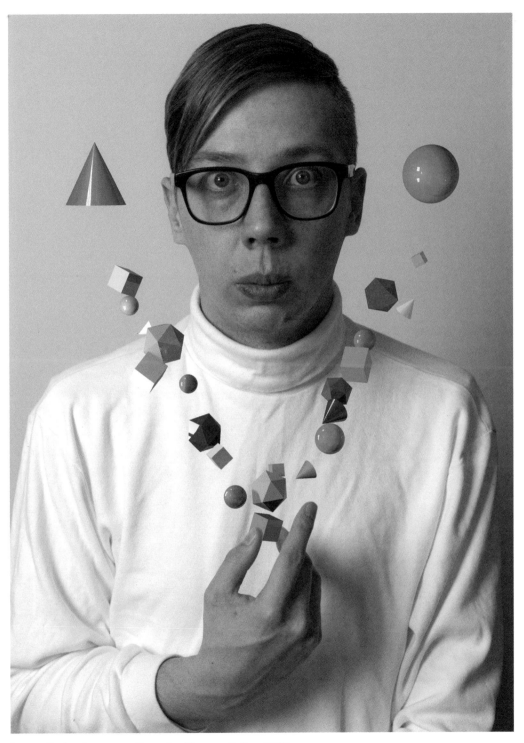

Jeremy Bailey, <u>Important Portrait of Jeremy Bailey</u>, 2013.

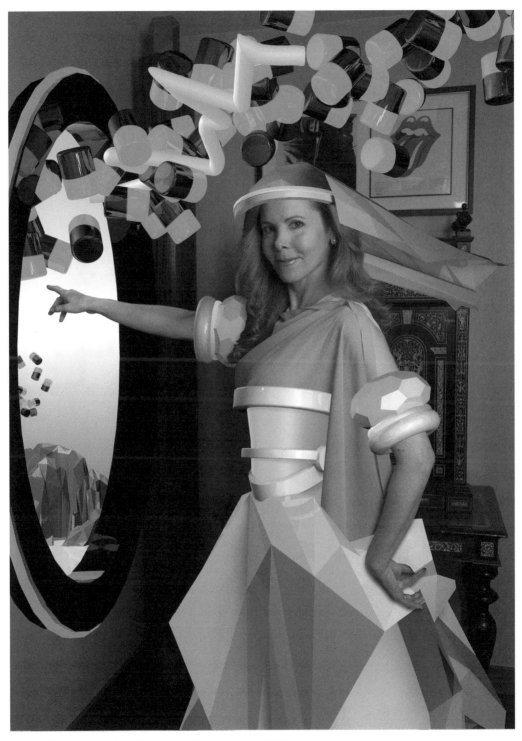

Jeremy Bailey, <u>Important Portrait of Marla Wasser</u>, 2013.

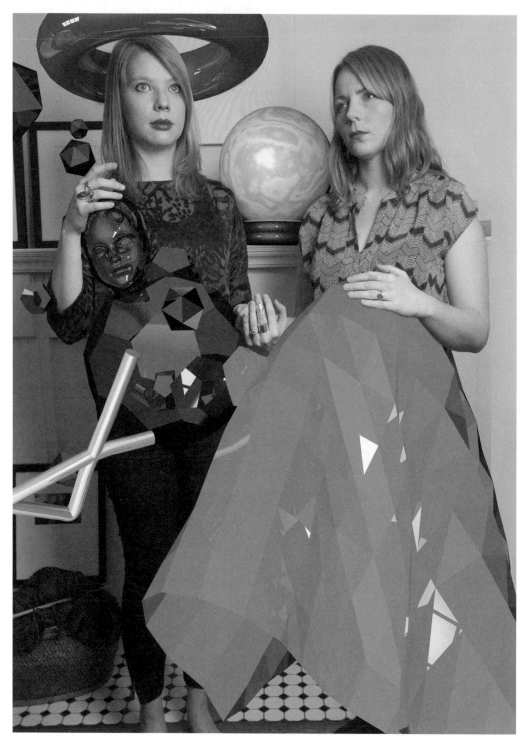

Jeremy Bailey, <u>Important Portrait of Natasha Bailey and Zena Bielewicz</u>, 2013.

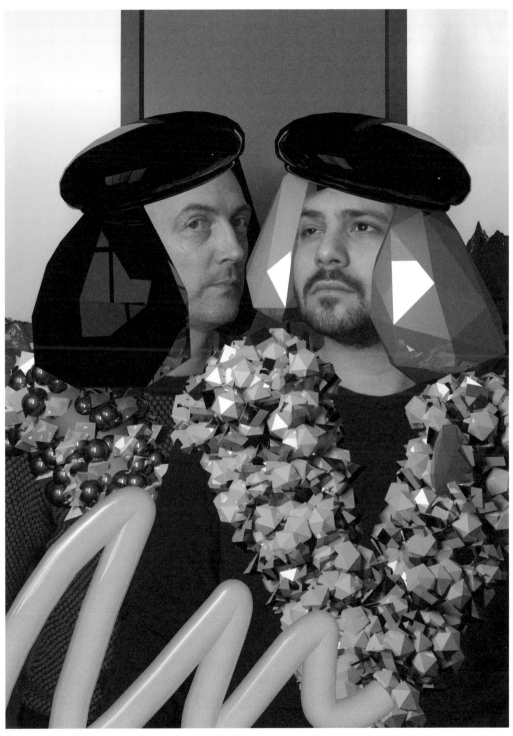

Jeremy Bailey, <u>Important Portrait of Omar Kholeif and Frank Gallacher</u>, 2013.

Virtual Worlds

Jon Rafman

Jon Rafman, Still Life (Betamale), 2013.

Canadian artist Jon Rafman has flung open the doors of the art world to a new kind of media art: the virtual world of Second Life and multi-player video games. Now considered one of the leading artists working with technology, Rafman professes that it is not technology itself that interests him: 'I am [more] interested in technology's creative social application. I love looking at what people have created just because they are simply excited to create things, without the intention of it being called "Art".'

The artist's recent work has focused mostly on such possibilities occurring in virtual worlds, as in his two most famous projects, *The Nine Eyes of Google Street View* (ongoing) and *Kool-Aid Man in Second Life* (2008–2011)—a video project that follows the innocent-looking mascot for the American drink mix Kool-Aid as he naively roams around the obscene hyper-reality of Second Life, where he stumbles upon such sights as a wolf having sex with a unicorn. The former is named after the nine lenses mounted on a Google street view car that photographs absurd realities by accident: selections include images of prisoners cooped up in the back of a police car, comic road accidents, as well as muggings, to name but a few happenstances.

These, like many of Rafman's projects, are about the joy of exploring the endless possibilities of distant or virtual worlds created or enabled by the internet. Rafman's latest works, such as *Main Squeeze* (2013), see the artist acting as a visual anthropologist mining through different subcultures in the online environment, as he tries to make sense of the reasons why users engage with this alternative universe. Rafman constantly captures these enacted journeys and fashions them together into narrative-based films, replete with original music scores. Asking him about his fascination with Second Life and multi-player video games, Rafman replies: 'Second Life reveals the anarchic psyche of the internet and also acts as the ultimate tourist destination. It's like a supercharged Las Vegas, Dubai, and Shanghai combined. It is grotesquely kitsch and I love it.'

On his inspiration, Rafman explains: 'On one level, I'm trying to draw a historical line between a classical, modern, or romantic quest for fullness, in a world that is completely fragmented and has no more centre ... I don't see what I am doing as new. I see the materials as new, and the technologies, virtual communities, and subcultures that are emerging a new mine of material for artistic practice.'

—Omar Kholeif

Virtual Worlds

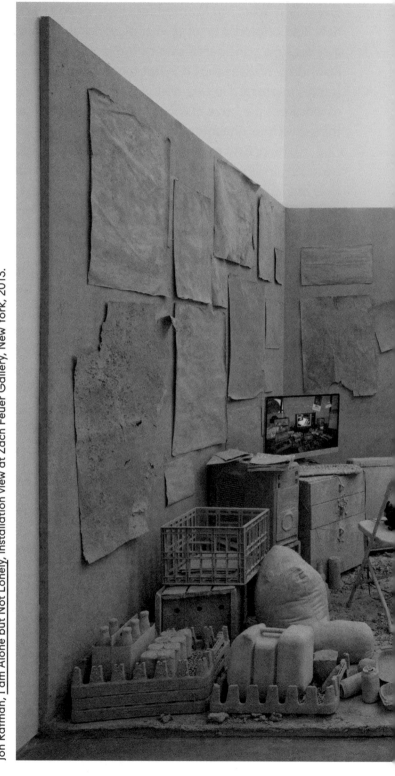

Jon Rafman, I am Alone but Not Lonely, installation view at Zach Feuer Gallery, New York, 2013.

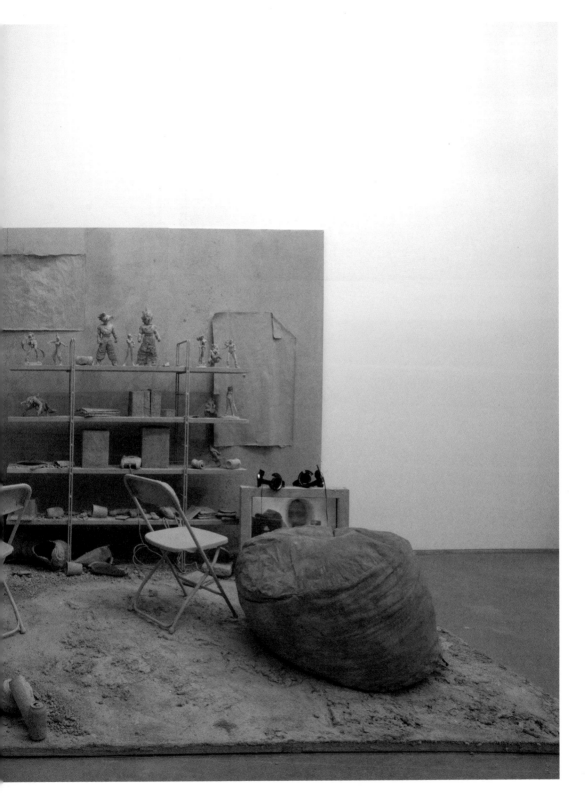

Virtual Worlds

Jon Rafman, Scratch Card, <u>You are Standing in an Open Field</u>, Zach Feuer Gallery, New York, 2013.

Jon Rafman, Still Life (Betamale), 2013.

Jon Rafman, I dig, you dig, and it, the worm, digs too, 2013.

Jon Rafman, Still Life (Betamale), 2013.

Previous spread: Jon Rafman, <u>Still Life (Betamale)</u>, 2013.

Jon Rafman, Still Life (Betamale), 2013.

Resolution 978HD: A Visual Essay

Model Court (Lawrence Abu Hamdan, Sidsel Meineche Hansen, Lorenzo Pezzani & Oliver Rees)

Resolution 978HD was an exhibition which took place at Gasworks (London) from May–July 2013, continuing Model Court's ongoing research into the shifting infrastructures of international justice. Some of the visual material used here appeared in the exhibition.

The material presented here focuses on the trial of François Bazaramba, a Rwandan citizen who, after seeking asylum in Porvoo (Finland) in 2003, was tried by the local court and found guilty for his involvement in the 1994 Rwandan genocide.

In an unusual geographical inversion, the Finnish court moved to undertake proceedings in Rwanda and Tanzania, where witnesses were heard while Bazaramba was not allowed to leave Finnish soil. Legal proceedings then had to be transmitted to and from Bazaramba's Helsinki prison cell via Skype and other video-conferencing technologies.

Universal jurisdiction, the legal principle by which the trial was conducted, is often presented as a form of 'juridical utopia' whereby atrocities such as genocide and crimes against humanity can be tried without regard for national borders. Whereas most similar international cases are brought to the International Criminal Court in The Hague, the Bazaramba trial presents a unique example of a decentred legal process. Its unprecedented use of media technology reconfigured the space of law and established an unexpected connection between peripheries.

This visual essay is based on material shot by Thomas Elfgren, the Finnish policeman who was the only individual to have followed the trial in its entirety. It is divided into eight chapters, each represented by a single image that explores a specific intersection of legal procedures and media apparatuses. The original photographs by Elfgren have been annotated by the Model Court group with short 'log entries'.

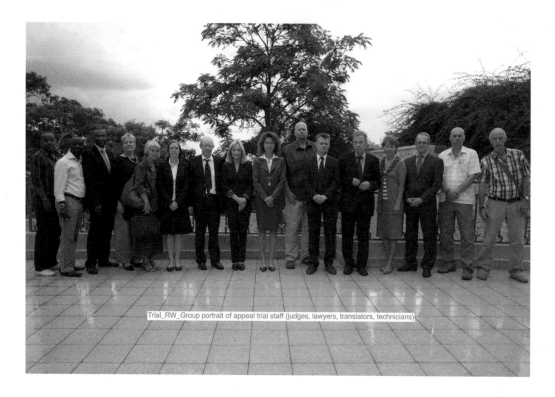

Trial_RW_Group portrait of appeal trial staff (judges, lawyers, translators, technicians)

1. Translation

In this trial, the court staff was often composed in equal numbers of legal professionals staff on the one hand, and various types of 'technician' on the other. Translation was a particularly delicate task that required the hiring of several staff members. It was in fact impossible for the Finnish court to find a court interpreter that could translate the witness testimony directly between Kinyarwanda and Finnish. As an alternative they constructed a two-step translation chain, whereby the witness testimony was first translated from Kinyarwanda into French or Swedish, and then into Finnish, and then back again. This chain of translation would be too large to fit into a whisper cube at the back of the room, so instead it was decided by the court that all interpreters were to sit on the bench together with the witness. The two interpreters were wired together with microphones and headsets and, even though they were seated next to one another, they used this audio setup to 'reduce' their presence in the proceedings. This complex network of translation increased the total duration of the trial three-fold and led to a record of more than 142 DVDs.

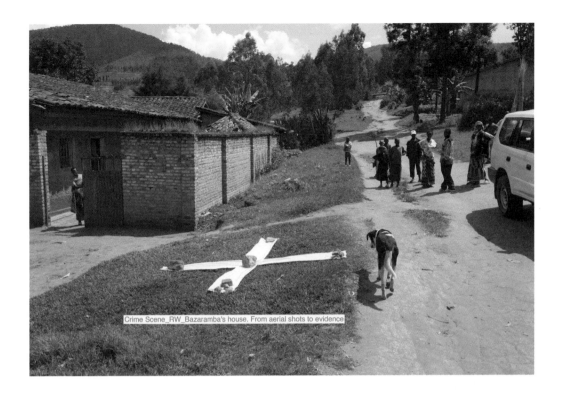

Crime Scene_RW_Bazaramba's house. From aerial shots to evidence

2. Crime scene

For the proceedings, the Finnish court needed to produce aerial shots of the house in which Bazaramba lived. These images provided the witnesses in court with a bird's eye perspective of the crime scene, in order to assist them in explaining Bazaramba's role in the attacks that took place on Mount Nyakizu on 16, 17 and 18 April 1994, which led to the death of 30,000 people. In one of the first trial sessions in Rwanda, the Finnish court travelled 150 km from the courtroom in Kigali to conduct an on-site tour of where the killings happened. The lead prosecutor for the case acted as the tour guide as she explained to the court and to the camera how the attacks had played out. The tour also presented an opportunity for the court's technical team to produce more video and photography of the site from the ground, as they used their cameras to map the scene of the crime and to test the veracity of eyewitness testimony.

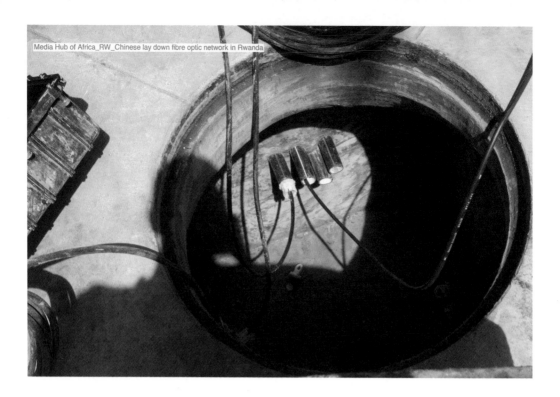

Media Hub of Africa_RW_Chinese lay down fibre optic network in Rwanda

3. Transmission

One of the biggest challenges of the trial was to establish an audio-video connection that would allow Bazaramba to participate in his own trial in an adequate way. When the Bazaramba trial started, East Africa relied on satellite communication as the region still remained in a broadband shadow with no fibre optic connection. This meant that the connection between Finland and Rwanda was constantly affected by the trade-off between image quality and speed of transmission: a balance between the two had to be continually negotiated to make sure communication remained uninterrupted, while the quality stayed within acceptable levels. During the trial, a Chinese company started to lay fibre optic cabling in Kigali. Rwanda aims to become the new media hub of Africa, and a series of companies are now competing to fill this gap by implementing fibre optic cables that will connect East Africa to Marseille and Mumbai. In some areas, fibre optic cables even precede vital facilities, like water and electricity.

4.　　Telepresence

The complex legal geography of the trial required Bazaramba to be kept in detention in Finland, while the Finnish court travelled to Rwanda and Tanzania to collect witnesses' testimonies. To allow Bazaramba to participate remotely in the proceedings in East Africa, an elaborate media infrastructure had to be put in place. A video conference setup that boasted a 'true to life experience' was provided by Polycom. The image of Bazaramba was broadcast onto a computer screen located on the floor of the courtroom in front of the witnesses' bench, in such a way that the judges could simultaneously follow the witnesses' statements and Bazaramba's reactions. Thus witnesses could not see Bazaramba's image but could only hear his questions and comments from a loudspeaker, also located on the floor in the centre of the room. This was a deliberate choice of the judges, who feared that the vision of Bazaramba's figure might have troubled the witnesses and not allowed them to deliver a fair testimony. Sometimes, after the session had ended, the video channel was left open, transmitting the image of Bazaramba's empty chair.

Court Set Up_RW_Putting the connection to Finland in Place. Cable mess.

5. Interference

'Today we again faced yet more issues with the video conference system. The balance of image quality is becoming almost political in this trial. The court secretary complained that the image on the screen kept freezing and reminded me that our entire claim for legal sovereignty in Rwanda was predicated on this connection which means that Bazaramba needs to be seen at a high resolution. Yet the connection also needs to be stable so that the proceedings do not stop all the time. The defense lawyer following the trial with Bazaramba in Finland also claimed that she was unable to participate in the cross examination because of a delay in the connection. The judge called for a break while we tried to synchronize the two spaces. In this situation, a lower quality of the image means that the connection can be smoother. We reached an agreement. A small delay was ok, but if the latency exceeded five seconds we would stop the proceedings.'

Statement made by the Finnish policeman (pictured) in the film
Resolution 978HD.

Racist Media_RW_The same problem he was having with his eyes was reproduced in the camera

6. Exposure

During the trial, lightning equipment was used to allow for the recoding of witnesses' testimonies. This was necessary in particular because the cameras' standard light-metering algorithm is calibrated to a fair skin complexion, and thus unable to register detailed visual information when recording a dark-skinned person. As this situation shows, while universal jurisdiction, as much as media, carries the empty promise of a universal format, its inadequacies emerge in the very way in which light is captured by camera sensors, cables transmit information, and memories are stored. The glitches that emerge from the friction between the smooth space of universalism and the material realities of our world constantly disturb the promises of international justice.

Pre-trial Investigation_RW_Police interview room 3 actors

7. Truth-production

'Perhaps I should refer to a notion the Rwandans know very well and that is ubgenge. U–B–G–E–N–G–E. And it refers to cunningness, being smart, not being caught red handed when you try to fool the other, and acting and speaking strategically. In most European cultures I think we would call it lying.'

'In a Juridical context I've said ubgenge refers to strategic speaking, it means for instance that a suspect or a witness wonders who asks me this question? Can that person harm me or help me? And so someone in Rwanda who answers a question always looks at the broader context. That is why for many Rwandans the notion of perjury, lying under oath, is completely strange or alien.'

'It is a real challenge for a judicial system if you have to assume that witnesses are lying, because that would make, in cases like these, most evidence unreliable and that would in turn make justice impossible.'

> Expert witness testimony of Filip Reyntjens,
> Porvoo District Court, Finland, 8 December 2009.

Chief Judge_RW_Universal Utopia

8. Memory

As a gift for each member of the Porvoo District Court, a series of African sculptures were commissioned so that they could take home a customized souvenir to Finland. These sculptures are in the shape of mini globes, to represent universal jurisdiction. On the sculptures, a map of Europe and Africa with a pioneering line connecting Finland and Rwanda is depicted. The sculptures contain carvings of the judges' bench hearing a witness, and next to it is a depiction of an incarcerated figure following the trial from afar; these elements are set amongst Rwandan and Finnish forests.

One of the main concerns of International Justice is the production of history. The ambition of universal jurisdiction could be understood as attempting to produce a global historical consensus that would allow societies to recover from the past and live once more with a sense of the future. The ways in which international law produces history and a universal memory of the past finds expression in media as different as sculptures and digital memory banks on which the entire outcome of the seven-year trial have been stored.

A Technology of Behaviour

Sam Ashby

'You can put this story in the Frontiers of Medicine file. Put it in front of the the Tulane University neurosurgeon who put an electrode in the pleasure center of a male homosexual's brain and then, in an effort to make the guy straight, turned on the current while showing him stag movies supplied by the psychology department.'
—Nicholas von Hoffman[1]

I first had the idea for a project on aversion therapy to 'cure' homosexuality a few years ago, as a potential subject for my publication, *Little Joe*. This initially came from a desire to uncover the types of images used in the clinical trials that I had understood to have taken place historically through various cultural and documentary references. Because of films such as Stanley Kubrick's *A Clockwork Orange*, I had always assumed that aversion therapy involved the use of film footage. I wanted to know if the doctors and psychologists simply used the pornography of the day, or if they made their own images. What were the ethical considerations relating to this material?

The period before the American Association of Psychologists took homosexuality off the list of mental disorders in 1968 was a very murky time for behavioural psychology, and numerous studies took place, particularly in the UK and US, using techniques that seem entirely shocking to us today. The belief that a person's behaviour could be changed through positive and negative reinforcement was common at the time and, after some research in the Stanley Kubrick Archives, I found its rhetoric exemplified in the work of behavioural psychologist B. F. Skinner. Kubrick, it seemed, was well aware of Skinner's methods. Skinner explored his theories of behaviour using rats and pigeons, utilizing his 'operant conditioning chamber' to train them to perform surprisingly complex tasks—even designing a pigeon-operated missile during World War II. After the war, Skinner set about writing his highly influential novel *Walden Two*, an exploration of a utopian 'intentional community', clearly referencing Henry David Thoreau's own *Walden*, an 1854 account of simple living and self-sufficiency. Skinner's novel was eventually published in 1948 and went on to inspire a number of real-life Walden Twos, some of which continue to this day, including Twin Oaks in Louisa County, Virginia, US, and Los Horcones in Hermosillo, Mexico. Skinner's fictional community is structured on ideas of behavioural engineering that he went on to describe further in *Beyond Freedom & Dignity* (1971), this time exploring its potential in the real world. The book rejects the concept of free will and proposes 'a

technology of behaviour' in order to solve the world's ills.

I began to explore the types of technologies that were utilized in these 'reparative' therapies and discovered an entire industry had been built up in order to help doctors implement these behaviour modification techniques. The 'Visually Keyed Shocker', produced by Farrall Instruments in Nebraska, promoted 'Automated Behaviour Conditioning' for addiction, masochism, alcoholism, aggression, transvestism, exhibitionism, and sexual preference. Essentially a modified slide projector, the 'Visually Keyed Shocker' came with a set of 35mm slides including sets of heterosexual acts, male and female homosexual acts, dating scenes, and nudes. I assume these were only sold to medical and research institutions, but it's not difficult to imagine that they were thinking about a broader market for this treatment, with the potential for the public to use it within the home.

Other technological developments included the penile plethysmograph (PPG), a device invented by Czech-Canadian physician and sexologist Kurt Freund in the 1950s to measure changes in the circumference of the penis. When used in conjunction with visual stimuli, the device—an electromechanical loop that is wrapped around the base of the penis—is supposed to determine a specific erotic interest. Originally invented to weed out fake homosexuals attempting to avoid the military draft in Czechoslovakia, the PPG went on to be used in a number of studies to treat homosexuality and continues to be used in order to determine the age range of sexual interest in sex offenders. A similar device has been invented for women, although with considerably less success.

Today, the moral question over what images can be used in studies to determine the age range of sexual interest is clearly an important one. A company in Canada, Pacific Behavioural Assessment, produces images for 'Sexual Interest Profiling' called 'Not Real People' (NRP). In place of pornographic material, semi-nude bodies are created from multiple sources and airbrushed into awkward amalgams. Another company I found offers entirely computer-generated three-dimensional models. These bodies become stand-ins, their mutant surfaces designed to demarcate and police the territories of desire.

In my video installation *They grew up on the outside of society. They weren't looking for a fight. They were looking to belong.* I present patient case studies from a 1964 study by psychologists M. P. Feldman and M. J. MacCulloch, titled 'The Application of Anticipatory Avoidance Learning to the Treatment of Homosexuality'. The work replicates the structure—a

Promotional photograph for <u>Violent Playground</u> (Basil Dearden, 1958).
Courtesy of The Ronald Grant Archive.

<u>A Technology of Behaviour</u>

wooden box screen—in which the male patients observed slides of men and women and were given electric shocks in conjunction with the former in order to 'cure' them. In my hacked version, the images are taken from Hollywood films about street gangs in order to subvert the treatment and position the subjects as heroic outsiders.

* * *

Patient No. 3

From M. P. Feldman and M. J. MacCulloch, 'The Application of Anticipatory Avoidance Learning to the Treatment of Homosexuality', October 1964.

A 40-year-old semi-skilled operative was referred to us via the courts, having received two years probation and a £50 fine for an offence involving a 19-year-old boy.

His first sexual experience, mutual masturbation, occurred at the age of 10. His refusal of homosexual approaches at the ages of 16 and 19 was caused by shyness and fear of the consequences, rather than lack of interest. At the age of 24, he commenced homosexual activity, which took place in cinemas and public lavatories. His usual form of activity was mutual masturbation and he frequently paid his partners small sums of money. He commenced live anal intercourse with the 19-year-old boy, who figured in his eventual court appearance, several months before he appeared in court. This was one of the few instances in which the patient was able to feel some degree of emotional attachment to his partner. The patient had never displayed any heterosexual interest, fantasy or behaviour. There was no previous medical or psychiatric history of note. The patient's father drank heavily and beat his mother, and at the age of 14 the patient and his mother went to live with his elder married sister. The patient's father visited the mother for sexual intercourse and the patient found these visits exciting, wishing to take his mother's place.

There was no known family history of psychiatric illness or homosexuality. The patient was clinically assessed as a mildly anankastic personality disorder with sensitive traits. He found social relationships of any kind extremely taxing for his reserved nature, and prior to treatment

he expressed sensitive ideas of reference. He responded well to treatment and this good response has generalized to his external behaviour. On discharge, he described only slight homosexual fantasy and interest, and slight heterosexual fantasy and interest. In the year since discharge he has displayed no homosexual behaviour and his interest and fantasy have shrunk almost to vanishing point. He has become more interested in looking at females and he now uses them instead of males for his masturbatory fantasies. He has begun taking ballroom dancing lessons with a view to attending public dances. He finds social mixing a great deal easier than previously, and there has been a marked increase in his confidence and ease of manner.

1 Nicholas von Hoffman, 'A Bit of Clockwork Orange, California Style', *The Washington Post*, 5 April 1972.

May Amnesia Never Kiss Us on the Mouth

Basel Abbas & Ruanne Abou-Rahme

May amnesia never kiss us on the mouth.
May it never kiss us.

The internet is an immense and expanding environment, permeated by and permeating the most intimate parts of our offline/online lives. In the sea of material(s) that shape this environment, seemingly endless inscriptions and mutations produced by virtually anybody and everybody infinitely circulate, creating an afterlife of images, sounds, and text. It is an afterlife of our experiences, as material as it is ephemeral, perpetually producing and obliterating incredible archives of the contemporary.

And here we are as artists. A small part of this surge of activity. Searching/downloading/sampling/cutting/pasting/mutating/inscribing/ copying/documenting/uploading/posting/blogging/tweeting/instagraming/ creating spontaneous archives of the moment.

Here is everyone.

After all what do artists as artists matter now?

The intersection between the digital and virtual has opened the possibility for anybody to actively bear witness to, publicly narrate, and comment on the events happening in their lives. These transformations, where people find themselves narrating anything and everything, from the seminal to the mundane as an 'event' (in the form of vines, memes, selfies, comments, and tweets, to name just a few), is informing new ways of being.

The creative vitality of this user-generated/modified material is now so seemingly mundane that it is often unnoticed and overlooked. And yet it demands a closer look.

It seems to us that the position of the artist (ourselves included) as archivist, assembler, collector, or sampler of sorts, is no longer as central as it once was. In fact, it has never been more evident that the internet has created the conditions for everyone to take up these positions and practices in one way or another. Maybe we could even say that the activist-as-archivist has replaced and surpassed the artist-as-archivist. All we need to do is look at any moment of insurgency, particularly in the last five years, whether it is

Egypt in 2011, Greece in 2012, or Turkey in 2013. Not only are activists shaping events on the ground, they are at the same moment producing and circulating counter-narratives through images, videos, sound, and text. In a video from 2011, while protestors leave Tahrir square in Egypt, someone is heard reminding people: 'Don't forget to upload online everything you filmed before you sleep ... before you sleep so we can wake up to a new Egypt without Hosni Mubarak.' The very act of producing dissonant archives, in real time as events unfold, is now understood by insurgent citizens as a fundamental way of rupturing the spectacle of power, not of simply sharing information. It is not only that they defy power through splintering the official archive—it is also through the very archival act that this defiance is being performed.

It is strange, then, to find that so much of our reflections are pre-occupied with how artists practices are affected by the internet, and perhaps not enough with looking at the unfolding impact, and the potential of people publicly taking up the very practices that artists were not only engaged in, but have clearly informed. Practices of appropriating, re-archiving, documenting, inscribing, remixing, re-narrating, to name just a few, are not only being produced en masse, but perhaps most critically are being performed publicly. Our contemporary landscape is marked by the overwhelming impulse to document, save, and narrate the moment, and significantly, the desire to publicly share this record. While perhaps this impulse is not new, its ubiquity is. Who has the power to record, to speak, and to perform this 'archival' activity has radically shifted in the last ten years.

The archival impulse is everywhere.

It has proliferated, intentionally and unintentionally, producing a common archive. Intentionally and unintentionally subverting the logic of the official archive. The archive has, for a very long time, been central to how power is both productive and repressive of life itself; a closed archive is a dead archive. Over the last thirty years or more, artists including ourselves and writers before, have been engaged in reactivating and questioning the archive. But in the end, these practices, although integral, have not been enough by themselves to create a common archive. The vitality that can turn the archive into something living is fundamentally connected to a moment of political becoming, when the individual, through a subjective gesture or act, becomes part of a common moment and articulates this potential of the common. The

interrogation of the archive that artists and writers have been engaged in, through counter-narratives and images, is only now coming alive through the overwhelming archival activity that seemingly everyone 'connected' is, to one degree or another, engaged in. Even under the shadow of surveillance, the flattening of the internet for commercial ends, the battle over the production of knowledge, incredible archives-of-the-moment emerge every minute from self-narratives of loss, love, desire, to documents of struggle and protest. A middle-aged man living in New Jersey who visits his hometown of Nablus, Palestine, every year, obsessively and minutely documents his everyday life; his voice narrating every video he uploads. To date, he has uploaded a total of 3,787 videos. The result is a performative video diary, an amateur documentary, a poetic reflection on the banal, and a remarkable insight into how we mediate our lives and selves in relation to the actual, digital, and virtual.

In another time/place, a physical confrontation erupts in the Dome of the Rock between Palestinian residents of Jerusalem and the Israeli military. Large numbers of the Palestinians protesting are running towards the Israeli soldiers with their smart phones and flip cameras in hand. The next week in Bilin, a site of continued confrontation, Israeli soldiers use their smart phones to obscure their faces and film the protestors. The politics and power of the record as testimony, whether as image, sound, or text, has perhaps never been as publicly grasped or contested. People's daily production and sharing of these subjective, horizontal 'archives' of experience expresses the desire and sometimes even the fight for a living, common archive. Perhaps then, one of the most significant unfolding affects of the internet, particularly for artistic practice, has been the implosion of 'the archive' in the face of the seemingly endless material of the everyday and everyday archivists.

May amnesia never kiss us on the mouth.
May it never kiss us.

And yet it is fleeting, the streams are always shifting; traces are lost and never found again, the excess threatens to overwhelm us all. The logic of contemporary capitalism pervades everything and informs most things; vast amounts of material are produced only to be rendered obsolete the very next second. The stream is continuous, perpetuating capitalism's obsession with the 'now', the immediate. The very sites that allow exchange of experience

and knowledge are sites of surveillance. Increasing surveillance on one hand and legislation on the other is attempting to control the flows of information and exchange between people. Within that logic, anything can be removed, not only for infringing copyright, but also and most importantly for simply being dissonant. We are amidst a struggle over the future of these forms: one that goes to the heart of the critical struggle over the production and control of knowledge.

How will these shifting forms continue to reshape the 'archivable' and our future memory? And more pressingly, how is our imaginary impacted and our very sense of self intrinsically connected to, and performed through, this activity?

We find ourselves here, widening our gaze, beyond our own practices as artist-archivists, rag-pickers, samplers, and assemblers, towards the potentialities of a common archive in the making.

The urgency of the moment demands a new imaginary.

After all what do artists as artists matter now?

The ideas discussed above are part of a research project entitled *May amnesia never kiss us on the mouth* commissioned by Thyssen-Bornemisza Art Contemporary and also appear in conversation with Tom Holert in *The Journal of Visual Culture*, Volume 12 Issue 3, December 2013.

Basel Abbas & Ruanne Abou-Rahme

Questionnaire

James Richards

James Richards, <u>Rosebud</u>, 2013. Courtesy of the artist and Rodeo Gallery.

<u>Questionnaire</u>

James Richards, <u>Rosebud</u>, 2013. Courtesy of the artist and Rodeo Gallery.

Do you want people to feel emotional when they look at your work?

I would like the work to provide an engaging space for the viewer to feel a movement through different emotions—an excitement at the shifts in emotional tone and register. I'm looking to play with the feelings produced through disjunction and harmony between the images at hand, and the emotions that are being produced.

Do you feel emotional when you're making it?

The process of making work means I'm really moving through a lot of different feelings about the material over the course of the work's development. Of all the material I collect and sift through, the matter that actually ends up in the final work is that which can repeatedly alight a sense of complex or interesting emotions in me.

Is it okay to be confessional?

The notion of a confession makes me think there's a crime or secret that's being disclosed.

I'm hoping and looking for directness, honesty—a kind of rawness; a feeling that the elements included are really meant, felt, and that the stakes are high.

Is the internet a physical space for you, or is it flat?

Maybe like a pond—a flat surface when seen from above, but once you get close and jump inside you can swim up, down, and sideways.

Where do you listen to music?

At home a bit, but I love listening on headphones while walking, cycling, or travelling.

Does size matter anymore?

That sounds like a question you would get on the cover of *Grazia Magazine*.

Do you read? If so, what?

Yes, in a steady trickle. I read different things—novels, artist monographs, photography books, as well as essays that friends send to me.

Where do you dig for material?

Different places at different times. The pleasure is in the looking for me—right now I'm ripping huge numbers of Blu-ray disks and then gleaning out fragments, shots, close-ups, and gestures.

I've not looked to cinema so much before as source material, favouring the instructional and the underground. But at the moment I'm finding this an exciting place to begin. I'm also doing research at the archive of the National Gallery in London and the Gemäldegalerie, Berlin, looking at images of paintings that have been made with x-ray and infrared photography.

I also like to keep a camera and sound recording device with me at all times; storage is now infinite so I can now keep on casually picking up snippets from life.

James Richards, <u>Rosebud</u>, 2013. Courtesy of the artist and Rodeo Gallery.

<u>Questionnaire</u>

On the Case of the I:
A Note on Capitalization

Stephanie Bailey

One of the major issues when deciding on a house style for this book was whether to lowercase or uppercase what lies at its thematic core—the internet. The decision was based on consensus. Our writers expressed their preference for the lowercase, some more strongly than others. Many were used to being edited to uppercase according to APA or Chicago, or when they write for *frieze* or *Artforum*, despite their personal preference.

In trying to reach a decision on this issue, we came to understand just how contentious the capitalization of this word—internet—really is. There is no global consensus: *Art Monthly, e-flux journal, WIRED, New Scientist, The Guardian, The Economist, London Review of Books,* and *Rhizome* have all converted to lowercase. On *WIRED*'s style change in 2004, *WIRED News* Copy Chief, Tony Long, wrote:

> ... in the case of internet, web, and net, a change in our house style was necessary to put into perspective what the internet is: another medium for delivering and receiving information. That it transformed human communication is beyond dispute. But no more so than moveable type did in its day. Or the radio. Or television.[1]

Many of our writers agree that the internet is nothing more than a pedestrian mode of communication. Yet, the comparison with the television or the radio does not sit neatly. When I think about visiting someone's home, for example, and I ask: 'Do you have the internet?' I am not asking for a specific thing or common object (and therefore, a common noun), like a telephone, though the thing that would provide me with this connection is certainly a common object—a computer, for instance. No. What I am actually asking for is something abstract: a connection or a link to a larger network. Doesn't that make the connection itself a singular thing? A proper noun rather than common? The Internet with a capital I?

The answer, apparently, is no. The internet is an expansive aggregate of networks. As British etymologist and writer Michael Quinion writes:

> The Internet was originally, in the late 1960s, a US Department of Defense project called ARPAnet (after the Department's Advanced Research Projects Agency). It was designed to permit its academic researchers to talk to each other more effectively by linking their individual computer networks. So it was an *inter-network*, or *internet*. The latter word, in lowercase, seems to have been first used in 1974,

in a standards document written by Vint Cerf; references to it in memoranda and technical specifications in the following years were also usually lower case.[2]

In fact, according to Quinion, the first example of the word's capitalization was in the magazine *Network World* in 1986, though by then, capitalization had become common in standards documents, with virtually all publications adopting this style throughout the 1990s. The reason given, as Quinion notes, was 'that there was just one entity that was called by this title ... it was a specific thing with a proper name.'[3]

For *You Are Here* contributor Jennifer Chan, the capitalization of the internet in the '90s reflected on the 'the standards put forth by organizations like IETF and W3C, and later the commercialization hype of the internet around the dotcom bubble.' Chan writes: 'People increasingly saw the internet as a collection of commercial entities (.coms) and a metaphorical virtual space,' even though the internet was, from the outset, 'an (interconnected) network of computer networks that spanned the globe.'[4] Chan's observations sit perfectly with the choice we eventually made with this publication. In the end, we went with *a* consensus—the decision made by all the constituents of this publication: a network of voices. Thus, Internet became internet. Even still, the decision ultimately remains unstable. For example, when editing this book, we chose to remain faithful to the original text or utterance when the internet and the web were capitalized in direct quotations. However, World Wide Web, as the title of a specific invention, remains capitalized.

On the case for the internet's lowercasing, Tony Long reminds us that such changes 'should not be interpreted as some kind of symbolic demotion.'[5] Rather, we should think of it more 'as a stylistic reality check.'[6] The same could be said for another term that proved problematic in this book: post-internet. It could be surmised that eventually this term, like most hyphenated terms, will eventually become obsolete, just as Post-Modern became postmodern (or Postmodern, depending on how you use it). Again, the rules of hyphenation are not absolute. They change with time.

In the case of post-internet, we opted for the hyphen and the lowercase. After all, we're talking about art after the internet: therefore, post-internet. And though *frieze* capitalized the term in a survey of writers, curators, and artists discussing the notion of 'Post-Internet art',[7] we followed consensus once more. The notion of 'Post-Internet art' as a genre is also unstable.

This instability is perhaps characteristic of art production in the emergent (post/metamodern) twenty-first century. To capitalize post-internet as one would capitalize Post-Impressionism, for example, feels anachronistic. Yet, in employing the hyphen we feel positioned somewhere between convention and non-convention—*Rhizome*, for instance, merges the two words, 'post' and 'internet' as one, suggesting that this term has become a condition like the postmodern.

Nevertheless, to enter into this publication is to explore something that has come to define so much about the way we live—the internet—while considering it through the myriad of voices who have played a role in defining various modes of thought and creative production around it. These ideas are still forming, and so is the lexicon. Grammatical conventions have been— and are being—flouted online and thus are changing at every moment, in a multitude of ways. Whether this is a good thing or not, time will tell.

Post-internet probably will become one word, some day. Or maybe it won't, and that probably won't matter. Or it will. If the word 'internet' and the case of its capitalization is anything to go by, it seems the twenty-first century—this 'connected' age—might well be a time of lexical dissensus, at least for the time being, or in the time in which this book was produced. This very uncertainty is a reflection not only of the internet as a word, but of the internet as a world of contestation—a network of networks, not always united as one.

1 Tony Long, 'It's just the "internet" now', *WIRED News*, 16 August 2004, http://www.wired.com/culture/lifestyle/news/2004/08/64596.

2 Michael Quinion, 'Internet', World Wide Words, http://www.worldwidewords.org/topicalwords/tw-int1.htm.

3 Ibid.

4 Jennifer Chan in email conversation with the author, 2 February 2014.

5 Long, op. cit.

6 Long, op. cit.

7 'Beginnings + Ends', *frieze*, Issue 159, with Chris Wiley, Katja Novitskova, Constant Dullaart, Karen Archey, Tyler Coburn, Hanne Mugaas, Steven Cairns, Lauren Cornell, http://www.frieze.com/issue/article/beginnings-ends.

A Note on Capitalization

Glossary

AVATAR: an image that represents a computer user, most often on the internet; the image of an online persona.

BEYONSENSE: is named after a translation of zaum, a hybrid word coined by early-twentieth-century Russian poets to describe non-referential and sensorial verbal expression.

BIT: the basic unit of information in computing and digital communications.

COMMENTARIAT: members of the news media, considered in this term as a class of social, cultural and political commentators.

CONTRA: in contrast/opposition to.

CLOSED NETWORKS: networks that require permission to join.

DARKNET: a computer network with restricted access chiefly used for illegal peer-to-peer file sharing.

DATABOTS: emerging, self-organizing systems; artificial life forms simulated in a computer.

DATA MINING: aims to find as yet undiscovered knowledge in datasets (see: datasets).

DATASET: a collection of data.

DEEP WEB: also deepnet, invisible web, or hidden web. A network of online content that exists outside of the so-called 'surface web', where users are anonymous and undetected. The deep web comprises of a matrix of undetected, encrypted websites, and is also known as Tor (The Onion Router).

DIGITALITY: the condition of living in a digital culture.

DIGITAL PROPHET: is what tech people are being called these days (Google AOL's Shingy).

HACK: to gain unauthorized access to data in a system or computer.

HACKABLE: capable of being hacked.

HACKTIVIST: an activist who uses computers and computer networks for political activism, using technology as a mode of civil disobedience, protest, and activism.

INFORMATICS: in computing, the science of processing data for storage and retrieval; information science.

INFORMATIC OPACITY: a tactics of withdrawing from control by evading detection or interception from the commercial internet: darknets and mesh networks are informatically opaque in that they share information through anonymity and function with autonomous technical infrastructure, government backdoors, wireless routers, or spambots.

IMAGE ANARCHISM: reflects a generational indifference toward intellectual property, regarding it as a bureaucratically regulated construct. This indifference stems from file sharing and extends to de-authored, decontextualized Tumblr posts. *Brad Troemel*

IMAGE ANARCHIST: one who behaves as though intellectual property is not property at all. *BT*

IMAGE NEOLIBERAL: one who still believes in the owner as the steward of globally migratory artworks. *David Joselit*

IMAGE NEOLIBERALISM: a belief that art is a universal cultural product that should be free to travel wherever the market or museums take it. Meaning is created through a work's ability to reach the widest audience, not through any particular location at which it's viewed. *DJ*

IMAGE FUNDAMENTALIST: one who believes art's meaning is inseparably tied to its place of origin through historic or religious significance; to remove this art from its home is to sever its ties with the context that grants the work its aura. *DJ*

IMAGE FUNDAMENTALISM: see image fundamentalist.

IRL: in real life.

JPEG (ALSO .JPG): a commonly used method of compressing digital images through a mode of data encoding (lossy compression) that compresses data by discarding some of it.

KETTLE: synonyms—contain or corral. A term used to describe police and security force tactics to control large crowds during protests and demonstrations. It involves the formation of large police cordons that gradually works to contain a crowd within a limited area.

LIVESTREAM: to transmit or receive live video and audio coverage of (an event) over the internet.

LUDDITE: English workers who destroyed machinery, especially in cotton and woollen mills, which they believed was threatening their jobs in the early-nineteenth century.

LAPSARIAN: as a noun, the term describes someone who believes that mankind has fallen from a better state. As an adjective, it pertains to the fall of man and woman's innocence.

NETSPEAK: internet slang, internet shorthand, cyber-slang, textspeak, or translexical phonological abbreviation (Wikipedia). Netspeak refers to online vernaculars, for example, IRL – in real life.

NOUGHTIES: Since, editorially speaking, to denote the first decade of the second millennium numerically is problematic (and since Chicago advise not to use the numerical '00s or 2000s), this publication refers to this period (2000–2009) as 'the noughties'.

OPEN SOURCE: universal access via free license; software for which the original source code is made freely available and may be redistributed and modified.

PRECARITY: a condition of existence without predictability or security, affecting material or psychological welfare. Usually related to debates around twenty-first-century labour practices, particularly within the creative industries (precarious labour).

REBLOG: the mechanism in blogging, which allows users to repost the content of another user's post (like retweet for Twitter).

STEGANOGRAPHIC ENCRYPTION: when information in an image or other digital file types is encrypted by way of steganography.

STEGANOGRAPHY: uses a method to attach bits of a file to the background noise of for example a jpeg file and is often used by security experts to ensure private communication over the internet.

SELFIES: a self-portrait taken with a smartphone, digital camera or other such device, and often uploaded to a social media site.

SPAMBOTS: an automated computer program designed to assist in the sending of spam.

TIMESPACE (OR SPACETIME): In physics, spacetime is any mathematical model that combines space and time into a single interwoven continuum (Wikipedia). In this volume, JD applied this to the model of the internet and its networks.

TECHNICAL DETERMINISM: a reductionist theory that presumes that a society's technology drives the development of its social structure and cultural values (Wikipedia).

TECHNICALISM: addiction to technology (see Technicalist).

TECHNICALIST: one addicted to technology.

TELEPRESENCE: a set of technologies that allow a person to feel as if they were present, to give the appearance of being present, or to have an effect, via telerobotics, at a place other than their true location (Wikipedia). (adj. telepresent.)

TOTALIZATION: to make or combine into a total.

URL: uniform resource locator, or web address.

UNICODE: an international encoding standard for use with different languages and scripts, by which each letter, digit, or symbol is assigned a unique numeric value that applies across different platforms and programs (Oxford).

WEB 2.0: though Sir Tim Berners-Lee, creator of the World Wide Web, maintains that Web 2.0 is really just an extension of the original ideas of the web that does not warrant a new moniker (Paul Anderson), nevertheless, Web 2.0 is defined by the Oxford Dictionary as: 'the second stage of development of the Internet, characterized especially by the change from static web pages to dynamic or user-generated content and the growth of social media.'

WORLD WIDE WEB:
The World Wide Web (www, WWW, or commonly known as the web) was conceived by Tim Berners-Lee in 1989. The web is a system of interlinked hypertext documents accessed via the internet—a global system of interconnected computer networks that use the standard Internet protocol suite (TCP/IP) to serve several billion users worldwide. The World Wide Web is a model of software that connects web pages to one another via a linking system called hypertext transfer protocol (aka 'http'). Every webpage and website is on the World Wide Web.

Biographies

EDITOR

Omar Kholeif is a curator, writer, editor, and producer. He is Curator at the Whitechapel Gallery, London, Senior Curator at Large at Cornerhouse and HOME, Manchester, as well as Senior Editor of *Ibraaz*. Previously, he was Head of Art and Technology at SPACE, London, and Curator at FACT, Foundation for Art and Creative Technology, Liverpool. Kholeif has also been Artistic Director at the Arab British Centre, London, and Founding Director of the UK's Arab Film Festival. In 2012, he was a co-curator of the Liverpool Biennial. Kholeif writes for the international press and curates projects internationally. He was a founding editor of *Portal 9*, an Arabic-English journal of urbanism and architecture. His most recent publications include, *Vision, Memory and Media* (Liverpool University Press, 2010), *Far and Wide: Nam June Paik* (Leonardo, 2013) and *You Are Here: Art After the Internet* (Cornerhouse Books, 2014). Kholeif holds degrees from the University of Glasgow and the Royal College of Art, London. He is a Fellow of the Royal Society of Arts and a member of AICA, the International Association of Art Critics.

FOREWORD

Ed Halter is a critic and curator living in New York City. He is a founder and director of Light Industry, a venue for film and electronic art in Brooklyn, New York, and his writing has appeared in *Artforum*, *The Believer*, *Bookforum*, *Cinema Scope*, *frieze*, *Little Joe*, *Mousse*, *Triple Canopy*, *Village Voice*, *Rhizome*, and elsewhere. He is a 2009 recipient of the Creative Capital | Warhol Foundation Arts Writers Grant, and his book *From Sun Tzu to Xbox: War and Video Games* was published in 2006. From 1995 to 2005, he programmed and oversaw the New York Underground Film Festival, and he has curated screenings and exhibitions at Artists Space, BAM, the Flaherty Film Seminar, the ICA, London, the Museum of Modern Art, the New Museum, PARTICIPANT INC., and Tate Modern, as well as the cinema for Greater New York 2010 at MoMA PS1 and the film and video programme for the 2012 Whitney Biennial. He teaches in the Film and Electronic Arts department at Bard College, and is currently writing a critical history of contemporary experimental cinema in America.

ASSISTANT EDITOR

Stephanie Bailey is a writer and editor. She has an MA in Contemporary Art Theory from Goldsmiths College and a BA in Classical Civilization with English Literature from King's College (both University of London), as well as a Foundation Diploma in Art and Design from Camberwell College of Art (University of the Arts London). Between 2006 and 2012, she lived in Athens, Greece, where she played a formative role in designing and managing the BTEC-accredited Foundation Diploma in Art and Design at Doukas Education. Concurrently, she wrote on contemporary art production and its discourses from around the world both as Art and Culture Editor of *Insider Publications*, and as a freelance critic and essayist. She is the Managing Editor of *Ibraaz*, a contributing editor for *ART PAPERS*, a correspondent for Ocula. com, and is on the editorial teams for *Dapper Dan* and *Naked Punch*. Her writing appears in publications including *Artforum*, *ArtAsiaPacific*, *LEAP*, *Modern Painters*, *Notes on Metamodernism*, *Rhizome*, *Whitewall* and *Yishu Journal of Contemporary Chinese Art*.

AUTHORS

Basel Abbas & Ruanne Abou-Rahme's work explores the politics of desire and disaster, subjectivity, and the absurdities of contemporary power structures, often examining the relationship between the actual, the imagined, and the remembered. The result is a practice that investigates the experiential, material possibilities of sound, image, and environment, taking on the form of interdisciplinary installations and live audio-visual performances.

Sophia Al-Mara is a writer and artist. Her first book, *The Girl Who Fell to Earth*, was published in 2012.

Sam Ashby is an artist, designer, writer, and film curator. Since 2010, he has published *Little Joe*, a collaborative forum for the discussion of film around the subjects of sexuality and gender within a queer historical context. He compliments the focus of the publication with an ongoing film programme, presenting screenings and events in the UK and internationally.

Jeremy Bailey is a Toronto-based *Famous New Media Artist* whose work explores custom software in a performative context. 'His work is often confidently self-deprecating in offering hilarious parodies of new media vocabularies' (Marisa Olson, *Rhizome*). Recent projects include performances, exhibitions and commissions for *Rhizome*'s Seven on Seven, Transmediale, the Stedelijk Museum, FACT, Turner Contemporary, the Tate Liverpool and the New Museum in New York. Bailey is represented by Pari Nadimi Gallery in Toronto. For more visit jeremybailey.net.

Erika Balsom is a lecturer in Film Studies and Liberal Arts at King's College, London. Her writing has appeared in journals such as *Cinema Journal*, *Screen*, and *Afterall*, and her study of the moving image in art since 1990, *Exhibiting Cinema in Contemporary Art*, was published by Amsterdam University Press in 2013.

Zach Blas is an artist, writer, and curator whose work engages technology, queerness, and politics. He is the creator of Facial Weaponization Suite and the art group Queer Technologies, a founding member of The Public School Durham, and a PhD candidate at Duke University.

James Bridle is a writer, artist, publisher, and technologist usually based in London, UK. His work covers the intersection of literature, culture, and the network. He has written for *WIRED*, *ICON*, *Domus*, *Cabinet*, *The Atlantic* and many other publications, and writes a regular column for the *Observer* newspaper on publishing and technology. James speaks and exhibits worldwide at events including SXSW (Austin), dConstruct (Brighton), LIFT (Geneva), Web Directions (Sydney) and NEXT (Berlin). He has been commissioned by organizations such as Artangel, SPACE, Eyebeam, Mu Eindhoven, the Corcoran Gallery, Washington DC, the BBC, and Channel 4.

Jennifer Chan makes remix videos that comment on art and gender after the internet. Her research on the histories and trends of internet art have appeared on *Rhizome*, *West Space Journal*, *Art F City*, and *Junk Jet*. She currently teaches Media Arts Practices at the School of Art Institute Chicago.

Tyler Coburn is an artist and writer based in New York.

Model Court is the name of an ongoing collaboration between Lawrence Abu Hamdan, Sidsel Meineche Hansen, Lorenzo Pezzani, and Oliver Rees. Using video, sound, drawing, and installation, their group work interrogates the production, dissemination, and transmission of the law, exploring how images and representations serve to complicate the production of legal space and the borders between nations. The most recent solo presentation of Model Court's work was *Resolution 978HD* at Gasworks London 2013.

Jesse Darling is an artist, curator, and occasional essayist, researching the deep links between technology, power, and experience. Stimulated by a profound thinking around modes of subjectivity on and offline in late capitalism, JD works in installation, digital, 'dasein by design', and the space in which performance becomes unmediated experience.

Brian Droitcour is a writer, translator and curator based in New York.

Constant Dullaart is a former resident of the Rijksakademie in Amsterdam, and lives and works in Berlin. His practice is focused on visualizing internet vernaculars and software dialects. He adopts a political approach that is critical of the corporate systems that influence our contemporary semantics. In his work, Dullaart is often found editing online forms of representation, and the user's access to them, to create installations and performances that exist both online and offline. Rather than seeking to write books, so to speak, Dullaart is interested in animating the very concept of the library itself. His work has been published internationally in print and online, and exhibited at venues such as Massachusetts Museum of Contemporary Art, Utah Museum of Contemporary Art, the New Museum in New York, the Polytechnic Museum in Moscow, Autocenter in Berlin, and de Appel, W139 and the Stedelijk Museum in the Netherlands. Dullaart has curated several exhibitions and lectured and universities throughout Europe, most currently at the Rietveld Academy in Amsterdam.

Gene McHugh is a writer and curator based in New York. His writing has appeared in *Artforum, Aperture, The Red Hook Journal, Rhizome*, among other locations; and his blog 'Post Internet' was published as a book by Link Editions in 2011. He has curated exhibitions at venues including Interstate Projects, Johannes Vogt Gallery, 319 Scholes, and Silver Shed.

Lucia Pietroiusti works with contemporary art and writing. She studied Critical Theory at Birkbeck College, University of London, and Gender Studies at Trinity College, Dublin, with a specific focus on trauma and mourning in literature and the visual arts. She is currently Public Programmes Curator at the Serpentine Galleries, London.

Jon Rafman is an artist, filmmaker, and essayist whose work explores the impact of technology on consciousness. His films and artwork have gained international attention and have been exhibited at the New Museum, the Palais de Tokyo in Paris, and the Saatchi Gallery in London. Rafman's work has been featured in *Modern Painters, frieze, The New York Times*, and *Harper's*.

James Richards is an artist who graduated from the Chelsea College of Art and Design in 2006. He was a 2012 recipient of the Derek Jarman award and participated in the LUX Associate Artists Programme in 2008. Recent solo exhibitions include CCA Kitakyushu, Japan, Chisenhale Gallery, London and Tramway, Glasgow. Recent two person and group exhibitions include *Frozen Lakes*, Artist Space, New York, *The Encyclopedic Palace*, Venice Biennale, 2013, *Art Now: Clunie Reid and James Richards*, at the Tate Britain, London; *Generational: Younger Than Jesus* at the New Museum, New York and *Coming After* at The Power Plant, Toronto.

Başak Senova is a curator and designer. She has an MFA in Graphic Design and a PhD in Art, Design and Architecture from Bilkent University and attended the 7th Curatorial Training Programme of Stichting De Appel. She curated the Pavilion of Turkey at the 53rd Venice Biennale; co-curated UNCOVERED (Cyprus) and the 2nd Biennial of D-0 ARK Underground (Bosnia and Herzegovina). She is the Art Gallery Chair of (ACM) SIGGRAPH 2014 (Vancouver) and the curator of the Helsinki Photography Biennial 2014 and Jerusalem Show. Senova is currently teaching at Koç University.

Jamie Shovlin is interested in the tension between truth and fiction, reality and invention, history and memory. His projects are long-term engagements with painstaking research applied to working practices specific to each particular project and its focus. Artificial distancing mechanisms are employed within work that seeks to confound and subjugate the role of author, originator, and practitioner. These often take the form of literary or filmic traditions including unreliable narration, alternate realities, multiple accounts of the same event, and meta-commentary. His work attempts to merge inherently flawed systems, pseudo-scientific exactitude, and doubtful philosophical propositions with the seemingly objective experience of the archive. Shovlin studied at the Royal College of Art. Solo exhibitions include *Various Arrangements* at Haunch of Venison, London (2012), *Thy Will Be Done* at Tullie House, Carlisle (2011), *Hiker Meat* at MACRO, Rome (2010) and *In Search of Perfect Harmony* at Tate Britain, London (2006) and *Jamie Shovlin: Hiker Meat* at Cornerhouse, Manchester (2014).

Brad Troemel is a conceptual artist, writer, lecturer, and instructor living in New York. He received his BA in Visual and Critical Studies from the School of the Art Institute of Chicago in 2010 and an MFA from The NYU Steinhardt School of Art in 2012. He is a regular contributor to *DIS magazine*, the website *Jogging* (thejogging.tumblr.com) and the organizer of many online art exhibits. His art and writing are primarily focused on the internet as context and medium.